INTRODUCTION

Modern technology has made the mechanics of photography so simple that even someone who has never touched a camera can take a technically perfect picture. However, to assume that an automatic camera will enable anyone to take *good* pictures is as naive as suggesting that the invention of electric rock-drills makes skilled sculptors redundant. Carving a baroque marble statue would be an unthinkable feat for most of us whether we use a hammer and chisel or a power drill.

Despite the push-button simplicity of today's cameras, photography remains as much a craft as the carving of stone. And like any craft, the necessary skills don't just magically appear overnight. They are learned, developed, and refined with use, and every learning process begins with imitation and copying. We learn to speak by copying our mother's vowels. Later we learn to write by copying down letters from a blackboard or book.

Craft skills have traditionally been taught by imitation, too: at the feet of master craftsmen, students would watch, study, and emulate. They would learn by example, by copying the actions and style of their tutor. Only when they had learned to reproduce faithfully the cut of the master's chisel would they be allowed to innovate, improve and originate.

What better way to learn the skills of photography than as the craftsmen of old did, by emulation and copying? So in these pages you'll read how photographers crafted nearly a hundred pictures: how and why they composed them as they did; and how they used the camera's controls to create exactly the style of imagery they were seeking.

Naturally you will not want to recreate slavishly the images illustrated here: you have your own ideas, and your own subjects to photograph. But by copying the compositional and camera techniques described, you will find that your photographic skills develop rapidly; and soon, like the craftsman's apprentice, you will no longer be copying, but innovating, improving on and surpassing what you see here!

Richard Platt

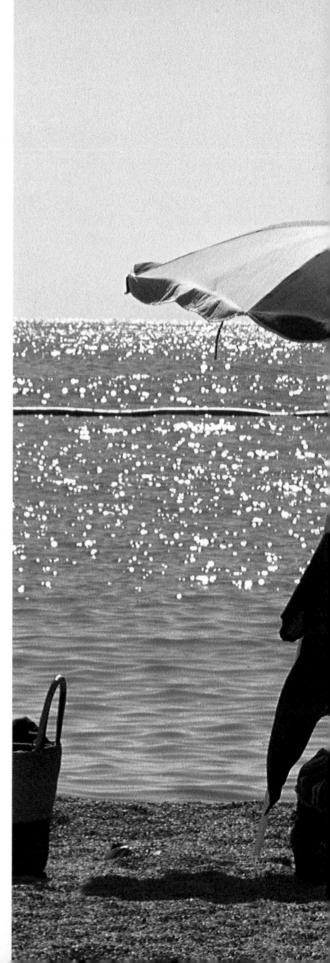

The
PHOTOGRAPHER'S
IDEA BOOK

The PHOTOGRAPHER'S IDEA BOOK

HOW TO SEE AND TAKE BETTER PICTURES

Richard Platt

AMPHOTO

AN IMPRINT OF WATSON-GUPTILL PUBLICATIONS/NEW YORK

CONTENTS

First published in 1985 in
New York by AMPHOTO,
an imprint of Watson-Guptill
Publications, a division of
BPI Communications, Inc.,
1515 Broadway, New York,
NY 10036

Library of Congress
Cataloging in Publication
Data 85-72455

ISBN 0-8174-5415-2 (hardback)
ISBN 0-8174-5420-9 (paperback)

**Designed and produced by
Robert Adkinson Limited,
London**

Editorial Director
Clare Howell

Editor
Anne Charlish

Art Director
Christine Simmonds

Designers
Kirby-Wood

Phototypeset by Dorchester
Typesetting Group Limited,
Dorchester

Colour and black-and-white
illustration origination by
East Anglian Engraving
Limited, Norwich

Printed and bound in Italy by
New Interlitho, S.p.A

23456789/98/97/96/95/94/93

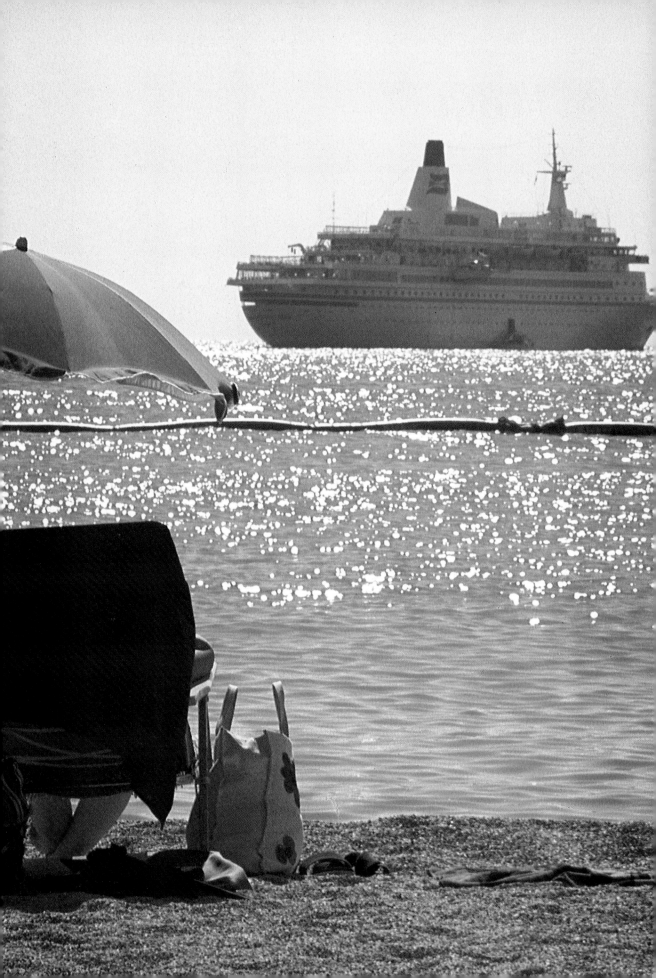

PEOPLE

To take great pictures of people, first find your subject. Obvious? In the literal sense, yes. But pictures of people are far from literal; and good ones are much more than just good likenesses. The subject of a portrait, nude or candid picture means not just the face or the body of the person portrayed, but something much broader than this. Taking a picture that says 'This is what my subject *looked* like' is quite easy. But to make an image that says 'This is what my subject *was* like' is not such a simple task.

The skill of a portrait photographer is to capture on film the essence of the sitter's personality. At the start of this chapter, you'll see how a number of photographers have taken up this challenge – and you'll be able to identify compositional and photographic techniques that you can instantly employ in your own portraits. Some of these styles of portraiture rely on metaphor to suggest character; others on the minutiae with which the subjects surround themselves. This is not to say, though, that the best portraits are difficult to understand or overloaded with detail. As the portrait opposite demonstrates, sometimes the most simple, direct pictures can speak volumes.

Photographers approach the nude as a subject in equally varied ways. Sensuality pervades some nude studies; others glory in the undulating lines of the body, unmistakably human even in extreme close-up. But, again, the lesson to be learned from the figure studies shown here is that the shape of the human body is only a point of departure, and good nude photography reveals more than just bare skin.

The chapter closes with some examples of candid photography. The subjects of these images go about their daily business oblivious of the camera. So, unlike nude and portrait photography, where the subject is aware of the camera, here the photographer's techniques are all directed towards unseen observation; the aim is to provide brief glimpses into other people's worlds, and thereby give a general insight into the human condition.

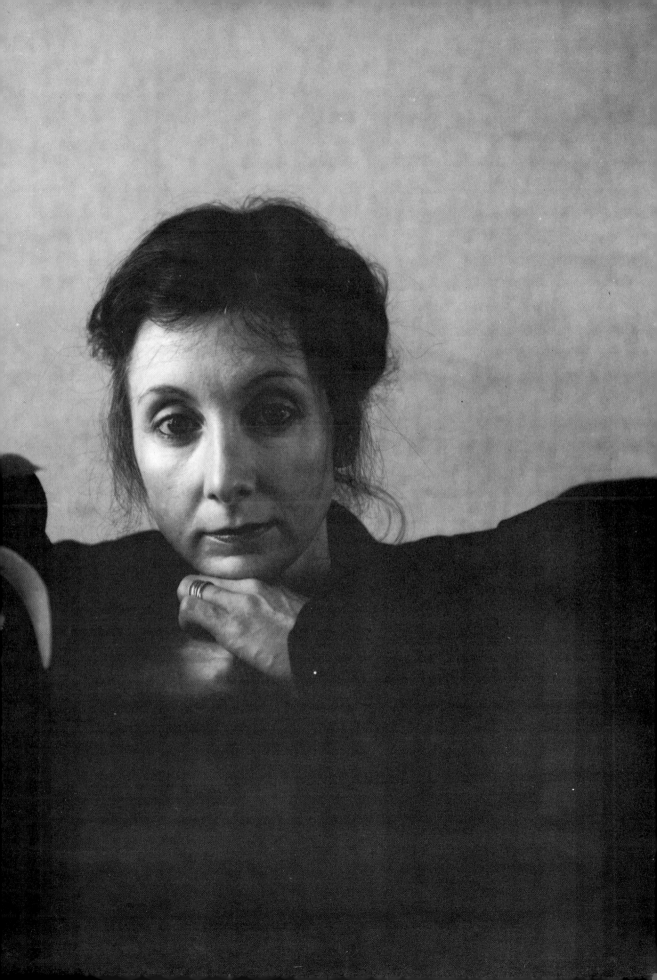

Subject movement during the exposure, and shallow depth of field, conspire to make the image very slightly soft, enhancing the painterly feel.

Choice of tungsten light also contributed that indefinable quality of 'moodiness' to the picture. By comparison, electronic flash has a clinical, needle-sharp edge.

The dark props and the generally sparing exposure make the portrait decidedly low-key.

The white shirt collar and the catchlight in the eyes add an essential sparkle which gives the image life and vibrancy.

Camera:
Rollfilm SLR

Lens:
250mm

Film:
ISO 40 colour
transparency

Metering:
Spotmeter, multiple
readings averaged

Filter:
—

Lighting:
Tungsten-halogen
photographic lamp

Composition This striking portrait was initially conceived as a simple technical exercise. As an experiment, though, it succeeded far better than the photographer had ever dared hope. The subject was her husband, and the theme was the paintings of Rembrandt: she aimed to make a portrait in the style of the artist.

She decided early on to keep the picture as simple as possible, so she posed her sitter against a roll of seamless background paper, which she crumpled slightly so as to add a little texture. To simplify his clothing, she draped a black blanket over his shoulders. Wrapped right round, the blanket made the picture look a little austere, so she asked her husband to put his hands on his waist, making the blanket fall open at the front. She unbuttoned the shirt to add some interest and activity around the neck, and to break up the otherwise unrelieved expanse of black.

The main feature of the portrait, though, is not the dress, but the sitter's intense gaze. The photographer enhanced this by using a long exposure, so that her husband would have to concentrate on keeping absolutely still. She operated the camera's shutter a couple of times at the chosen speed, so that he could hear just how long he had to hold the pose for.

Finally, she asked him to lean slightly forward, and turn his shoulders to the side, so that the picture is asymmetrical, rather than rigidly balanced around the centre-line of the frame.

Technique Lighting helped to create the Rembrandtesque feel. There was only one source of light: a tungsten floodlight bounced off the wall on the right of the camera. This created a soft yet strongly directional lighting that resembles north light from a window. To cut the contrast down, the photographer placed a reflector card on the opposite side of her sitter's face, throwing light back into the shadows.

She used a spotmeter to measure the light falling on her husband's face, taking two readings – one each from highlight and shadowed sides – and averaging them to come up with the exposure settings of ½ second at f/11. Other meter readings confirmed that the black blanket would appear a solid tone, and that the hands would be just visible in the shadows.

Before making the exposure, she took a final check on lighting and exposure using Polaroid film. On the basis of this, she opened up the aperture half a stop for the picture, which was taken on tungsten light-balanced film.

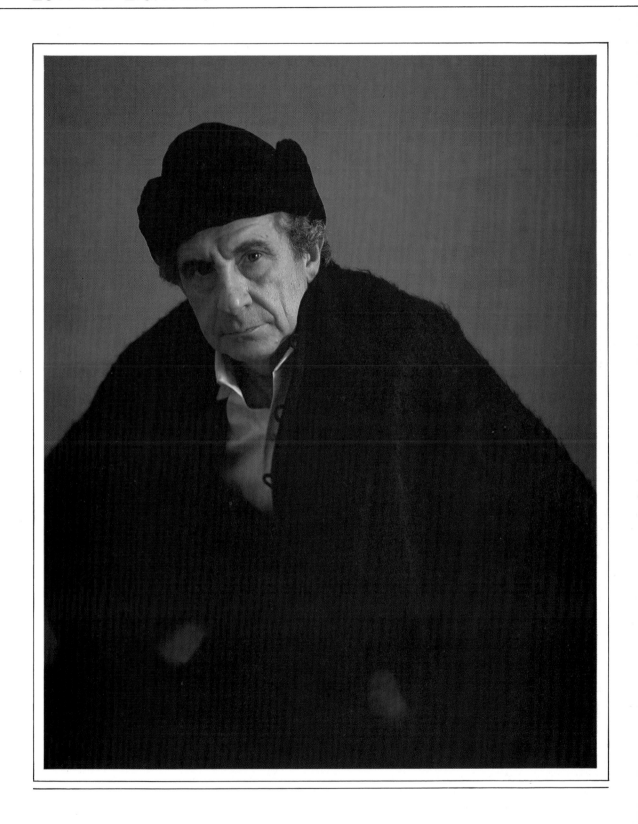

The single light source would normally have created heavy shadows on the face, but in this instance, the abundance of white reflecting surfaces has bounced light back into the right side of the baker's face.

The soft but directional lighting brought out the texture of the dough.

Small details help to build up an impression of the subject's character. This mug, for example, hints at a tea-break snatched on the run.

Camera:
Non-reflex wide-angle rollfilm

Lens:
Fixed 38mm wide-angle

Film:
ISO 125 black and white

Metering:
Hand-held flash meter used in incident mode

Filter:
—

Lighting:
1200 w/sec studio flash unit bounced from ceiling

Composition Surrounded by all the paraphernalia of his trade, a working baker weighs out – by hand – the dough for several hundred dozen bread buns. An abundance of detail puts the portrait into context, but the baker's direct gaze at the camera ensures that none of this clutter draws attention away from him. On the contrary, every element that has been included in the picture contributes something and tells us a little more about this hardworking man. He is framed by the early morning darkness outside the window, and dwarfed by the huge pile of dough – representing his work both literally and metaphorically.

The photographer wanted to include as much of the bakery as possible, but this meant keeping the 'sitter' himself quite small within the frame. To compensate for this, and emphasize the figure, the photographer tilted the camera downwards, creating converging lines that direct the viewer's eye back to the middle of the frame. Then he turned the roll-covered tray in the foreground to align it with the picture's edges, so that the rows of white moulded rolls also converge towards their maker.

Technique Coated in flour, and populated with burnt-black bread tins, the scene was almost monochromatic, and begged the use of black and white film. The photographer decided on a slow emulsion so that every detail of the scene would be clearly drawn in the print, but this then introduced problems of light – the available light was inadequate.

To provide enough illumination without sacrificing atmosphere, the photographer supplemented the existing light bulbs with a powerful studio flash unit. He placed the flash generator on the floor, and clamped the flash-head to a shelf, directing its beam towards the light fitting. The effect of this was to produce on the ceiling a large pool of light, which in turn illuminated the room and the baker. This soft but directional illumination simulated the light from the fluorescent tubes that normally lit the room. Direct flash would have provided an equal amount of light, but the quality and modelling would have been less satisfactory – very flat and frontal, with deep shadows behind the figure, and a harsh reflection of the flash unit in the window. A large studio flash was used, simply so that the photographer could set a small aperture. After setting up the lighting, exposure was then easily determined by using a flash meter.

By using an ultrawide-angle rollfilm camera (a Hasselblad SWC) the photographer was able to take a very broad view of the bakery, with practically no distortion. Additionally, when stopped down to f/16, the 38mm lens provided enough depth of field to keep the entire scene pin-sharp. The photographer set the camera's shutter speed to ½₅₀, so that the natural light would not cause secondary images in the event of subject movement. (Exposure to flash light is unaffected by shutter speed, provided it is slow enough to synchronize with the camera's shutter and this camera synchronizes at all speeds.)

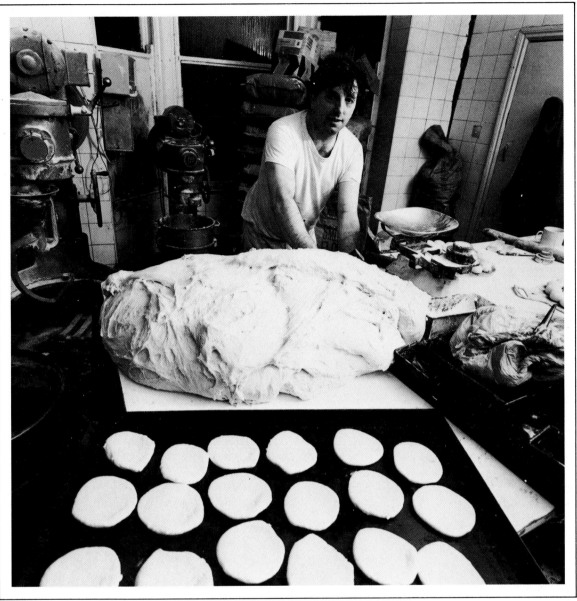

In the confined space of the bakery, there was no room to use conventional diffusers or umbrella reflectors, so the white ceiling was used to soften the light of the flash unit.

A meter reading from the trees in the background indicated that they were four stops darker than the brightest parts of the face, and would therefore appear black and completely featureless on film, enhancing the theatrical qualities of the portrait.

Metering from the narrow band of light on the face was difficult, so the photographer instead took an incident light-meter reading with the diffusing dome of the meter pointing directly at the setting sun. This provided an adequate substitute reading.

A white card reflector close to the camera bounced a little light back into the shadows, which would otherwise have appeared too dark on film.

Camera:
35mm SLR
Lens:
200mm
Film:
ISO 64 colour
transparency

Metering:
Hand-held incident light
meter
Filter:
Pale blue 82C filter to
compensate for the warm
hued evening sunlight
Lighting:
Natural

Held out in front of the model, a narrow strip of ordinary household mirror projected the brilliant line of light on to the subject's face.

Composition It has become a cliché to say that a good portrait expresses the character or perhaps the occupation of the subject, but this does not mean that expressive portraits need themselves be clichés, as this example illustrates.

The subject of this picture is a creative holographer – an unusual mixture of art and science. His day-to-day work involves control of laser light to a high degree of precision, but to artistic, rather than scientific, ends. The photographer therefore chose to depict the subject in a manner that reflected this work – the control of light.

The portrait was scheduled for sunset because at this time of day the low sun backlit the subject, creating a ring of light around the head. To focus attention on the face, a plain background seemed appropriate – shady trees provided this.

The image is dominated by the bar of sunlight on the face, which creates a theatrical spotlighting effect. A narrow strip of mirror held by the subject reflected the light back in this graphic manner – changing the position and angle of the mirror controlled exactly where the light fell.

Technique The sun itself was just outside the frame, causing flare and severely reducing contrast. Fitting a 200mm lens reduced the camera's angle of view, which partially solved the problem. A conventional lens hood, though, did not provide sufficient shading from the sun, so the photographer shaded the lens with a French flag (as described in Glossary).

The camera was tripod-mounted, virtually eliminating the risk of camera shake, even with the relatively long lens in use. The photographer, therefore, used a shutter speed of ⅟₆₀, stopping the lens down to f/11 to increase depth of field and hold sharp detail in as much of the face as possible.

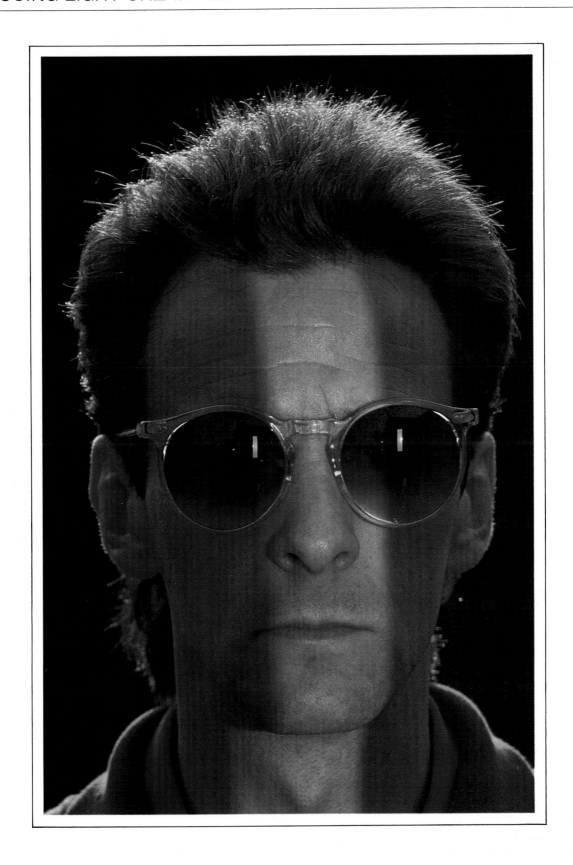

To take in the figures, the road and the building meant using an extreme wide-angle lens. Fitted to the 6 × 9cm roll-film camera used here, the 50mm lens chosen has a field of view similar to a 20mm lens on a 35mm camera.

Holding the flash at arm's length to one side of the camera prevented the lighting on the faces from looking too flat and frontal.

The intention of the photographer was to create an image that echoed the personalities of the subjects – vigorous, young and fashionable. The wide-angle lens helped to do this by creating a steep, dynamic perspective.

Use of a medium-format film minimized grain, which tends to be larger with negative film than with transparencies.

Camera:
Rollfilm rangefinder type
– format 6 × 9cm

Metering:
Hand-held, measuring
reflected light

Lens:
50mm wide-angle

Filter:
—

Film:
Colour negatives, daylight
balanced

Lighting:
Portable flash, hand-held

Composition The brief for this picture was simple: to take an informal double portrait of the couple and their dogs. The interpretation was left entirely to the photographer, but time was short, and the only available location – the garden of an inn alongside a busy road – seemed unpromising.

Surprisingly, the location proved to be an asset in the end, rather than a handicap, because the surroundings provided a variety of different light sources: plain and coloured household bulbs, tungsten spotlights, the light from the sky, and headlamps from passing cars. Combined with photography's own light source – electronic flash – these coloured lights provided a brilliant backdrop for the seated figures.

The conventional structure for a double portrait such as this is to pose the man very close to and slightly higher than the woman. This composition was chosen specifically to reverse the convention, physically separating the figures, and bringing the woman forward so that she appears larger in the frame. The motive was not purely a graphic one, but also reflects the independence and unconventional lifestyle of each of the partners. The touching glasses on the table – which itself links the two figures – is sufficient to suggest a bond.

Technique The final picture owes much of its impact to the unusual and dramatic lighting, but, surprisingly, no elaborate lighting equipment was used to create the effect shown here: the fore- ground figures were lit by an ordinary portable flash gun.

To balance the various light sources, the photographer first checked the calculator dial on the flash unit to see which apertures could be used with ISO 100 film. There was a choice of three: f/4, f/8, and f/16. The intermediate aperture seemed the best option, and provided ample depth of field with the 50mm wide-angle lens in use.

The next step was to take a light-meter reading from the window of the building to find a shutter speed that would record the window with the same brightness as the foreground figures. This proved to be a two-second-long exposure. (The burst of light from a flash unit is so brief that altering shutter speed has no effect on the brightness of flash-lit areas of the image. However, for the flash and camera to work properly together, the shutter speed must be slower than the flash synchroniz- ation speed – usually ⅟60 or ⅟90.)

The final meter reading was from the rapidly darkening sky. When this area was the same brightness as the window, the photographer waited for a passing car to complete the picture, and pressed the shutter release.

In situations such as this, where the light changes rapidly, the narrow exposure latitude of colour transparency film is a handicap. Colour negative film such as the Kodak Vericolor II used here is a better choice, because minor exposure and colour imbalances can be corrected in printing.

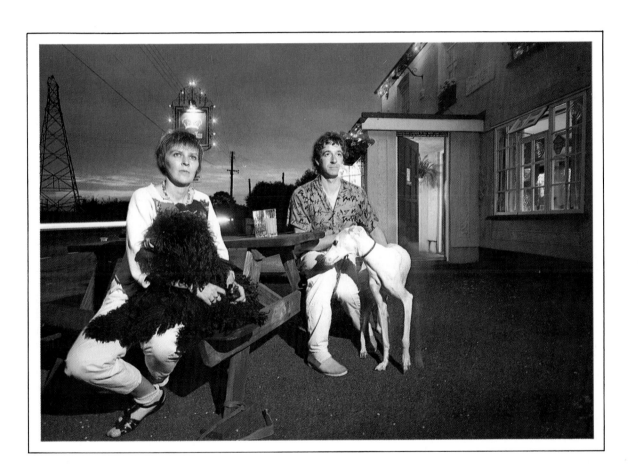

Snow on the ground beneath the window reflected light upwards, softening the lighting, and filling in shadows under the chin and in the eye-sockets.

The open-eyed, smiling grin at the camera counteracts any tendency for the picture to look sombre and heavy.

The muted hues of the woman's sweater reiterate the wintry theme of the image.

Camera:	**Metering:**
35mm SLR	TTL, substitute reading
Lens:	**Filter:**
200mm	81B
Film:	**Lighting:**
ISO 64 colour transparency	Natural

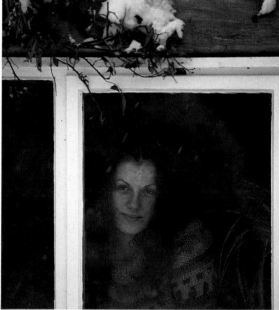

Without the smile, the muted hues of this winter portrait give it a sombre, melancholy mood – but the model's happy expression in the main picture adds unseasonal warmth.

Composition Misty, soft-focus imagery has become one of the greatest clichés of photography; a formula approach used as a shorthand for romance by unimaginative photographers. Remember, though, that a cliché achieves that status only after endless and cynical repetition – every one started life as a genuine and sincere appeal to the emotions.

Thus, as this example illustrates, the soft-focus portrait can in skilled hands still be truly attractive – without being mawkish. What sets this image apart is that the photographer lets us see the source of the diffusion, by studiously including the frame of the window on which the condensation has formed. Without this hint, the picture would be routine. The frame helps in another way, too: it literally encloses the top and left side of the image.

Bucking convention in another way, the photographer chose a low-key approach. He placed his subject inside the window looking out, and thus surrounded her with a gloom that was suggestive of the short days of winter. Shot from the inside

looking out, the model would have been veiled in light – as in the standard fashion-plate convention.

Technique A snow-filled sky cast a cool-grey light on the scene, so the photographer began by fitting an 81B 'warm-up' filter over the lens to take out any excess blue from the picture. He set the exposure by taking a meter reading from the wall above the window. The grey stone of the wall was more or less the same tone – that is to say, reflected the same amount of light, irrespective of colour – as his model's face, and was therefore suitable for a substitute reading; the large dark areas around the face would have misled an ordinary straight TTL automatic meter reading.

To enhance the soft-focus effect, the photographer focused on the glass of the window and set the 200mm lens to its full aperture of f/4. Nevertheless, in the dull winter light, he still had to set a shutter speed of ¹⁄₁₂₅, barely fast enough to prevent camera-shake.

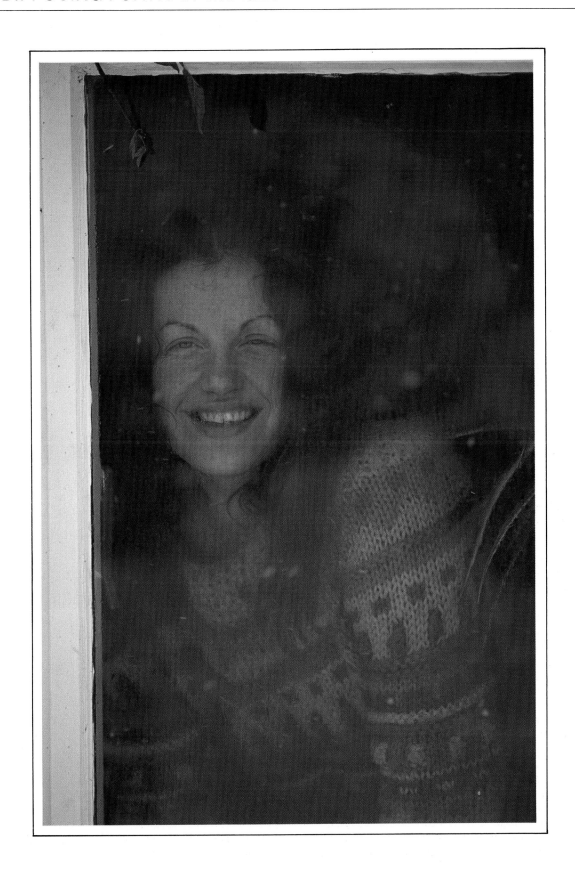

Coincidentally, the combination of natural light and draped textiles gives the picture a more than passing resemblance to early portraits by Irving Penn.

At first sight, the leggy pose seems reminiscent of advertising imagery that uses the lure or promise of an attractive woman's body to sell consumer fripperies. But just a glance above the waist soon dispels any such idea: her angular self-confident pose could not be further removed from the coy, pouting submissiveness of commercial glossy girls. This contradiction of styles – pivoted about the exact centre of the picture – is what gives the portrait its power.

The use of black and white film gives the picture a formal, traditional flavour.

Camera: 5 × 4 in field camera	**Metering:** Hand-held incident meter
Lens: 90mm wide-angle	**Filter:** —
Film: Instant positive/negative	**Lighting:** Natural

Composition This image is one of a series that the photographer took of mothers and daughters; all were part of a continuing personal project, rather than commercial work. This gave her the freedom to experiment that she might not have enjoyed in the context of a commissioned portrait. She knew this girl through her mother, so she decided to photograph the daughter first, and get to know her a little before attempting a picture of the two of them together.

The photographer decided to make the picture in a studiedly casual manner. From her friendship with the family, she knew that a very formal studio sitting would only make the two women nervous, so she draped fabrics around the room in an apparently careless way that she anticipated would put her subjects at ease. She eschewed elaborate lighting, too, preferring to work with natural daylight – for similar reasons.

The young girl had pretty legs, of which she was justifiably proud, and the photographer made them the lynchpin of the composition. She put the girl's knees at the exact mid-point of the picture, so that a full half of the frame was devoted to her crossed legs. By using two uniquely photographic devices – defocusing and wide-angle distortion – the photographer made her subject's legs seem more symbolic than real. Thus the picture is *suggestive* of colt-like legginess, rather than shouting it in a bald and much less romantic manner, perhaps as an advertisement for tights might do.

The photographer did not direct the girl into any particular poses – she just watched for characteristic expressions and gestures as they talked, and asked her subject to repeat the most appealing postures. This was one of them.

Technique Shooting the picture on a large and cumbersome 5 × 4 in camera forced sitter and photographer into traditional and quite formal roles. However, the photographer had the benefit of one modern innovation that was not available to early portraitists: instant film. She used Polaroid positive/negative film, which provides not only an instant print, but a fine-grain negative, too. So when the two women saw an image they liked on the Polaroid print, this represented not just a conventional lighting test, but a final result.

Fading light and the slow speed of the film (ISO 40) forced the photographer to use very long exposures. The negative from which this picture was printed received four seconds' exposure. Light levels were measured using an incident light meter held in front of the subject's face.

In order to emphasize the girl's legs, the photographer fitted a 90mm lens to the camera. On 5 × 4 in film, this is a wide-angle lens, and takes in a field of view that can be compared to a 24mm lens on 35mm film. The lens allowed the photographer to move very close to her subject, so that the girl's feet are much closer to the lens than her body, and her legs appear supernaturally long and elegant.

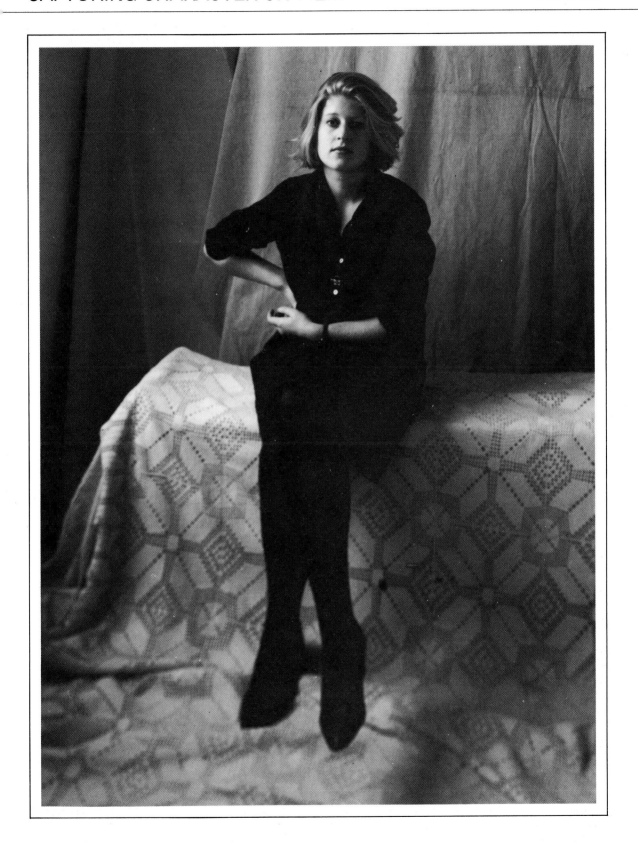

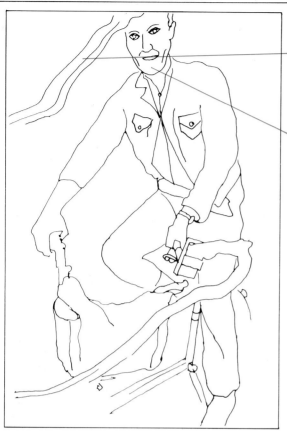

In the normal course of events, setting the camera to 'flash' automatically sets the shutter to ¹/₆₀. Combining existing light with flash to create these swirling lines meant outwitting the camera's automation by switching back to the 'daylight' setting as soon as the ready-light on the flash indicated that the unit had charged up.

Most simple cameras set exposure quite approximately, because the colour negative film that is usually used by amateurs has wide exposure latitude. To check the accuracy of the meter, the photographer ran a test roll of colour transparency film through the camera, and, based on the results, set the film speed scale half a stop faster than the camera's nominal ISO value. Exposure here is more or less perfect.

Camera:
35mm pocket camera

Metering:
Automatic

Lens:
35mm fixed

Filter:
—

Film:
ISO 400 colour transparency

Lighting:
Flash on camera

Composition The snapshot is no longer the poor relation of photography. Respected professional photographers have based reputations and careers on their ability to produce pictures that (to the untutored eye) resemble family album snaps.

The principal characteristics of the snapshot style are its spontaneity and apparent casualness or innocence. This perhaps explains its attraction in the world of high fashion and reportage – like oysters to the jaded palate of the gourmet, such an approach comes as a pleasant change after the over-rich and mannered styles that are more common on printed pages.

Here, conscious emulation of the snapshot style has led to a portrait that has a freshness and vitality often lacking in more carefully prepared compositions. Cropping seems to be haphazard, though care was taken to ensure that the face appeared in the picture! Deliberate movement of the camera smeared the beam of the bicycle lamp into a long flowing streamer, suggesting movement and urgency. And the direct flash close to the camera's lens creates the same kind of flat lighting that appears not only on snapshots, but on news pictures of celebrities and underworld figures.

Technique Behind the casual façade of the picture lies concealed a methodical approach to its execution. The photographer used a small pocket camera. This was one of the few that had a coupled rangefinder to aid focusing, though in the near-darkness conditions, an autofocus camera would have been easier to use, and would have produced an equally effective picture. An SLR would not have been suitable because its viewfinder would have been blacked out during the long exposure.

The camera's automatic meter determined the shutter speed, based on the aperture that the photographer set. There was no real choice of aperture – the camera's automatic flash unit only gave correct exposure at full aperture.

To be sure that the shutter would be open long enough to record the swirling lines of the cycle lamp, the photographer first made a 'check' exposure of the same scene and listened for the sound of the shutter opening and closing. This rough and ready test showed that the shutter would remain open for about two or three seconds.

After this preparation, taking the picture was easy – framing, pressing the shutter release, then waving the camera around after the flash had fired.

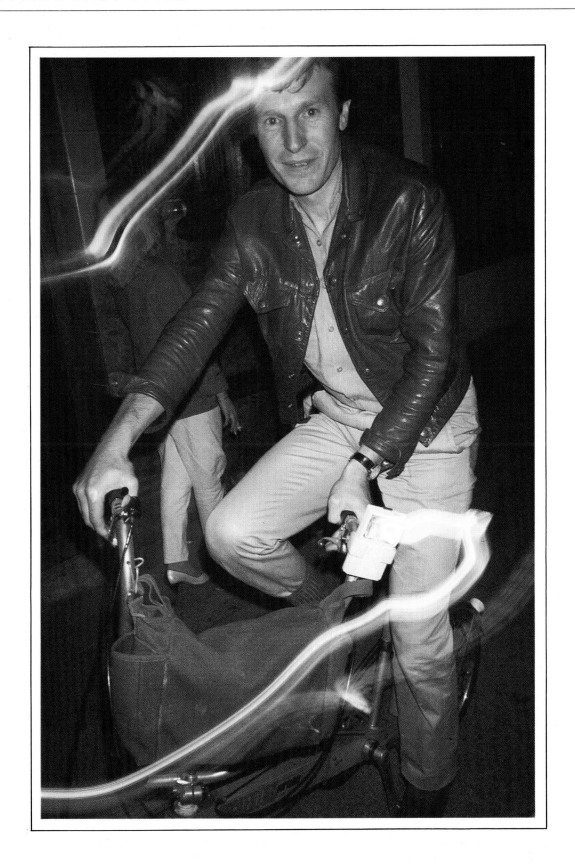

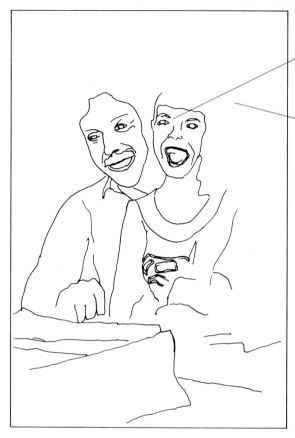

The warm hues of the picture were created by the tungsten bulbs and candlelight that provided illumination. The film in the camera was daylight-balanced, and the photographer deliberately chose not to use filters to correct the expected orange cast. He made some correction at the printing stage, however, to prevent the image from looking too brilliantly orange.

Careful choice of camera angle excluded the distracting out-of-focus Christmas tree lights that mar earlier pictures on the roll (see image below).

Camera:	Metering:
35mm SLR	TTL
Lens:	**Filter:**
105mm f/3.5	—
Film:	**Lighting:**
ISO 400 colour negative	Domestic light bulbs and candlelight

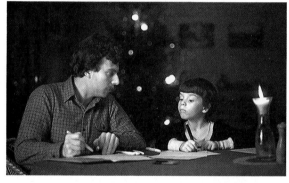

In this picture, taken slightly earlier, the two figures are farther apart, and the composition is less intimate and powerful as a result – the man could be the boy's teacher.

Composition Most of us take our best and our worst pictures at home: there is ample opportunity for picture taking, and our closeness to the people we are photographing should make them the easiest of subjects. Paradoxically, though, the very intimacy of family life often makes objective photography more difficult. Domestic environments don't help, either: they are usually cluttered with possessions and furniture that give our pictures untidy, distracting backgrounds.

Here the photographer coped with the last problem by the simple ploy of framing the figures against a plain area of shadow, and cropping the image tightly. Implying the warmth of a parental bond, though, was more difficult, and here both technique and patience played a part.

He suggested it in two ways: first, by making the picture literally warm in hues, so that the two figures seem washed by the glow of a fire. And, secondly, by waiting until the pair moved closer together. When the boy climbed on his father's knee, the composition immediately became tighter

and more evocative – and then it was just a matter of waiting for the right expressions before pressing the shutter release.

Technique Choice of film is of paramount importance in dimly lit interior pictures. Here the photographer chose fast colour negative film, because its speed made photography practical in the very low light levels, and because he knew that he could control the hues of the picture in the darkroom. Slide film – even tungsten light balanced – would have required filtration, and this in turn would have cut down the light reaching the film, forcing the use of exposures even longer than the 1/15 to which the shutter was set.

In order to keep his distance from the pair, the photographer fitted a 105mm lens, using it at its full aperture of f/3.5. Then he took a conventional TTL meter reading as a guide to exposure. The meter indicated a very slow shutter speed, so he braced the camera by resting his elbows on a nearby table-top.

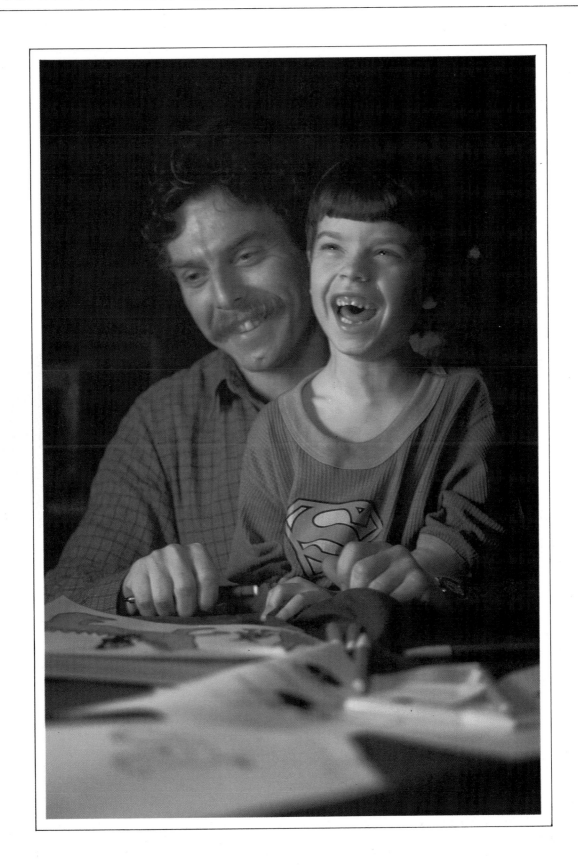

Slow film generally yields richer colours and higher apparent contrast. Here the photographer used Kodachrome 25 – noted for its extremely fine grain and faithful rendering of hues.

The curving line of the white column-top contrasts with the angular hardness of the rest of the wall, and echoes the shape of the shadow below.

The frontal lighting makes the colour of the wall stand out vividly. Lit from another angle, the orange brickwork appeared duller.

Camera:	**Metering:**
35mm SLR	TTL automatic – 1 stop compensated
Lens:	
28mm	**Filter:**
Film:	Polarizer
ISO 25 colour transparency	**Lighting:** Natural

Composition One of the unique qualities of a photograph is its ability to say to the viewer 'Look, I was here'. The photo is proof-positive that the photographer really did visit St Peter's Square, or the Niagara Falls.

Shadows make this clearer still: photographers usually avoid standing with the sun behind them, so as to exclude their own shadows from the frame, but if a snapshot says 'I was here' then surely a photograph with a shadow says it even louder?

Such was the rationale behind this unconventional self-portrait. The photographer chose the location partly for its colour, but additionally for its complete anonymity. The place is totally lack-lustre, so the viewer turns automatically to look more closely at the shadow.

The bands of contrasting tone and colour invited a very formalist approach: lining the camera up parallel with the wall would have created a rigidly geometric pattern of coloured strips, interrupted only by the shadow and spikes. Instead, the photographer opted to turn the camera to the right and compose the picture with a diagonal stress. The converging lines that resulted lend to the image a sense of movement and direction that would otherwise be lacking.

The narrow band of white at the top of the wall divides the inviting warmth of the brickwork from the cool hue of the sky and the threatening spikes above. The position of the wall-top was therefore an important consideration in the composition. The balance chosen uses a reassuringly wide expanse of wall to separate the shadow – representing the familiar – from the spikes and unseen domain that they protect – symbolic of the unknown and dangerous.

Technique Colour was all-important, so the photographer deliberately underexposed the slow colour transparency film by half a stop, in order to enrich the hues. A polarizer helped in this respect, too, darkening the sky, and making the gloss-painted spikes look darker and more unpleasant.

The lens was a 28mm – there was little practical choice, because the sun's direction and the height of the wall restricted the positions in which the photographer could stand to include both the wall-top and his own shadow.

The camera was set on automatic, since the wall was a mid-tone, and in the bright sunlight neither depth of field nor camera-shake were likely to present problems.

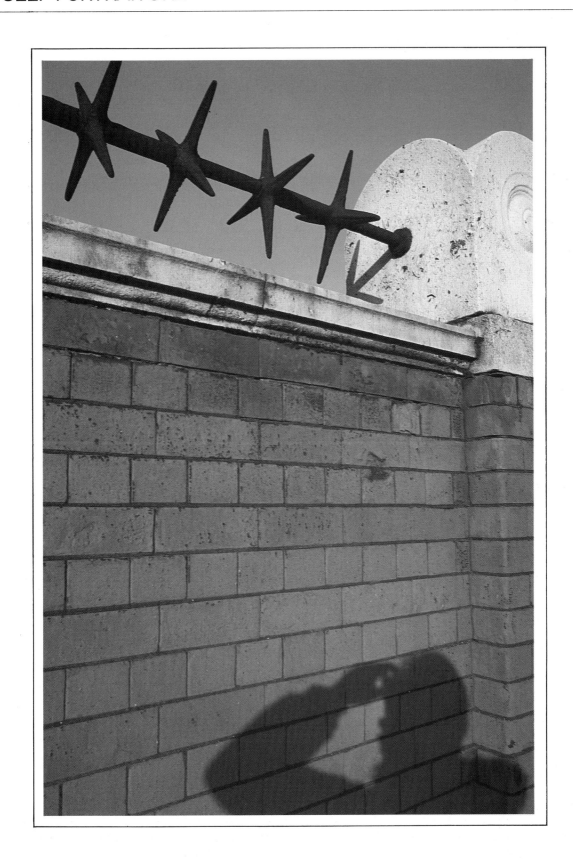

The warm hues of the image are entirely natural – no filter was needed.

The photographer waited for the bird to spread its wings, thus making a more interesting profile, before pressing the shutter release.

The picture is strengthened by the clash of rigid geometry – the perfect circle, and the exact horizontal – with the shapes of man and bird.

Camera:	**Metering:**
35mm SLR	TTL from sky
Lens:	**Filter:**
600mm	—
Film:	**Lighting:**
ISO 25 colour	Natural
transparency	

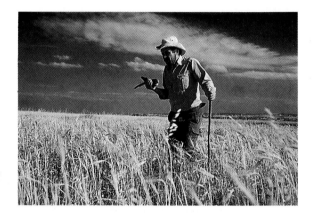

Earlier in the day the hawk and his master seem worldly and uninteresting. Against the sun, they become imperial and dream-like.

Composition Sometimes, less can mean more. A silhouette gives away little about the subject apart from its outline. Yet the elimination of fussy details can be a very positive factor, enabling the photographer to make a visual statement in a bold, simple way.

This picture was taken at a hawking festival in Tunisia. The picture was unplanned: the photographer had the idea late in the day as the sun sank low in the sky. He was looking for an image that summed up the romance of falconry – long a sport of royalty. He knew before even processing the film that most of the pictures he had taken earlier would seem prosaic and lacking in atmosphere.

This picture suggested itself when the man perched his bird on the outstretched walking stick. Since the photographer had taken pictures of the same man earlier, arranging to take this image presented only mechanical problems of manoeuvring subject and camera into the best position relative to each other.

Technique Getting a big image of the sun on film meant using the longest focal length of lens available – a 600mm. However, the narrow field of view of the lens presented logistical problems for the photographer: the subject was so far away that instructions had to be shouted, and even a movement of several centimetres (a few inches) was enough to move the hawk away from the sun.

Supporting the lens proved difficult, too, as the photographer had no tripod. He lay prone on the ground, taking the weight of the lens with his left hand. To set exposure, he metered from the area of sky just alongside the sun – not from the sun itself. The meter indicated a shutter speed of $\frac{1}{500}$, with the lens set to its full aperture of f/5.6.

The sun's rays can easily damage your eyes – especially when magnified by a telephoto lens. Unless it is comfortable to look directly into the sun with unprotected eyes, never train your camera on it. The safest times to photograph the sun are when its energy is dissipated: by an atmospheric barrier – as at dusk and dawn; by smoke, perhaps after a large fire; or by cloud.

The sun may look disappointingly small on film, even when you use quite a long lens. On the transparency from which this picture was taken, the sun's disc was just 6mm across. As a general rule, divide the focal length of the lens in use by 100 to determine how big the sun's disc will appear on the final transparency.

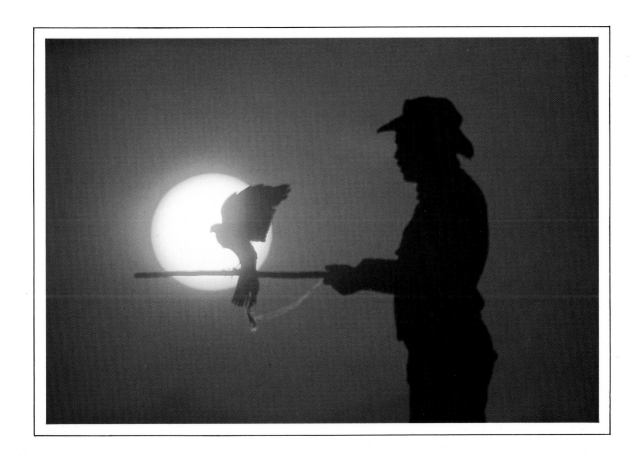

Jerking the camera down and to the left while pressing the shutter release created these streaks.

The tarmac background for the picture was chosen for its dark tones. A light background would have left traces across the figure – much as the white sleeves on the child's shirt have left traces across his chest.

Framing was rather haphazard, because the photographer was running backwards while taking the picture. However, the camera's wide-angle lens was forgiving of framing error.

This foreground area was heavily exposed by the flash, and appeared much too dense on the negative. Burning in during printing brought the foreground down to a tone that was more closely matched to the other areas of the picture.

Camera:
35mm SLR

Lens:
28mm

Film
ISO 125 black and white

Metering:
Reflected light, using TTL meter

Filter:
Neutral density

Lighting:
Hot-shoe mounted flash-unit

Composition Children at play have a vitality and excitement that is hard to capture in a still photograph, yet this picture succeeds in conveying the joy and innocence of a youngster in his element.

The diagonal stress of the picture helps in achieving this – diagonal lines always appear more active and dynamic than horizontals or verticals. Deliberate diagonal movement of the camera during exposure has stretched the buildings on the horizon into sweeping streaks and arrowheads. And by getting his subject to run in circles, the photographer ensured that the child was always leaning to one side, thus reinforcing the sense of diagonal movement.

Part of the charm of the image is that we see the child on his own level, because the camera was just over half a metre (a couple of feet) above the ground. In contrast, most pictures of children are taken from a much higher point, and therefore show the child in an unnatural perspective, but one in which adults normally view their offspring. The lower viewpoint used here makes this a more intimate glimpse of childhood.

Technique By using a combination of flash and daylight to make the exposure, the photographer vividly conveyed movement without sacrificing detail. The technique was simple – a flash unit in the camera's hot shoe lit the foreground, its brief pulse of light arresting all movement. Distant subjects, though, were lit only by daylight, so they are blurred by the movement of the camera during the ⅛ second long exposure.

In setting exposure, the photographer first chose the shutter speed. However, in the prevailing lighting conditions, such a slow speed would have forced the use of a very small aperture – f/32. Since the smallest aperture available on the lens was f/16, a neutral density filter was pressed into service to prevent overexposure.

Providing a level of exposure that matched that of the ambient light meant setting the flash unit to manual. (This ensured that it gave its maximum output.) The calculator dial confirmed that, at the short camera to subject distances involved, the flash would give approximately the right exposure.

The broad exposure latitude of the black and white film took care of exposure errors; the negatives were overexposed, but this was easily corrected when making the print.

Although this picture was taken with a quality SLR, the same effect can easily be achieved using a simple pocket camera with a built-in flash. Choice of black and white was a matter of taste, rather than necessity: colour negative film has similarly broad tolerance of overexposure.

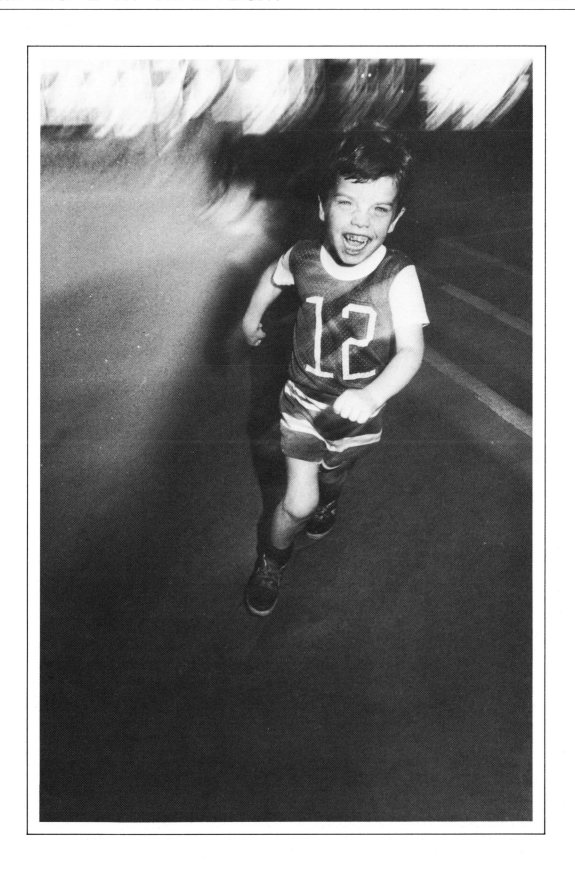

Use of a polarizer cut flare from the sea-water, deepening its graduated blue hues.

Cropping in tightly on the woman's torso focuses attention on the clinging garment, and her curvaceous figure beneath.

Using a short telephoto – a 150mm – the photographer was able to take the pictures without getting his feet wet!

The photographer decided on a pink shirt to make a colour contrast with the blue hues of the sea in the background.

Camera:	**Metering:**
Rollfilm SLR	TTL
Lens:	**Filter:**
150mm	Polarizing
Film:	**Lighting:**
ISO 64 colour	Natural
transparency	

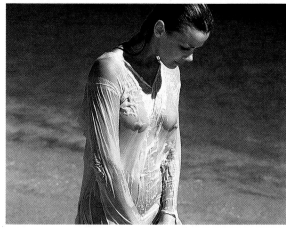

The exclusion of the model's face from the main image opposite makes the picture symbolic – the figure comes to represent femininity, rather than a particular individual. Including the face makes the picture less general, more of a portrait.

Composition Making attractive, sensual pictures isn't a particularly easy task – and probably gets more difficult as society becomes increasingly sophisticated, and tolerant of public nudity. Now that women's bodies appear daily in newspapers and advertising images everywhere, simple naked-ness has lost the voyeuristic allure that it once used to have.

The photographer who took the image opposite was well aware of this. So he took pains to find an extra element that would lift the picture out of the ordinary. He wanted to make a very tactile image – one that would be romantic and erotic, rather than explicitly sexual.

The 'wet shirt' idea is hardly a new one, but here it is given an original twist. Dry, the woman's dress would be extremely modest, covering her from neck to knees, but soaked in sea-water it is virtually transparent. This complete contrast of implied concealment and actual revelation is what gives the picture its charm. To reiterate the message of unexpected exposure, the photographer posed the model with her arms wrapped around herself, as if suddenly made vulnerable by a wave. By tilting the camera down to exclude all but a stretch of sand, he

gives the image a special intimacy, a suggestion that viewer and model are alone on a deserted beach.

Technique The picture was taken in the late afternoon, when the sun was quite low in the sky. Though brighter around the middle of the day, sunlight is harsher, creating deep shadows that are not well suited to glamour photography. Late in the day, sunlight is warmer, giving richer, more healthy-looking skin tones.

Textures in fabric were particularly important, and, to emphasize them, the photographer fitted a polarizing filter to the lens. This cut down glare from the wet fabric, making its colours richer and more saturated. The polarizer also cut glare from the girl's neck and hands, so her skin appears velvety-smooth.

The pale sand and water threw light back into the shadows, so no extra fill-lighting in the form of flash or reflectors was needed. The photographer took a reading with the camera's TTL meter, then shot a roll of film with the controls set to $\frac{1}{250}$ at f/8. He ran a clip test (see page 106) and, based on this, requested a half-stop push for the rest of the roll to lighten the images very slightly.

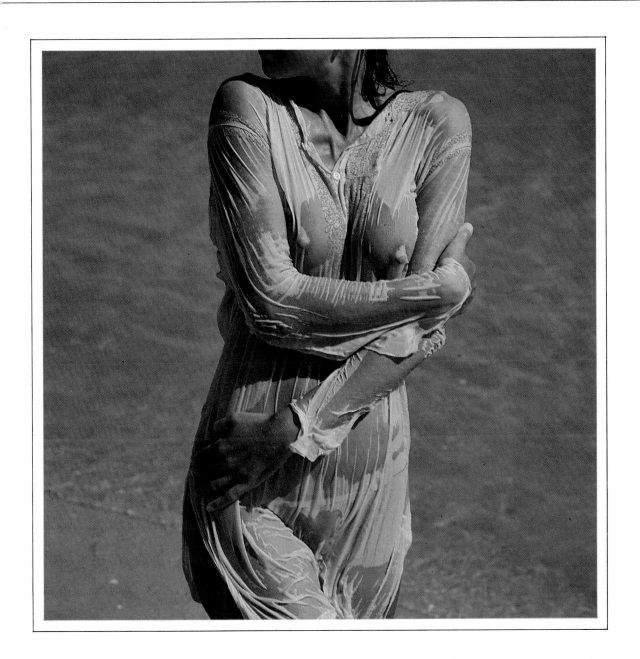

The dark background makes a strong contrast with the obliquely lit hairs on the man's legs, so that they stand out in high relief.

A pale straw-coloured 81B filter on the lens warmed up the skin-tones, further enhancing the model's tan.

The photographer kept the studio almost uncomfortably hot for someone fully dressed, since goose-bumps would have ruined the picture!

To position these highlights, the assistant moved the single light back and forth while the photographer watched through the viewfinder and directed.

Camera: 6 × 7cm SLR	**Metering:** Flash meter
Lens: 200mm	**Filter:** 81B
Film: ISO 64 colour transparency	**Lighting:** Studio flash

Composition This picture is one of a series of body details made for a book on fitness. The photographer was particularly interested in bringing out the texture of skin and hair, and in creating an image suggestive of healthy, lively living.

His choice of pose contributes activity to the picture: diagonal lines always evoke motion and movement far more than verticals and horizontals, which tend to lend a more static feel to a picture. The pose chosen also tenses the muscles in arm and leg, giving the feeling that the man's body is wound taut like a watch-spring, ready for action.

The model was quite tanned, but to make the flesh tones darker and more ruddy-looking, a brown backdrop was used. Far more light fell on the model than the background, so it appears virtually black in this picture; but, nevertheless, enough light did bounce back off the backdrop to tint the shadows on the model's body in approximately the same hue.

Bringing out texture in the skin was simple: the photographer lit the picture from the side, so that the raking light caught the hairs on the man's muscular legs and arms.

Technique Since a full-toned image was required – rather than a dramatic, harshly lit one – the photographer diffused the light. He stretched a double layer of tracing paper over a wooden frame, and mounted this half a metre (a couple of feet) in front of the flash-head to the right of the camera. To reduce the contrast still further, he placed large reflector boards facing the light, to throw light back into the shadows. This approach is not only more economical than the use of two light sources;

it also avoids the risk of double shadows. When positioning the reflectors, the photographer moved them back and forth until the shadows cast by the modelling light looked just slightly too weak. Film tends to exaggerate differences in brightness, so that what appears to the eye as flat lighting can often look quite harsh in photographs.

The picture was shot on roll film. This was a good compromise between quality and ease of use. On 35mm film, the fine hairs on the man's legs would not have been sufficiently sharply rendered, and the sense of texture would have been lost. A larger format would have given even better resolution, but 5 × 4 in cameras are time-consuming to use, and the model could easily have moved out of sharp focus in the time it took the photographer to load the darkslide containing the single sheet of film. With a rollfilm SLR, though, the photographer was able to press the shutter release and make the exposure as soon as everything in the viewfinder appeared as he wanted it.

To squeeze the maximum possible quality out of the format, he used ISO 64 colour transparency film. It is common knowledge that slow films produce finer grain and better definition than fast films – what is less well known is that colour slide films produce sharper pictures than negatives. This is a consequence of the mechanics of photographic image-formation: slide film forms the picture from the smallest, least light-sensitive grains of silver halide; whereas negative images, on the other hand, are created from the larger, faster grains.

To set the exposure, the photographer used a flash meter, then bracketed the pictures over a range of two stops.

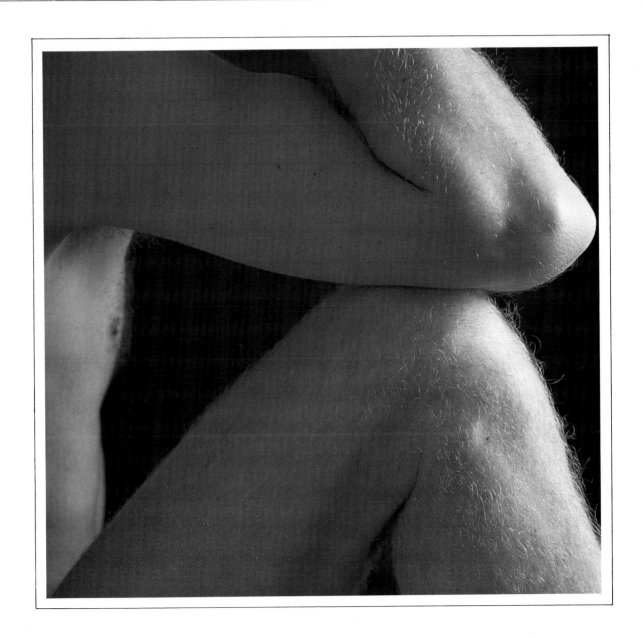

The direct stare at the camera gives the image impact. Here we see a self-confident man who is proud of his body – there is no question of a coy look with averted eyes.

Printing on to hard paper ensured that the image had a rich range of tones, and that the shadows were solid black.

By using a medium format camera which produces a negative more than four times bigger than 35mm, the photographer ensured that he recorded a wealth of fine detail and texture in the man's hairy body and arms.

Camera:	**Metering:**
6 × 6cm rollfilm	Flash meter
Lens:	**Filter:**
150mm	—
Film:	**Lighting:**
ISO 125 black and white	Studio flash unit

Composition This image has a brooding presence – an overpowering maleness that makes an immediate impact on the viewer. The physique of the model obviously contributes to this, but lighting and pose play an equal part.

By turning sideways-on to the camera, the model presents one shoulder and elbow forward, stressing the power and strength in his body. Since one side of his body is closer to the camera, this side appears larger on film, exaggerating the inverted-triangle shape of his torso. The photographer emphasized this further by asking the model to fold his arms.

The lighting for the picture was soft but strongly directional, and, in combination with a black background, made the picture very low-key – dominated by dark tones. This, too, was in keeping with the strongly masculine look of the picture. (High-key lighting, where the image is mainly light in tone, is usually thought to suggest femininity.) Though the light comes mainly from the left of the picture, the shadows are not entirely empty – a small but important amount of fill-light from the right has neatly defined the shape of the model's back and shoulders.

Technique The picture is a studio nude *par excellence*, made against a backdrop of black seamless paper, and lit by a battery of studio flash lights. The main light, placed to the left of the camera, was a large, heavily diffused 'window light'. This is a powerful flash-head, diffused by a sheet of white acrylic to produce a light very similar to that which comes from a north-facing window. The diffusing surface was positioned between about half and one metre (two to three feet) from the model.

Fill-lighting was provided by a large reflector board on the other side of the model. The photographer watched through the camera's viewfinder while an assistant moved the board back and forth, until there was just sufficient fill-light to separate the edge of the back from the black back-drop, but not enough to show any real detail in the shadows.

Exposure was set using a flash meter, and the power output of the flash unit adjusted so that the photographer could use quite a small aperture – f/11 – in order to record the figure pin-sharp throughout the image. A Polaroid test confirmed the exposure.

Finally, careful printing ensured that the background appeared as a solid black, and that the brightly lit highlights did not completely burn out to a clear white.

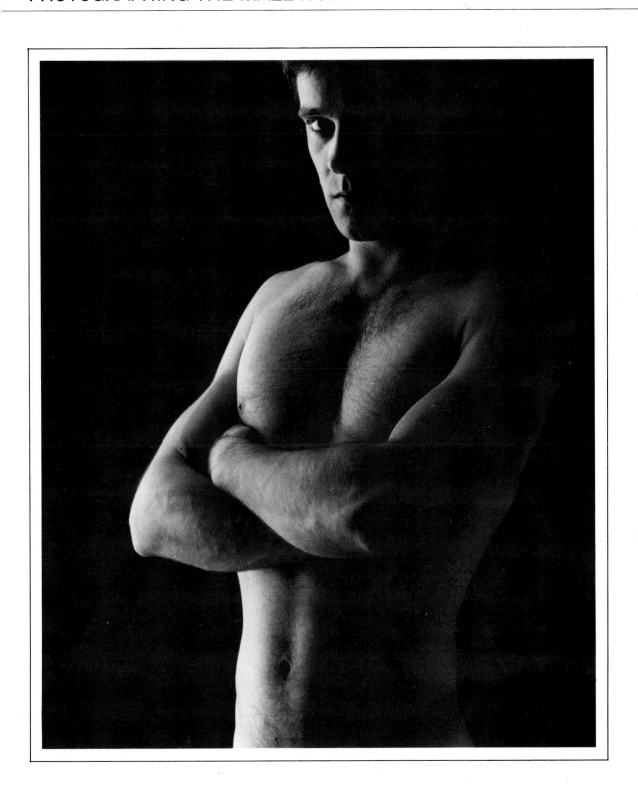

To emphasize the nostalgic atmosphere the model's face was deliberately made up in a style that evokes memories of early screen heroines, and her hair set in an equally archaic manner.

Slow film and a medium format camera kept grain to a minimum.

The S-shaped curve of the model's body makes her look particularly sinuous and elegant.

Camera:
Rollfilm SLR

Metering:
TTL meter

Lens:
80mm

Filter:
Diffusion

Film:
ISO 125 black and white negative

Lighting:
Natural

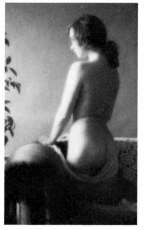
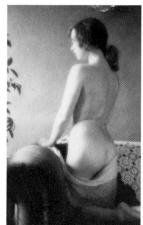

NO REFLECTOR WITH WHITE REFLECTOR

Adding reflectors, as explained below, greatly reduced contrast, creating much more flattering lighting.

Composition Professional photographers soon tire of the taunt 'anyone could do that, given expensive lighting equipment, highly paid models and a fancy studio'. The fact is that a good photographer will manage even without these advantages.

This image, for example, was taken in an ordinary living room, using natural light and an amateur model. Yet the photographer has succeeded in conjuring up a dream-like image of decadence and languor.

To a large extent, the model's pose sets the scene – she gazes into the distance, eyes half-closed and head propped up as if dozing off to sleep. The props, though, also help: the scarf draped across her thighs is reminiscent of the last threads of clothing discarded in the summer's heat. And the chaise-longue, too, is a relic of a bygone era.

The photographer kept the lighting as even and soft as possible, in order to reduce shadow areas to a minimum. The result is a high-key image which makes the model's pale skin seem paler still, as if chiselled from alabaster. Slight diffusion adds the final touch to the composition, smoothing and rounding the body's contours.

Technique The photographer wanted to emphasize the smoothness of the model's skin, and the suppleness of her body, so he was keen to avoid any trace of grain in the final picture. He therefore used a rollfilm camera, because the large negatives that such cameras produce need little enlargement, and grain therefore remains imperceptibly small at normal print sizes.

To soften the light from the window, he covered the frame with tracing paper, and positioned on either side of the camera two large sheets of polystyrene insulation foam, each 2.5 × 1.25 metres (8 × 4 feet). These reflected large amounts of light back into the shadows, softening the modelling on the girl's body.

To diffuse the image, he used a commercially made soft-focus filter – a Softar – and made exposures at a range of apertures, since he knew from experience that the degree of diffusion produced depends on the aperture to which the lens is set. This picture was taken at f/8.

After printing the picture, the image was toned to give it a sepia patina, emphasizing the feeling of nostalgia he wished to create.

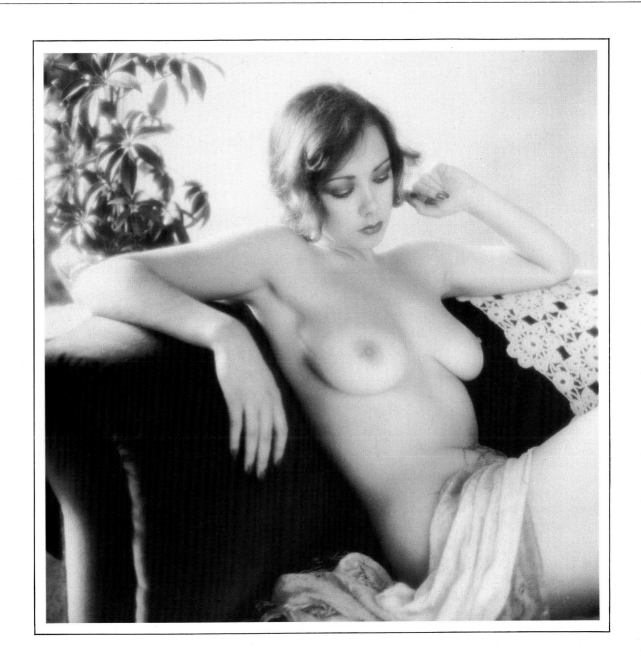

The photographer knew from experience what the approximate aperture would be, given the power of the single flash-head and its distance from the background, and therefore dispensed with a meter reading.

By taking a series of photographs at a range of different exposures, the photographer had a range of different background tones from which to choose.

Standing the model on a box in front of the background made the upward-looking camera angle a little less inconvenient: the camera could then be mounted on a low stand, instead of being literally at floor level.

Camera:
6 × 6cm SLR

Lens:
150mm (short telephoto)

Film:
ISO 64 colour
transparency

Metering:
—

Filter:
—

Lighting:
Studio flash units

Composition The shape of the human body is instantly recognizable, even when distorted and abstracted, or twisted and contorted into all manner of unlikely postures. However the photographic image is manipulated, the characteristic contours of the original subject are always apparent.

Partly for this reason – but also because the nude is a traditional subject for artists – photography has a long history of nude abstractions. Photographers have used the naked body as a starting-point for their own explorations of light and shade, of form and shape, of colour tone and texture. This image focuses primarily on shape; but colour, too, plays a subtle though significant role.

The picture is deceptive in its simplicity, but repays second and third glances. The photographer was preoccupied not only with the woman's outline, but equally with the two negative shapes created by the illuminated backdrop on either side of her. Even with the model static, a slight change in the position of the camera changed the relative proportions of the two grey-white areas, thereby altering the delicately poised dynamics of the picture. In fact, each of these two areas makes an elegantly simple image in its own right – cover one of them with your hand if you doubt this.

Viewpoint and framing are crucial, too. The picture was taken from a low viewpoint, with the model's arms raised above her head. The upward-looking camera angle shows the woman's body in an unlikely perspective – she appears statuesque

and goddess-like, as if literally 'on a pedestal'. The framing chosen also echoes the theme of statuary: the frame edges include just a hint of neck and pubic hair, creating an image that is reminiscent of shattered statues from the ancient world.

Technique The role of colour in the picture is extremely subtle. The image is almost monochromatic, but, significantly, the photographer opted for colour transparency film, rather than black and white. Though the background looks almost white in parts, this is in fact the result of overexposure – it was actually a mauve colour. Variations in light intensity turned its uniform hue to a range of continuously varying tints and shades. The resulting grey-greens and lilac-greys give the picture a life and interest that it would have lacked in monochrome.

Lighting and background were essentially very simple. The photographer lit the background with just one flash-head, moving it around until he was satisfied with the pattern of light and shade that it threw on to the paper. He used instant film as a final check on the lighting and exposure.

The camera was a rollfilm SLR, fitted with a 150mm lens. Since the focusing screen was on the top of the camera, it was easy to frame the picture even with the camera on a studio stand near floor level. A 35mm SLR with a standard viewfinder would have forced the photographer to stretch out full-length on the studio floor.

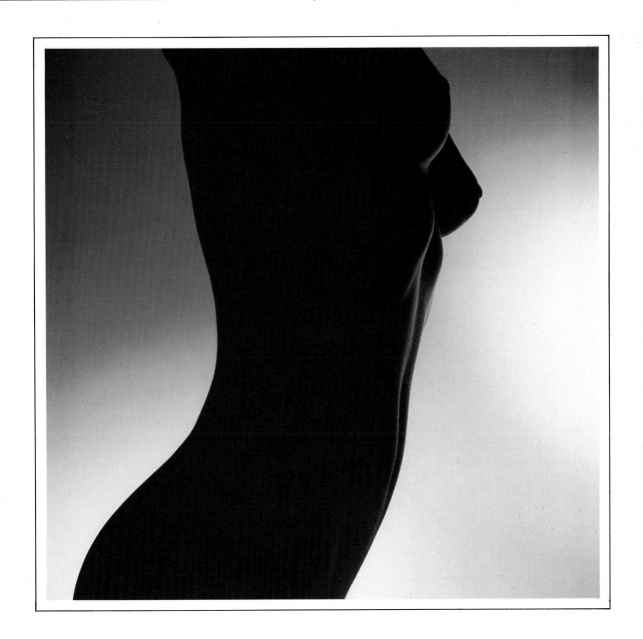

Close-ups of ice patterns at the water's edge provided a diversion for the photographer while he waited for the boat to drift into the best position.

In overcast light, snow and ice can appear very blue. An 81A filter partially corrected this, but left enough of a blue cast to suggest coldness.

The pillar-box shape of the man's hat – totally impractical for the icy conditions – adds a touch of humour to the image.

Setting the lens to a wide aperture – f/5.6 – threw these blades of grass in the foreground out of focus.

Camera: 35mm SLR	**Metering:** TTL selective area
Lens: 200mm	**Filter:** 81A
Film: ISO 64 colour transparency	**Lighting:** Natural

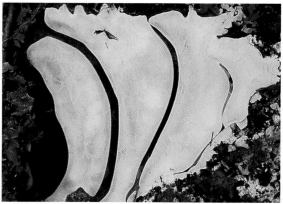

Composition The main interest in this picture is shape. Against the ice-covered lake, we can clearly see the effort that the bending figure is making to concentrate on the task in hand, while he takes care to maintain the delicate balance of the rowing-boat.

The awkward pose, and the tension in the man's legs, only became clear when the boat drifted round and presented the camera with a profile of the subject. So the photographer simply watched while the boat drifted back and forth, taking pictures only when he had a side-view of the figure.

Choice of an upright format for the picture at first seems rather curious. The framing has cropped the prow of the boat, but left large areas of empty space at the top of the frame. Surely turning the camera to make a horizontal would have been more logical? The photographer chose a vertical format for several reasons. First, he felt that the subject itself – the pole, and the standing figure – had a vertical stress, and figured that an upright format would echo this. Then, he reasoned that keeping the camera vertical would give the picture an equilibrium that the figure himself lacked. The water's dark tones put the weight clearly at the foot

of the frame, while the white at the picture's top seems light and airy. This keeps the centre of gravity low, implying stability. Finally, the white area at the top of the frame suggests a great expanse of frozen water stretching away into the distance, signifying an isolated wilderness location.

Technique To emphasize shape, the photographer used a 200mm lens. This allowed him to fill the frame from quite a distant viewpoint high on the bank of the lake, and thereby isolate the figure against the expanse of white. A shorter focal length lens would have demanded a closer viewpoint lower down the bank – and this would have meant framing the figure against a background of the dark trees on the far side.

TTL exposure meters work best with average subjects, and this one was far from average. Uncompensated readings from either the foreground or background would have led to over- and underexposure respectively. To prevent this, the photographer took a reading from the ice, and gave two stops more exposure than that recommended by the meter.

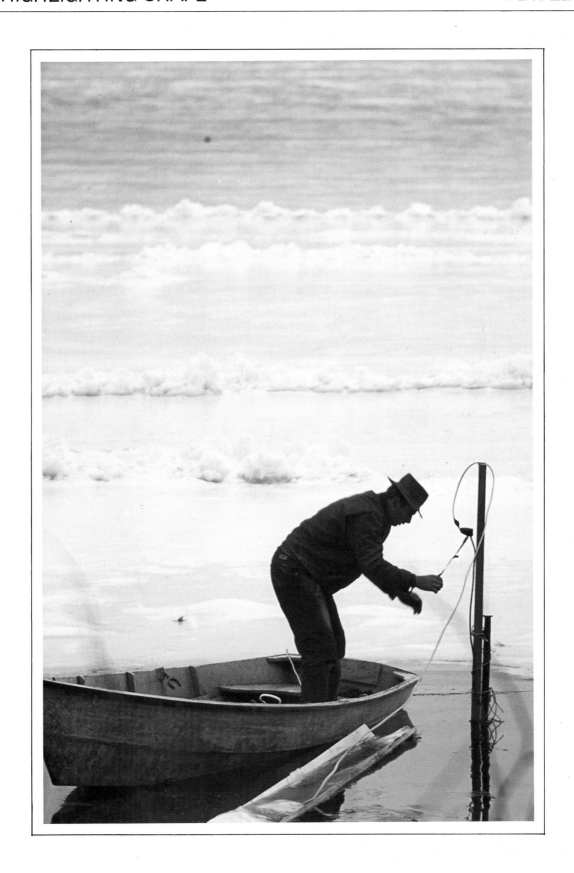

The relatively natural colours of the scene are more the result of luck than judgement. The fading evening light was very blue, but sodium street lighting restored much of the yellow part of the spectrum, so that colour reproduction is acceptable.

The bus interior appears green because it is lit by fluorescent tubes, which give out a light that is deficient in red.

Bright lighting on the top of the bus makes it appear like a stage.

A spotmeter reading from the faces would have been a more reliable method of metering than the one described in the text – but few photographers carry spotmeters everywhere with them!

The mid-grey surface of the road provided a starting point for exposure setting.

Camera:
35mm SLR

Lens:
300mm

Film:
ISO 400 colour
transparency

Metering:
TTL (see text)

Filter:
—

Lighting:
Natural

Composition The two faces at the top of this picture are tiny in relation to the overall size of the frame, yet the viewer's eye is drawn inexorably towards them. People like looking at other people, and if there is just one face – however tiny – in a picture, all other features will take second place.

Here the photographer used this device to draw attention to the affectionate couple on the top deck of a London bus. He spotted the pair when the bus pulled up at traffic lights, and had to make a snap decision about the composition of the picture before the lights changed. Recognizing that the faces were well lit, he felt confident that they would still be sufficiently prominent, and form a pivot for the picture, even when they occupied relatively little space in the frame.

He therefore chose to frame the entire bus, and take advantage of its brilliant red colour, and the contrast it made with the fading blues of dusk.

Technique The picture is a double exposure. Realizing that the bus driver and conductor would form a distraction in the picture, the photographer considered how he could make their unwanted faces less obvious. He eventually decided to make a second exposure with the tripod-mounted camera in the same position. For the second image, though, the shutter remained open for several seconds, so that the lower deck of the bus was crisscrossed with traffic trails. The upstairs part of the bus where the couple sat was too high to be affected by these coloured streamers of light.

Metering presented problems, because the bright, moving lights of the traffic caused the needle to bounce constantly in the viewfinder. The basic exposure for the bus was arrived at by noting when the light level was at its lowest – when the meter needle dropped to ½ a second. This, the photographer assumed, was a reading from the mid-grey surface of the road, uninfluenced by traffic headlights. The lens was set to its full aperture of f/4.5.

After the bus had moved on, the photographer recocked the shutter without advancing the film, using the camera's multi-exposure control, changed the aperture to f/16 and the shutter speed to 8 seconds, and made a second exposure. Since this was about 1.5 stops below the level of the first exposure, he knew that only the head- and tail-lights would show up.

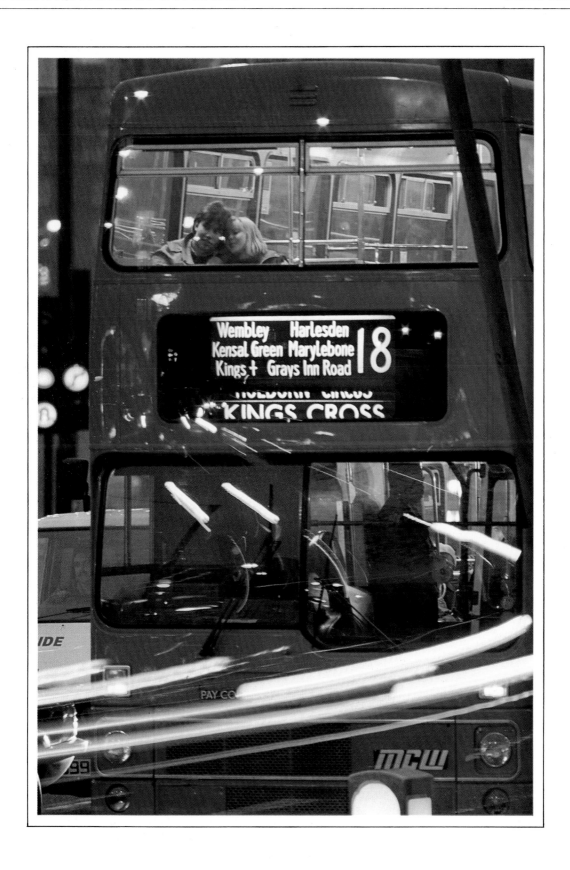

These figures at the side of the steps would have created a confusion of shadows had they been closer to the main subject.

Picked out in bars of sunlight, the treads of the staircase set the scene, and provide visual rhythm and texture.

The strong asymmetry unbalances the image, and adds to its uneasy atmosphere.

Printing on hard paper, and burning in the shadows, ensured that they appeared solid black in the print.

Camera:
35mm SLR

Lens:
28mm

Film:
ISO 125 black and white

Metering:
TTL from highlights and shadows, averaged

Filter:
—

Lighting:
Natural

Backlighting always creates strong silhouettes, but reveals detail and pattern in any translucent material that appears in the picture – such as the banner and sign shown here.

Composition Most photographs are made up of a broad range of tones, running from black and very dark greys, through mid tones, to very pale shades of grey and pure white. It is this tonal range that gives the photograph its ability to carry large quantities of detailed visual information.

However, in the picture opposite, the photographer has deliberately limited the tonal range, almost cutting out the mid-tones. The resulting image carries minimal information about its subject – and so appears mysterious and threatening.

Much of the latent malice in the picture springs from the large areas of dark tone. By stepping back, and including much of the interior of the darkened pedestrian tunnel, the photographer ensured that the picture would be dominated by shadow. In musical terms, this set the composition in a minor key. Moving forward to fill the frame with the sunlit staircase would have dissipated the feeling of menace, creating an optimistic, light-hearted mood.

Standing in the tunnel, the photographer waited for figures who cast graphic, descriptive shadows down the stairs. While waiting, he studied the position of each person's shadow as they approached, and noted that the highlight cast by the tunnel entrance neatly framed the pedestrians' shadows when they were halfway down the stairs. He pressed the shutter release only when one suitably expressive silhouette had reached the best point on the staircase, and was casting a shadow that was separate from those of other passersby.

Technique The photographer chose black and white film for this image because colour was not an important part of the composition. In black and white, the tones – not hues – dominate the image.

The exposure latitude of black and white film is very broad, so exposure determination was not as crucial as it would have been, say, with colour transparency film. A meter reading from the dark subway wall indicated 1/15 at f/5.6. The sunlit floor area was five stops brighter, so the photographer set the camera midway between the two extremes.

In the cramped confines of the tunnel, a standard lens would have been useless, and in order to include both the staircase and the shadows, the photographer had to fit a 28mm wide-angle lens.

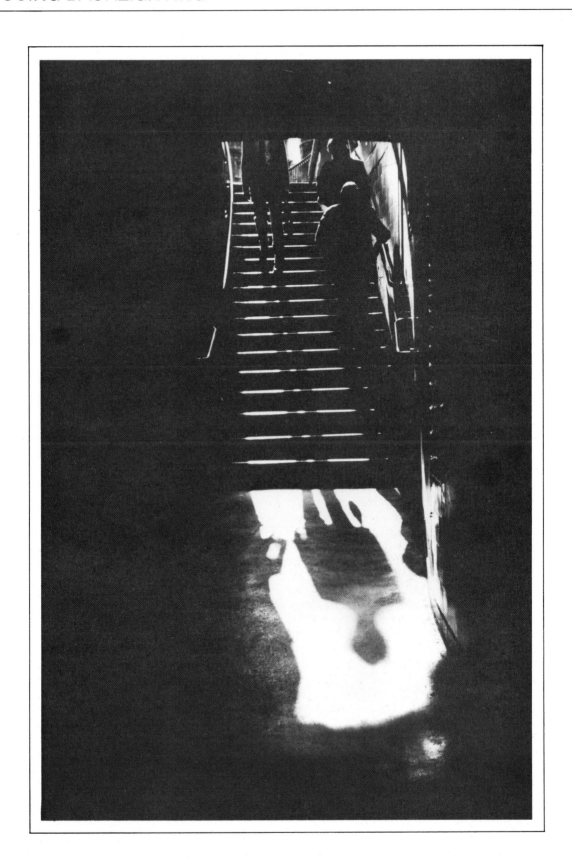

The hue of the wood panelling adds warmth to the scene, and hints at tradition rather than modernity.

Cropping the picture at this edge (it was a horizontal format 35mm slide) has removed the bright window area which drew attention away from the figures.

Camera:	Metering:
35mm SLR	TTL automatic
Lens:	**Filter:**
28mm	—
Film:	**Lighting:**
ISO 400 colour negative	Natural

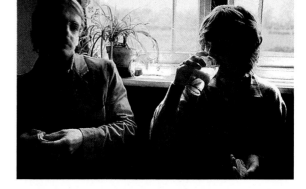

This picture that the photographer took of his own drinking companions illustrates the importance of the camera position when a window is the main light source.

Composition The atmosphere of an English inn is hard to define or describe, but is renowned all over the world – and quite unlike that of any other kind of bar. The photographer's aim in taking this picture was to try and catch some of the warmth and welcome that makes a traditional pub such a pleasant place to drink, meet people, or just sit.

To capture the ambience of the place in a single picture, he chose to take in a broad sweep of room. A tighter framing would have made more of the two women who form the main subject, but would have failed to convey the fact that they had come out for a lunchtime drink on their own, rather than with their menfolk.

A tighter crop would also have removed – or made meaningless – other small elements that contribute significantly to the homely atmosphere. The all-encompassing composition finally chosen takes in the cat, the umbrella, the Sunday papers on the seat, even the row of coloured lights above the bar, and all these details help to build up the context in which the viewer eventually sees the two main characters.

Though they dominate by virtue of their central position in the frame, these two women are not the only people in the picture – and it is their conversation with the man half their age that makes this more than a straightforward genre scene. Biding his time, knowing the noise of the camera would put his subjects on their guard, the photographer waited until the discussion had become animated before pressing the shutter. For his patience he was rewarded with an expressive, active pose that hints at the role of the pub as a forum for debate and social contact between people of all ages and opinions.

Technique Ambient light levels were low in the dark panelled room, and light flooding through the window meant contrast was high. By picking a seat close to the window, the photographer was able to exclude it from his pictures, and to photograph the more brightly lit side of the figures in the bar.

He fitted a 28mm lens to the camera, both for its broad field of view, and because depth of field is so much greater with wide-angle lenses. To avoid attracting attention, he did not raise the camera to his eye to focus or take a meter reading. Instead, he set exposure to automatic and guessed the subject distance. Taking the picture then just meant raising the camera to eye-level, framing quickly and pressing the shutter release.

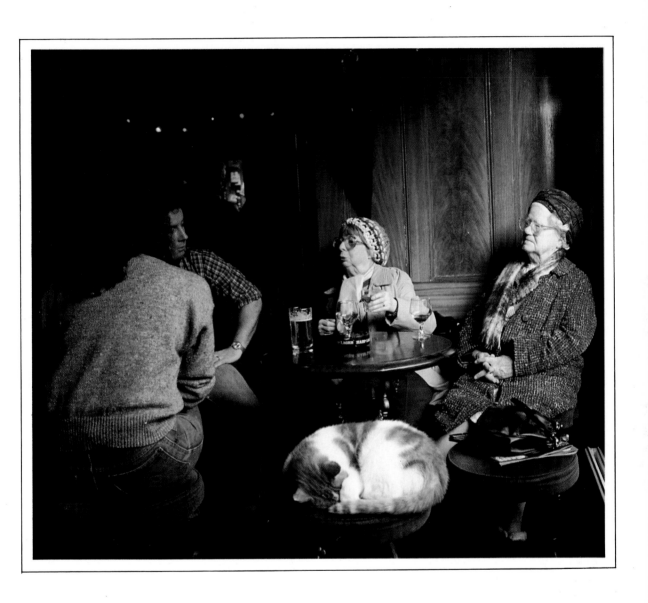

Red is an active colour, and here the hue of the paintwork gives the picture vibrancy and conveys the child's excitement.

Subtle reflections on the surface of the number show the street and the photographer's outline.

The contrast of scale between the child and the enormous number is what really makes the picture work; filling the frame with the number is just a means to an end, making it seem larger than life.

The converging joints between the flagstones sweep the eye upwards from the bottom of the frame to the child in the middle.

Camera:	**Metering:**
35mm SLR	TTL from pavement
Lens:	**Filter:**
35mm	81A
Film:	**Lighting:**
ISO 25 colour	Natural
transparency	

Composition 'If your pictures are no good, you're not close enough' is a piece of advice once reputedly handed out to an aspiring war photographer, but it is wise counsel for anyone with a camera. To make this simple but striking image, the photographer moved close, to frame tightly the amusing scene; then he moved closer still, so that the number – a familiar landmark on the streets of New York – fills the picture almost to the corners. Almost, but not quite: little triangles of light creep in at the top of the picture, and define the shape of the bright red form. Moving any closer would have lost these details, and the picture would have been weaker, as you can see for yourself by covering them with your hand or a piece of paper.

Technique This was almost as simple as composition. The picture was a grab-shot, snatched with a 35mm lens. Recognizing that the dark red of the paintwork would probably mislead the camera's meter, the photographer tilted the camera downwards to take a meter reading from the paving, then used the camera's 'memory-hold' button to lock the meter reading while he recomposed the picture. The aperture used was f/8, and the camera set the shutter speed to about 1/60.

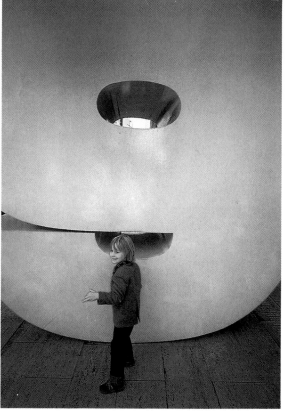

A second later, the boy noticed the photographer, and the magic of childhood discovery and exploration was gone.

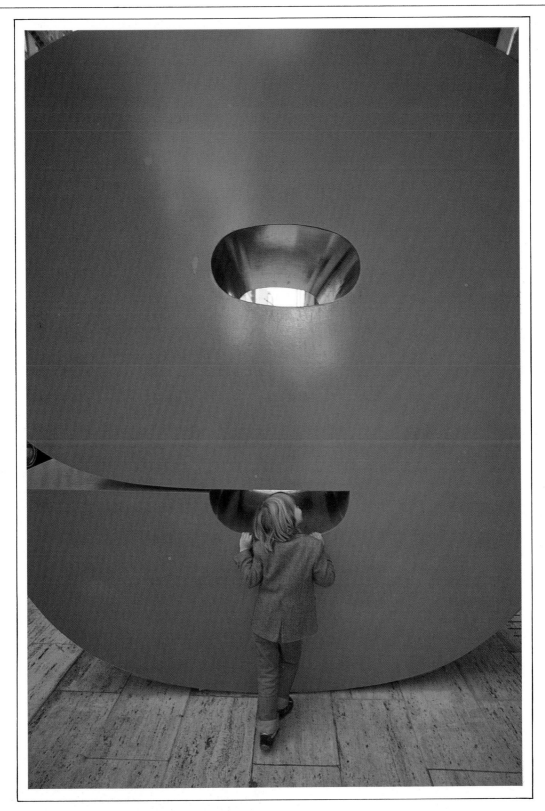

Wandering figures on the periphery serve to reiterate the cohesion of the ring itself.

Pattern plays an important role in all pictures taken from above. Besides the major motif of the ring, the regular texture of the cobblestones and the stripes of the hypnotist's mat both contribute interest to this image.

The square in which the picture was taken was lit by blue sky and weak sunlight, so the photograpner used a pale yellow 81A filter to remove excessive blueness from the scene.

Camera: 35mm SLR	**Metering:** TTL automatic
Lens: 80-200mm zoom	**Filter:** 81A
Film: ISO 64 colour transparency	**Lighting:** Natural

Composition A high viewpoint shows a view of the world that is new and different. Seen from on high, familiar scenes and figures take on a completely new perspective, as this example demonstrates.

We see a street performer – a hypnotist – at work, yet the high viewpoint from which the picture was taken has made his act seem less important than the audience. From the ground, we would have watched the routine against a backdrop of attentive faces, but looking down we see instead a pattern of remarkable regularity. The row of faces changes into a clearly defined ring.

The cropping of the picture makes the ring pattern as clear as possible without sacrificing detail. A broader view (from higher up, or with a shorter focal length lens) would have made the ring shape even more evident, but would also have made the individual faces and figures smaller. This would have weakened the picture, because part of its charm is that the viewer's eye switches from the general view – the ring – to the specific – the details of the faces and postures of members of the crowd. For the same reason, a more tightly cropped image would have been less satisfactory; it would have shown just a portion of the circle.

Technique Hazy sunlight and an even toned subject produced relatively low contrast: well within the exposure latitude of the colour transparency film in use. Exposure metering was therefore not problematic and the photographer left the camera set to auto.

Viewpoint did present difficulties. The picture was taken from an exposed escalator, near which there were scratched and dirty plastic windows. The picture was possible only because one of the windows had been left open. Framing was fine-tuned using an 80-200mm zoom lens.

Hedge your bets. Don't stick to just one viewpoint. After taking bird's eye views, spend some time on the ground as well. Coming down to earth, the photographer caught this interesting detail of one of the audience, using a 28mm lens.

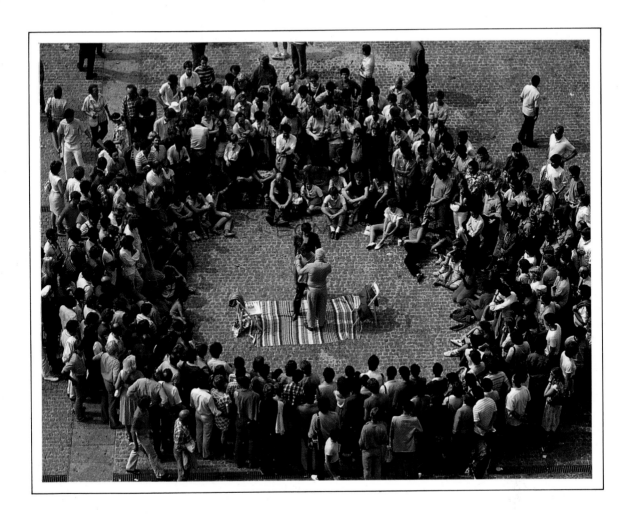

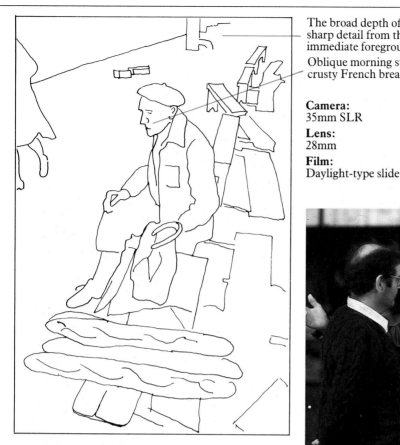

A close approach is impractical in situations like this – the photographer's proximity would have interrupted a heated argument. This picture was taken from the other side of the market using a 105mm lens.

The broad depth of field of the wide-angle lens records sharp detail from the far distance through to the immediate foreground.

Oblique morning sunlight picks out textures on the crusty French bread, and on the face of the figure.

Camera:	**Metering:**
35mm SLR	TTL set to automatic
Lens:	**Filter:**
28mm	—
Film:	**Lighting:**
Daylight-type slide	Natural

Composition This old man was sitting on a market bench, watching the world go by, his shopping complete. Isolated from the surroundings, his face was interesting enough, but seen in context, his alert look (one eye on the packages, and the other on the passersby) has much more meaning. Photographically, the challenge was to capture on film the man's surroundings and possessions without letting these extra elements draw the viewer's attention away from the principal subject.

Although the shopping occupies over half the picture, it supports rather than overwhelms the figure. By standing at the end of the bench, the photographer has managed to turn the loaves, the shopping bag and the brown-paper parcel into an arrowhead that points directly at the figure sitting beyond them.

Showing the face of the passing shopper would have created a conflict of attention between the two figures. So, instead, the camera crops her in half, yet retains the urgent footsteps which take her out of the picture, and towards the activity that has

attracted the man's gaze. The photographer waited until the woman's shadow sloped directly across to the seated figure – thus drawing the viewer's eye back once again to the main subject of the picture.

Technique This type of composition, and in fact this style of photography generally, relies heavily on the characteristics of the wide-angle lens. The 28mm lens used here allowed the photographer to move in very close, yet still take in the whole of the seated figure and his surroundings. It was the close viewpoint and the downward-angling of the camera that created the strongly converging lines that rush away into the distance.

Wide-angle lenses have an additional advantage for candid photography: they have more depth of field than other lenses, so focusing is less critical. For this picture, the photographer preset the focusing ring to two metres (seven feet), and the aperture to f/8. Precise focusing was therefore unnecessary, and picture-taking was quick and inconspicuous.

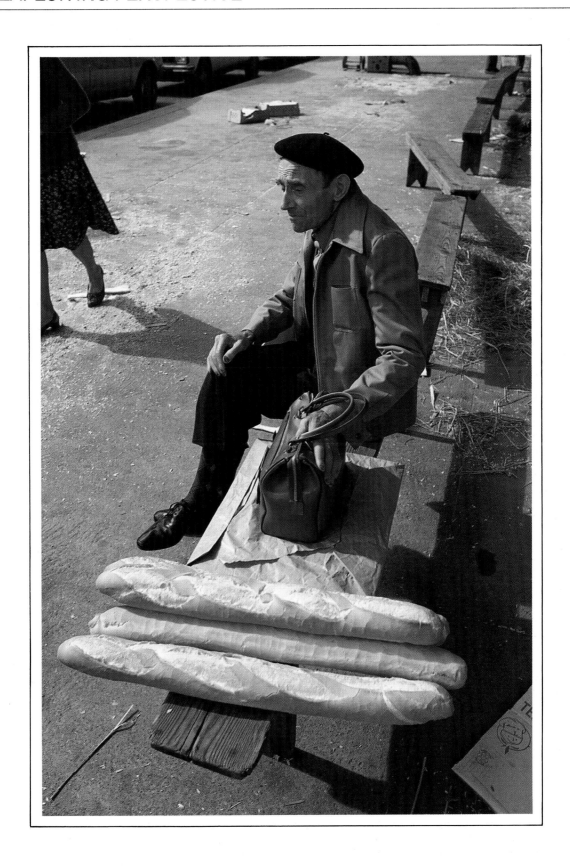

Cropped to a mere suggestion, these cars no longer intrude – instead, they make a neat support at the foot of the frame.

The arms of the two workers on the right seem to stretch out as much to invite applause from onlookers as to support the window.

This attendant figure adds to the tension of the scene. Like us, he waits to see if the glaziers will drop their load.

Camera:	**Metering:**
Motor-driven 35mm SLR	TTL automatic
Lens:	**Filter:**
105mm	—
Film:	**Lighting:**
ISO 64 colour transparency	Natural

Composition Street scenes are full of natural humour, but only a photographer who constantly carries a camera will catch these everyday comedies.

These glaziers struggled like mime artists with an invisible burden, and this paradox forms the central theme of the picture. When reflections revealed the plate glass they were holding, the scene was less curious, and less amusing. Recognizing this, the photographer waited until the window had been moved into the shadow of the shopfront.

The sub-plot is a social one – the man apparently doing all the work wears a suit, while those in working clothes either play a supporting role, or stand around and watch. The trestle on which the suited figure stands helps to emphasize this irony by sweeping the eye up the frame.

Technique The 105mm lens used for this picture did not really crop in tightly enough on the scene, as the uncropped image (right) illustrates. The only available alternative – a 200mm – had too narrow an angle of view, so the photographer opted to crop the picture later. The ideal would have been a zoom lens, since this would have made precise framing a simple matter.

Bright sunlight meant that camera-shake and depth of field were unlikely to present problems, even with the relatively slow film in use. A meter reading from the figures themselves (but excluding the dark shadow on the left) suggested that an exposure of $\frac{1}{125}$ at f/11 would be appropriate.

Using a motor-drive, to make speed of operation quicker, the photographer took five or six pictures. Since the figures on the opposite side of the street had their hands full, the noise of the camera attracted little attention.

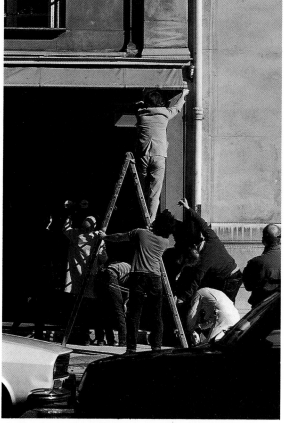

Perfect composition, like perfect pitch, is a rare gift. Even if you have it, physical obstacles may prevent you from achieving exactly what you want at the moment of pressing the shutter release. However, cropping the image after exposure can correct even considerable errors in composition. The cropped version of this picture uses only about half of the full area of the transparency, but as the frame from the same roll (above) shows, the parts of the picture that have been removed would otherwise have severely weakened the composition. At the bottom of the frame, out-of-focus areas of cars have been removed, and at the top and left, redundant space has disappeared, producing a tighter composition.

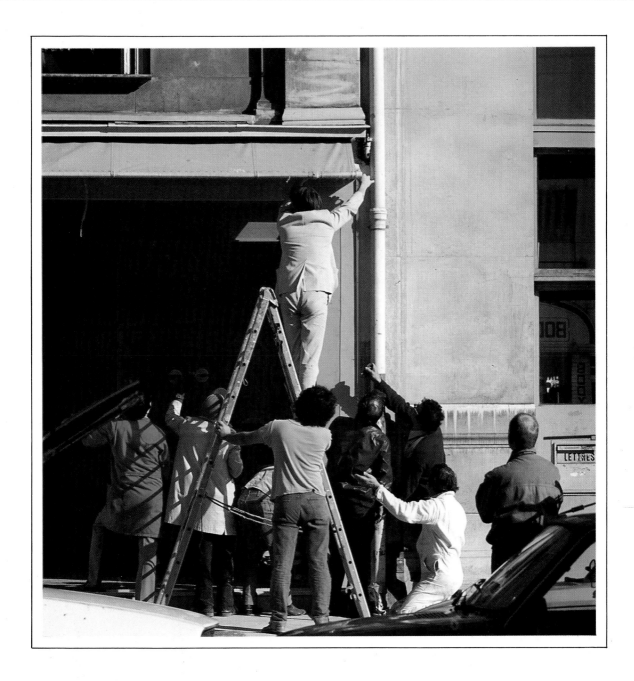

Some aspects of the composition owe more to good fortune than to judgement: the curving shape of this glazed part of the door picks up the dynamic sweep of the boy's limbs, carrying the eye round in a graceful arc.

The sky tinted these shadows blue, but filtration to correct this would have made the more important sunlit area of the picture look unnaturally warm.

The broad field of view gives the image a sense of scale that would be lacking in a more tightly cropped picture – the ornate masonry dwarfs the boy below.

Camera:
35mm SLR

Lens:
50mm

Film:
ISO 200 colour
transparency

Metering:
TTL automatic

Filter:
—

Lighting:
Natural

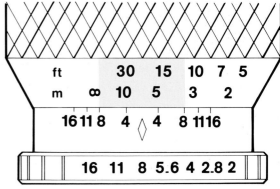

The focusing technique described below is called 'zone focusing': all subjects within the zone shown shaded on the focusing ring appeared sharp in the picture, so no focusing was needed.

Composition The legendary photo-journalist Henri Cartier-Bresson used the phrase 'the decisive moment' to describe that instant when all the subject elements in a scene are positioned exactly right. Releasing the shutter at this moment, he suggested, yields an image that describes the subject better than the pictures taken even a fraction of a second before or after.

The picture shown here illustrates the 'decisive moment' principle at work. The image is entirely dependent on timing – a moment earlier, and the boy had not assumed his spreadeagled, impatient pose; a second later, he had disappeared through the door and the moment was lost.

In his haste, the photographer simply raised the camera to his eye and made a snap judgement about the composition. The picture reproduced here has been cropped to correct a tilted horizon, but, apart from this, shows more or less what appeared in the viewfinder. Though framed instinctively rather than with care, the composition nevertheless makes the most of the lad's outstretched pose; by placing the doorway to the left of centre, the photographer makes the figure lean into the picture, his youthful energy and activity balanced by the static weight of the shadows on the right.

Technique Anticipation and preparation obviously help in fast-moving situations such as this. Here the photographer was using an aperture-priority automatic camera, and had set the 50mm lens to f/8. He adjusted the focusing ring so that the infinity symbol was just beyond the depth-of-field marking for f/8, and could tell from the scale that this setting would record sharply all subjects between about 4 to 12 metres (13 to 40 feet) from the camera. When the scene shown here unfolded in front of him, he therefore knew that focusing was unnecessary – even though the figure did not appear to be entirely sharp on the matt screen of his SLR camera.

The camera's meter took care of the shutter speed, and though there was no time to glance at the scale in the viewfinder before taking the picture, a quick check after the event provided the photographer with the reassurance that the speed was sufficiently fast to arrest camera-shake and subject movement.

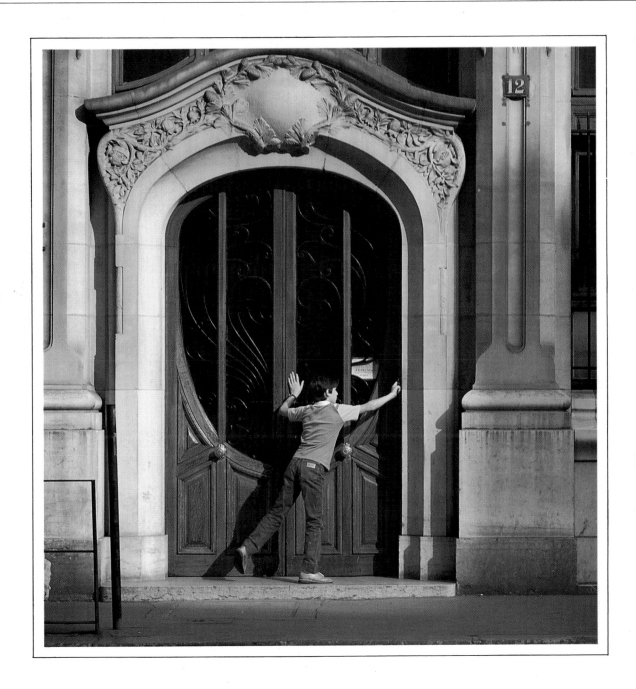

PLACES

Like so many abstract qualities, the 'spirit of place' is instantly recognizable, yet hard to define, and even harder to catch on film. Perhaps the reason is that the qualities that give a particular place its character and identity engrave themselves on all our senses. Waiting for the ferry at the quay opposite, we run our hands along the wooden rail, polished smooth by the waiting bottoms of thousands of tourists; and we smell the oilslick-and-weed perfume of the lake beneath our feet.

The camera catches and preserves the evidence of just one sense, but the visual record it makes can be an extraordinarily powerful one, compensating at least in part for the missing sounds, smells, flavours and textures of the places we once knew.

Recapturing the spirit of place, therefore, means being aware of the camera's weaknesses; and using its strengths to imply and evoke the sensations felt by people who stand where your tripod once stood. In this context, photography's greatest strengths are its ability to record a wealth of fine detail; and the capacity of film to preserve fleeting changes in the colour of light. As you look at the pictures that follow, you'll see how other photographers have used these and other aspects of the medium to good advantage, and how, with similar techniques, you too can bring back more evocative records of the places you visit.

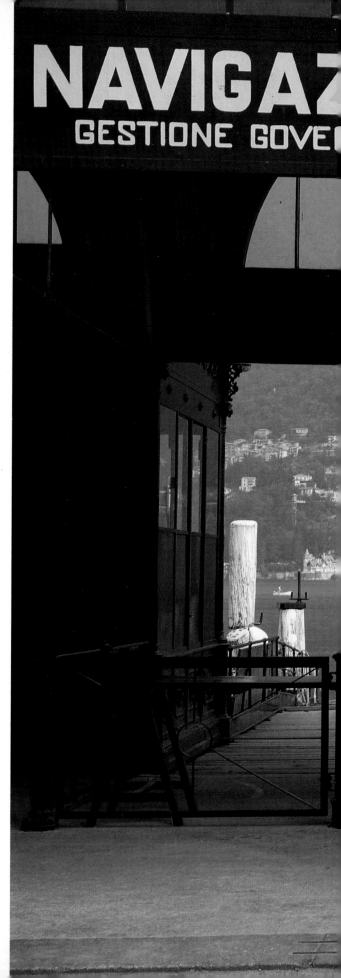

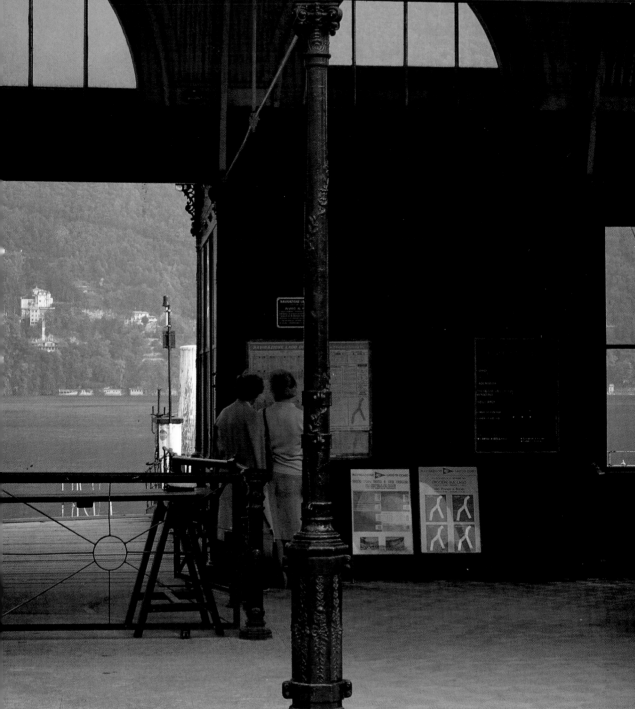

A pale yellow 81B filter warmed up the image slightly, counteracting the naturally bluish colour of the light from the overcast sky.

Compositional options were limited by the narrowness of the street: the photographer literally had her back to the wall.

Use of a large-format camera gives the picture microscopic detail. On a smaller format, the film's grain and structure would have been more evident, and the image would have not had the same 'you are here' crystal clarity.

Camera: 5 × 4 in sheet-film	**Metering:** Hand-held incident light meter
Lens: 150mm (standard)	**Filter:** 81B
Film: ISO 64 colour transparency	**Lighting:** Natural

Composition This tiny terraced cottage caught the photographer's eye in a rural street. Initially attracted by the curious shape of the holly tree, she soon noticed the theme of yellow repeated inconspicuously and subtly across the house front and road. She described it as 'a piece of reality that was very tightly organized by chance'. Her picture succeeds because she managed to make a composition that, like the scene itself, is understated.

To do this, she took the broadest possible view of the cottage, rather than closing in to concentrate all the yellow areas in a tightly framed composition. She moved the camera back until it was almost pressed against the wall of the house opposite, then carefully shifted the tripod left and right to adjust the relative positions of the façade, tree and sign.

She chose a flat, frontal view because had the cottage been regular, precise and symmetrical, this would have oriented all the straight lines in the scene with the edges of the frame. But, precisely because there are virtually no straight lines, this frontal composition emphasizes the hand-crafted architecture of the building, and the careless, meandering growth of the tree.

Technique The photographer used a view camera to take the picture, making full use of its various movements. With the camera aligned with its back parallel with the wall, she was able to fine-tune the composition by shifting the lens left and right, and up and down. The effect of these shifts is significant, as you will discover by experimenting with a view camera. Shifting the lens sideways moved the image of the cottage sideways on the focusing screen, rather as if the whole camera had been moved sideways. This action enabled the photographer to frame the façade centrally in the picture, even though there was a lamp-post directly opposite the window. Had she been using a camera without a shifting lens, the lamp-post would have obstructed her view.

In a similar manner, she shifted the lens upwards, too, so that the top of the cottage appeared at the top of the picture, and the amount of road was reduced at the bottom. In terms of moving the camera, this upward shift corresponds to using a much taller tripod.

The photographer set exposure by taking a reading using an incident light meter. Since this was a static subject, and the camera was tripod-mounted, she set the shutter for a second-long exposure. This enabled her to use a small aperture – f/22 – and thus keep the image as sharp as possible from corner to corner.

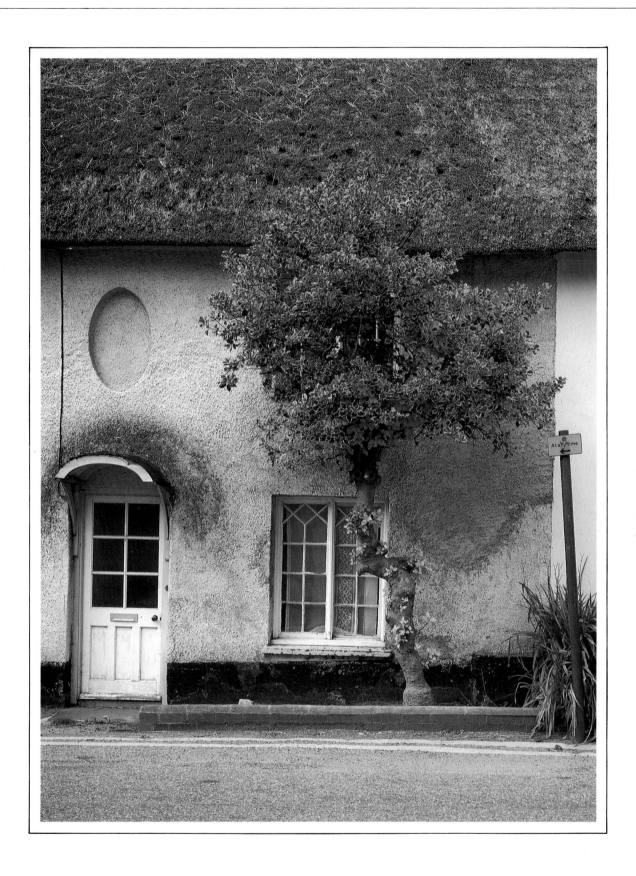

Keeping the horizon high in the frame minimized the uninteresting sky area.

Trees surrounding the house put a severe restriction on the number of viewpoints available to the photographer.

The warm filtration used for the picture brought out the red of the building's brickwork.

Camera:	Metering:
35mm SLR	TTL aperture-priority
Lens:	**Filter:**
20mm	81EF
Film:	**Lighting:**
ISO 64 colour transparency	Natural

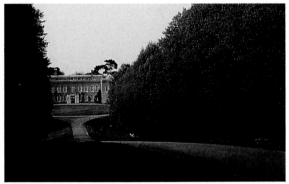

The majestic approach from the gatehouse gave a better impression of what the architect had in mind, but made for a less interesting picture.

Composition Most of the charm of this rambling mansion lay in the rural setting. The eighteenth-century building was architecturally unexceptional, but stood in grounds laid out by a brilliant landscape gardener.

It was therefore important, on the one hand, that the picture's composition should not subject the building to too much scrutiny. On the other hand, an architectural shot was required, not a landscape.

The photographer satisfied both these conflicting demands by keeping the house quite small, but using water to twin its image. Reflected in the still pool, the mansion dominates the picture, and appears almost larger than life.

Choice of a low viewpoint not only gave more space for the reflection, but also filled up the foreground. Close to the camera, the rushes, nettles and reeds provide extra interest and identify what is clearly a country, rather than city-park, setting for the house.

Turning the camera to include the tall bulrush on the right helped to unify the image and give it a sense of coherence: the powerful vertical stalk provides a link that bridges the lake, tying the foreground to the house behind.

Technique Keeping the whole picture sharp presented severe problems. The vegetation in the foreground was just half a metre (a couple of feet) away, yet the building itself was quite far off. The photographer fitted a 20mm wide-angle lens, and stopped it down to its smallest aperture – f/16. Then he focused on a point midway between the foreground and background, in order to maximize depth of field.

Use of such a small aperture forced the photographer to set a shutter speed of just ¹⁄₁₅, and this introduced the risk of camera-shake, so the camera had to be tripod-mounted. Fortunately, the day was still, so subject movement did not occur.

Because of the overcast weather, the picture lacked sparkle and colour, and the photographer experimented with filtration to get round this problem. This picture was taken with a tobacco-coloured 81EF filter, which has lent an attractive 'antique sepia' tint to the scene.

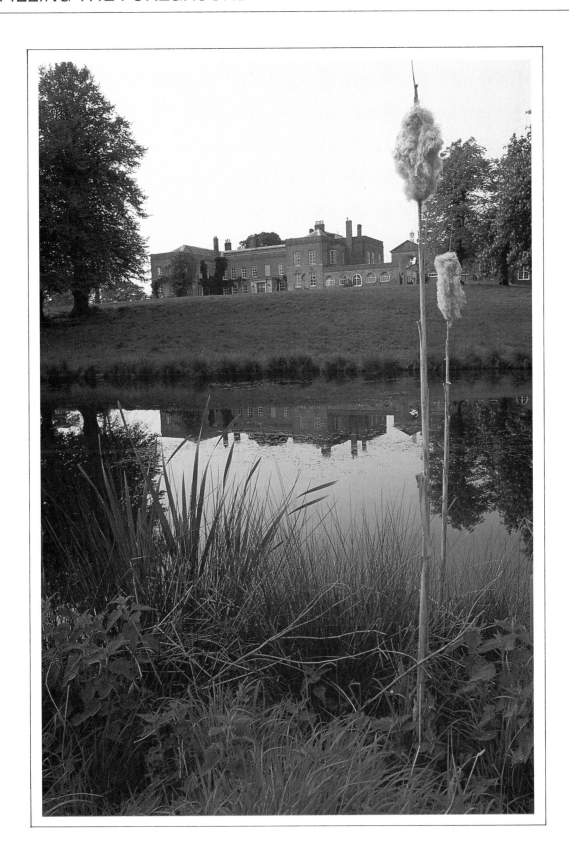

A reflected light meter reading from the shadow areas confirmed that these would be some four stops underexposed – easily enough to ensure that they appeared inky black.

Irregularities in the surface of the plaster and timber act as a reassuring reminder that a human hand had been at work here, and confirm that this is a photograph, not an ink drawing.

Careful framing ensures that this window divides the frame exactly into four.

Camera: 35mm SLR	**Metering:** Hand-held incident light meter
Lens: 105mm	**Filter:** Wratten 81B
Film: ISO 64 colour transparency	**Lighting:** Natural

Composition Unlike painters and artists of other types, photographers cannot create pictures purely from their imaginations; they must necessarily start with solid objects from the real world. Creating abstract images with a camera is therefore very much more difficult than with a brush and canvas. Nevertheless, this picture illustrates that even a mundane scene can be the source of elegant abstract photographs.

The subject matter couldn't be simpler – several strips of timber leaning against a wall. The photographer noticed the striking pattern of shadows that they cast, and returned with his camera at the same time the following day.

His aim was to create an enigmatic photograph that forces the viewer to look twice, and question what the image depicts. The picture achieves this through its stark simplicity, and its almost total lack of colour. Though the picture opposite is reproduced from a colour transparency, it looks virtually monochromatic; the framing was chosen deliberately to exclude almost all coloured objects.

The sun's position dictated the angle of the window's shadow, but the laths and their shadows were obviously 'portable'. A few minutes' experiment yielded the arrangement shown here, with the narrow bands of shadow cutting the frame about a third of the way in. They divide the picture almost exactly according to the 'Golden Section' – the proportions long believed best to express elegance

in asymmetrical compositions, as shown on the right.

The rigid formalism of the picture is not unbroken, though. The row of brown tiles in the centre of the frame alleviates the coldness of the otherwise purely black and white scene. And the soft-edged shadows at the right provide a degree of relief from the geometry of the other lines. A different lens or a different viewpoint would have eliminated these, but without them the scene would have looked sterile and lifeless.

To make the picture more puzzling, it is reproduced upside down, so that the light appears to slant upwards.

Technique For the picture to succeed, it had to be composed in pure black and white. This demanded precise exposure, and corrective filtration.

The film used – Ektachrome 64 – has a slight tendency towards blueness, particularly in the shadow areas. A straw-coloured 81B filter corrected this. The picture was taken by noon sunlight (the light source most films are balanced for), so no other corrective filtration was necessary.

The pattern of shadows and the extreme contrasts would have misled the light meter in any camera, so the photographer used a hand-held meter in the incident mode. He held the meter in the sunlit area, with the diffusing dome directed at the camera. This ensured that the sunlit wall appeared pure white.

5 8

The Golden Section is a phrase used to refer to a particular division of length, as shown left. A line divided according to the golden section is split in a ratio of about 8:5; the ratio of the smaller section to the larger is the same as the ratio of the larger section to the whole. Composing the photograph around this traditionally perfect proportion is not a guarantee of success, but it will provide a sense of harmony and stability that other compositions sometimes lack.

Seen from below with a shorter focal length lens, the same building assumes quite a different character, and the statuary is almost hidden by the pediment it stands on.

The optics of the mirror lens caused this arc of light across the sky. Often such an aberration would be undesirable, but when atmosphere, not accuracy, is the aim, such flare marks can be an asset.

For 'perfect' colour around dusk and dawn, recommended filtration is a Wratten 80B, but often the golden glow of uncorrected sunlight is more attractive than a technically ideal colour balance.

The barely noticeable movement of the sun across the sky is accelerated by long lenses; with a 500mm lens the sun will cross the short side of the frame in less than a quarter of an hour. This reflection, therefore, soon disappeared from the window, and the photographer had to work quickly to set up the camera and tripod.

Camera:	Metering:
35mm SLR	TTL
Lens:	**Filter:**
500mm mirror lens	—
Film:	**Lighting:**
ISO 64 colour transparency	Natural

Composition City skylines always reward the observant photographer. Up above the grimy canyons of the street there are sweeping airy vistas where the pigeons and sparrows soar: little interesting details, and odd juxtapositions of ancient and modern, decorative and practical.

It is exactly such a combination that makes this image interesting. Building in the grandiose style of ancient Greece, our forefathers didn't forget their creature comforts; they installed coal fires to cope with a climate that was far from Mediterranean.

To align the chimney pots and statue, the photographer chose a distant viewpoint. Closer to the building, the Palladian façade obscured the tiles and chimneys behind, just as the architect had intended. From so far away, the horizontal lines of the building intersect at gentle angles, with the converging lines of the tiles and the chimney pots pointing the way to the goddess positioned at the left of the picture.

The framing of the picture was not dictated only by the statue and roof-line. The glowing gold of the reflected sunlight, and the contrasting blue of the sky imposed upper and lower limits on the composition. And below the statue, the small colonnade picks up and repeats the rhythmic marching theme of the chimney pots higher up – so this, too, is included.

Technique Picking out such small architectural details high on a building demands a long telephoto lens. Here the photographer used a 500mm mirror lens. This had a fixed aperture of f/5, so he deliberately chose a section of the building that had limited depth. Nevertheless, the depth of field was still barely adequate: the most distant chimney pots are drifting out of focus. This would be unacceptable in an architectural photograph made in the traditional style, but it is not distracting in a subjective view such as this.

In direct sunlight, and with such a fast lens, exposure presented few problems. A TTL meter reading from the sunlit façade (avoiding the reflection on the window) indicated a shutter speed of $\frac{1}{500}$ with the ISO 64 film – just fast enough to hand-hold. However, since the photographer was carrying a tripod, he decided to use it and avoid the risk of camera-shake.

Haze made the hills seem lighter and bluer – a phenomenon called atmospheric perspective, which suggests distance.

The tiny aperture – f/22 – may seem abnormally and unnecessarily small, but large-format cameras create pictures with much less depth of field than smaller formats, so considerable stopping down is usually necessary to keep everything sharp.

Placing the horizon so that it divides the frame exactly into two is usually ill-advised. Here the immobility that this half-and-half composition creates is entirely appropriate to the subject matter and mood of the picture.

Camera:	**Metering:**
5 × 4 in sheet-film	Hand-held incident light
Lens:	meter
150mm	**Filter:**
Film:	—
ISO colour transparency	**Lighting:**
	Natural

With the camera's lens on-axis, the picture included too much foreground. Shifting the lens upwards removed this, resulting in the more satisfactory picture shown on the right.

Composition Photographs can be intensely personal, having far deeper meaning for the photographer than they ever have for other people. Nevertheless, such pictures often seem imbued with enormous emotional charge and energy – even when the motive and circumstances of their creation are not known to the viewer.

This is one such picture. The whole image is filled with finality: the end of a road, and an incongruous sign that needlessly reiterates the fact; the parked car; and oddly truncated trees. The swirling, cloudy sky above adds to the sensation of gloom and despair.

Despite a feeling of morbidity, the composition of the picture is still optimistic and forward-looking. The photographer decided on quite a high viewpoint, so that the camera looks out over flat farmland, and, further out, to distant blue-hazed hills. By carefully selecting the camera position in a lateral plane, she positioned the brilliant white barn directly behind the yellow traffic sign, so that the eye is led directly from this note of finality in the foreground, onwards to a track leading away into the distance, and by implication, to the future.

Technique The camera used was a wooden 5 × 4 in sheet-film camera, with a 150mm lens. The use of a large-format camera played an important part in the composition, because it enabled the photographer to change the field of view without tilting or turning the camera. She raised the front panel bearing the lens, so that the camera took in more of the sky, and less of the foreground. On a 35mm camera, this could have been achieved by using a 'shift' lens (often called a perspective control lens), which duplicates some of the features of a sheet-film camera. The alternative – tilting the whole camera upwards – would have made the vertical lines converge towards the top of the frame.

Other details of technique were straightforward. The photographer took an incident light-meter reading to set exposure. She adjusted the lens of the tripod-mounted camera to f/22, and the shutter speed to half a second. Focusing and composition were carried out as on any sheet-film camera: the photographer viewed the inverted and reversed image of the subject on the ground-glass screen at the back of the camera, her head and the screen covered by a light-excluding black focusing cloth.

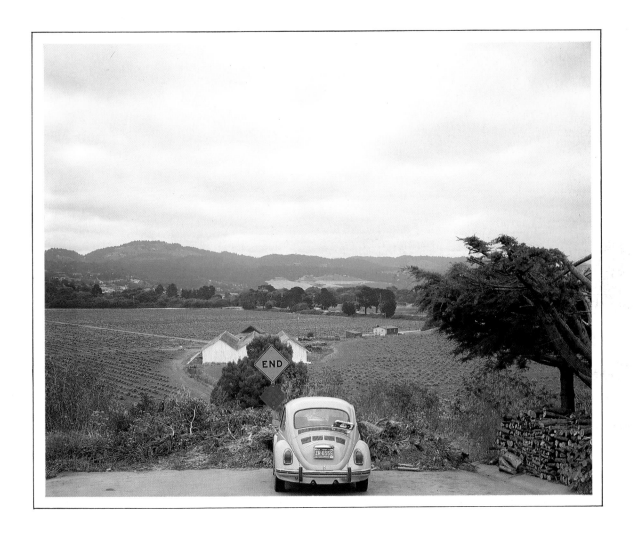

A telephoto lens provides a different, more abstracted view of the sunlit building.

Reflected window stanchions pick up the sun's colour, carrying it upwards towards the top of the frame.

The sun sank from view just moments after the picture was taken, so timing was critical.

Sparing exposure hid street clutter and traffic in this area of the frame.

The reflection of the adjacent building hints at the crowded city-centre context, without distracting the viewer as much as the neighbouring building itself would, had it appeared in the frame.

Camera:	**Metering:**
35mm SLR	TTL, selective area
Lens:	**Filter:**
20mm	—
Film:	**Lighting:**
ISO 100 colour negative	Natural

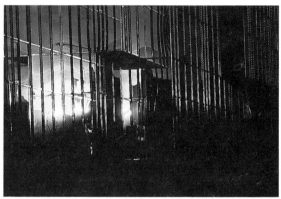

Composition The aggressive, upward-thrusting style of much modern architecture demands an equally definite and dynamic approach from photographers. In photographing an old building the aim is usually to emulate an architect's elevation, and show the structure isolated from its surroundings, with all vertical lines parallel. However, in the modern city restricted viewpoints make such an approach impractical.

The photographer's aim in taking this picture was to capture on film the ambiguity of such reflective buildings. However massive they are, their surfaces reflect the constantly changing brilliance and colours of daylight, thereby amplifying the light that reaches the pedestrian at street level, rather than attenuating it.

The steeply angled camera encourages this notion by running the sky and glass together where they meet at the top of the block. The close viewpoint and camera angle also cause the building's vertical lines to converge rapidly skywards, emphasizing its soaring, optimistic lines.

By shooting at sunset, the photographer caught the sky's colours at their most brilliant, and was better able to control the sun's brightness. Earlier in the day, the sun would have formed a burned-out white patch in the middle of the frame, but, on the horizon, the rays are weaker and warmer in hue, so that the sun balances the Telecom tower, and forms a colour contrast with the blue.

Technique The broad field of view of a 20mm lens made possible a very close approach to the building, and reduced the apparent size of the skyline that was visible at the bottom of the frame. However, to prevent the camera's meter from being over-influenced by the setting sun, the photographer removed the wide-angle lens before taking a meter reading, replacing it with a 200mm. Combined with the camera's strongly centre-weighted metering pattern, this effectively made possible spotmeter readings from the sky reflected in the mirrored glass. The photographer selected the area of glass that he wished to appear as a mid-tone, noted the indicated exposure, and set this manually after replacing the 20mm lens. He took care to stop the lens down to f/11, since he knew from experience that optical performance was poor at wide apertures. He bracketed the pictures because the scene was very high in contrast.

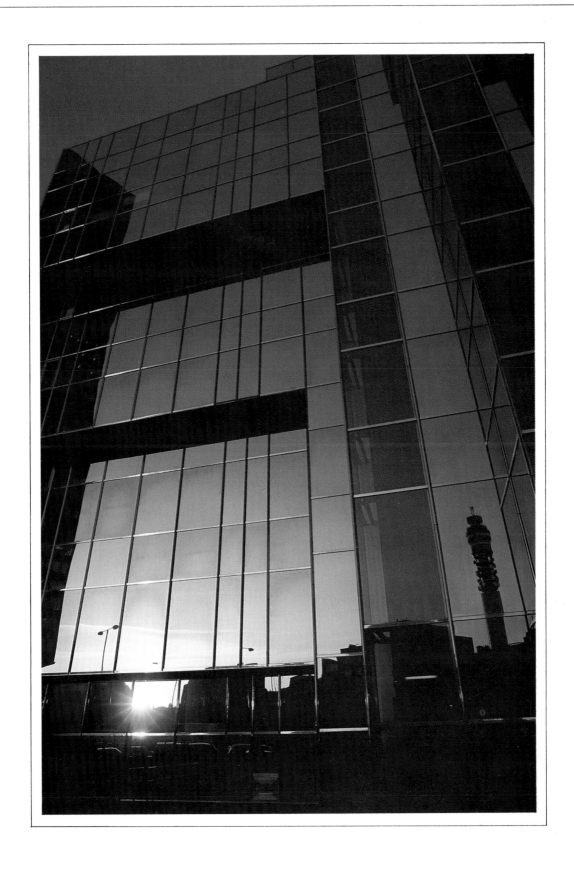

Paradoxically, some of the most interesting images are those that are technically the least satisfactory. Set to auto for this picture, the camera's shutter remained open for several seconds, inducing camera-shake, and turning cars' tail-lights to streaks.

The light of the setting sun gilded the shiny façade of glazed tiles.

Underexposure in sunlight blotted out half the building.

In shadow the hotel appeared pale green.

Camera:
35mm SLR

Metering:
TTL

Lenses:
Various

Filter:
Polarizer

Film:
ISO 64 colour
transparency

Lighting:
Natural

Composition A change in the colour or direction of the light can totally alter the appearance of a subject. Think of a full-face portrait: lit from the front, the sitter's identity is obvious, but lit from behind, they become totally anonymous.

To the eye, changes in the colours of light do not change the apparent colour of the subject – a phenomenon known as 'colour constancy'. Film, on the other hand, responds to even tiny changes in the colour of the illumination.

The series of pictures opposite explores these ideas through the study of a single subject in widely varying lighting conditions. The photographer selected this subject for a variety of reasons, but most important was its colour. The glazed white surface of the hotel not only picks up the colour of diffuse ambient light, but also creates spectral reflections which glow with the changing hues of direct sunlight. Furthermore, the building – unlike, for example, a landscape – did not change with the seasons.

The specifics of the composition change from frame to frame, but the single theme unites all the pictures. Individually, few of the images stand out, but as a group they are far more interesting, and make a glittering mosaic of light and colour.

Technique All the pictures were taken on daylight-balanced film, without any colour balancing filtration. Changing film or filters to correct for the changing colours of daylight would have defeated the object of the exercise. However, a polarizing filter was used for some pictures to make the sky colour richer.

Metering techniques were varied to take account of the changing lighting conditions, but unless there was very high lighting contrast – as, for example, in the bottom left hand picture – the camera was set to automatic.

The photographer used a variety of lenses, mainly wide-angles. Use of colour transparency film ensured that the hues were faithfully reproduced in the pictures – negatives could have been altered using filtration at the printing stage.

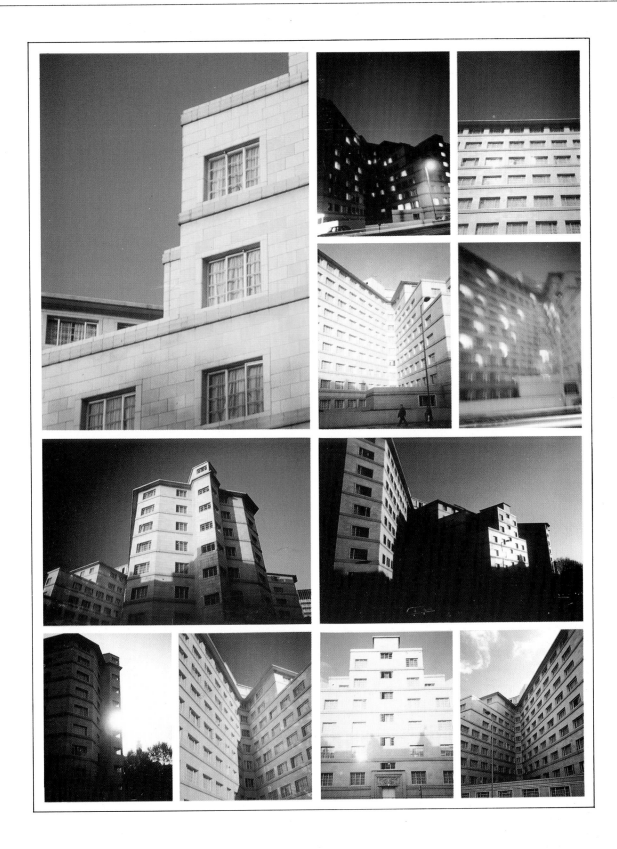

This area appears quite neutral in colour because two 80A filters were fitted over the lens while the first floor landing light was on. Such filtration corrects the colour of domestic tungsten lamps to match the sensitivity of daylight-balanced film.

The lower area is washed with an orange colour cast, because no corrective filtration was used here.

Because of the long exposure used, reciprocity failure (see page 100 and Glossary) caused a slight overall colour shift towards the green part of the spectrum.

Camera:
35mm SLR

Lens:
20mm

Film:
ISO 25 colour
transparency

Metering:
Hand-held meter in
reflected light mode

Filters:
Various 80 and 85 series
light-balancing filters

Lighting:
Household light bulbs

Composition This elegant staircase snakes up the centre of a nineteenth-century town house: the hardwood banister makes an apparently unbroken journey up from the basement of the house to the third floor. However, the photographer chose the first floor landing as the best location, because here the staircase doubles right back on itself, looping extravagantly in and out within the space of a metre or so (a few feet).

The framing of the picture gives maximum emphasis to the curves in the scene, using the banisters themselves to conceal much of the jagged detail of the steps and risers. Moving the camera left and right, the photographer chose a position where the white banister supports would stand out clearly against the dark carpet.

The final composition allows the banister rail to lead the eye smoothly upwards through the frame, as a figure would ascend the staircase, starting at the bottom left of the picture and moving across to the right before continuing up the next flight. Where the banister disappears from view, the swirling shape of the plasterwork takes up the serpentine motion, swinging back round to the right again.

Switching on the downstairs light echoed the banisters' shape yet again – in their shadow. So, before taking the picture, the photographer made a final adjustment to the composition: he turned the camera slightly to balance the coloured shadow with the rails that cast it.

Technique The colours of the picture were generated by the camera; to the eye, the walls of the staircase appear plain white. To make the picture more interesting, the photographer therefore switched on three light bulbs for different periods of time in the course of a 2 or 3 minute exposure. The three bulbs were on three different landings – the landing on which the picture was taken, the landing above, and the one below.

Colour was introduced by changing the filter that covered the lens while all the lights were switched off. A series of pictures was taken, trying different exposure times and different filtrations for each.

A typical sequence would be: **1** Without filtration, open shutter. **2** Turn on ground floor light for 30 seconds, turn off. **3** Fit two 80A filters, turn on the light on the first floor landing for 1 minute. Turn off. **4** Remove one 80A filter, turn on second floor lamp for 30 seconds. **5** Close shutter.

Exposure was determined by taking reflected light-meter readings from the walls close to each light source. After compensation for the density of the filters, these readings gave an indication of how long each light bulb should be switched on.

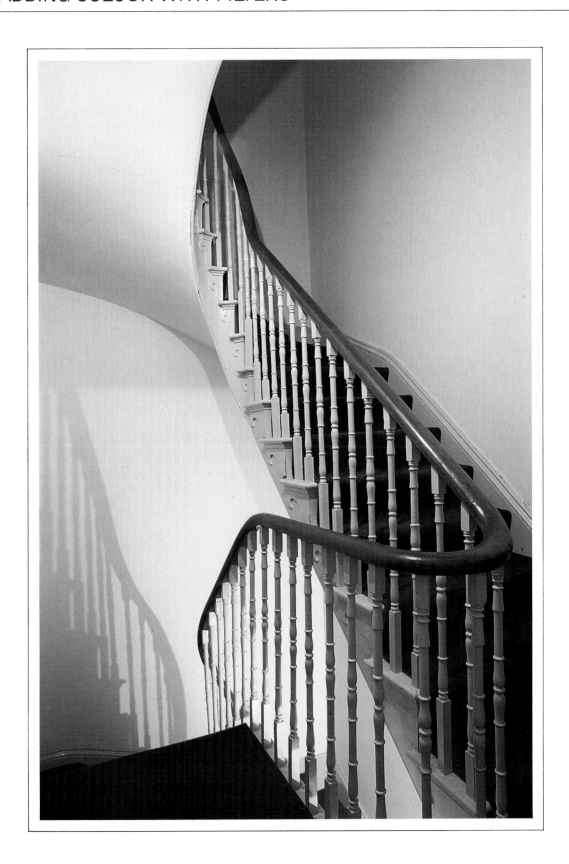

Metering from the neon tubes themselves gave a good indication of the basic exposure required.

Distracting detail lit only by ambient light disappeared as daylight faded.

Camera:	**Metering:**
35mm SLR	TTL from close to the sign
Lens:	**Filter:**
200mm	—
Film:	**Lighting:**
Daylight-type slide for best colour	Natural

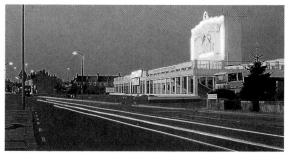

To inject movement into what can sometimes seem a rather static subject, use a tripod, and prolong the exposure. Passing traffic then leaves trails of red, white and yellow.

Composition This wall of neon was a work of art in itself, and though a close-up of individual details might have made a more dramatic picture, a literal, objective approach was chosen instead. As a result, the picture eschews graphic impact in order to portray the designer's original intentions for the building more clearly.

Neon has a tendency to appear brash and gaudy on film, so picturing this sign in the pastel hues that were so popular when it was constructed during the Thirties was not easy. The subtle and harmonious colours captured in this picture stem from the time of day when the exposure was made.

As the sun set, the ambient light level fell until it precisely matched the glow of the gas-filled tubes. Before the sky darkened, it illuminated the white-painted supporting wall, so that this appears very pale blue in the picture. As daylight faded after this picture was taken, the sky turned from blue to black, and the tubes themselves provided more of the illumination, so the background gradually picked up the colours of the sign. Thus, as night advanced, the attractive contrast of warm and cool hues was lost.

The obvious viewpoint for the picture was directly opposite the sign. However, from this position the sign looked flat and rather boring.

Additionally, seen from a close viewpoint, the columns at either side of the sign appeared to converge towards the top of the picture, spoiling the sub-classical lines of the sign. Backing away from the sign recorded its shape in a truer perspective – and the oblique view has given depth to the supporting wall.

Technique To strike the correct balance between daylight and neon, the photographer first took an exposure meter reading from the light source that would not change in colour or brightness – the tube itself. To do this, he walked close to the sign, and tightly framed a section of closely packed tubes using a 200mm lens. A TTL meter reading provided the correct exposure setting – ½ second at f/8, with ISO 64 film. Moving back to the tripod, he then periodically took exposure meter readings from the sky. When the sky was just one stop brighter than the sign, he began to take pictures at regular intervals, and continued until the reading from the sky had dropped by three stops. The basic exposure remained the same for the whole sequence, but exposures were bracketed at one stop over and under the indicated setting. This provided a range of pictures that showed a gentle and progressive variation in colour saturation.

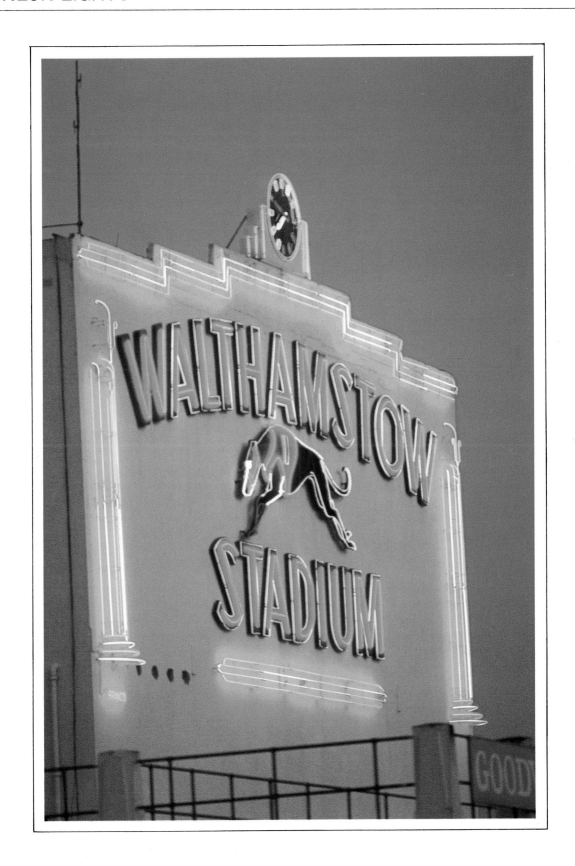

The red light provides a vivid counterpoint to the generally cool hues of the rest of the image.

Using the perspective control lens on maximum shift, the photographer chose to stop well down. There was little alternative, because at wider apertures, the off-axis lens barely covers the film format – and the corners of the picture darken on film.

The blue paintwork of the passing bus echoed the blues of the central mural.

Camera:
35mm SLR

Lens:
35mm perspective control (shift) lens

Film:
ISO 64 colour transparency

Metering:
Hand-held incident light meter

Filter:
—

Lighting:
Natural

Composition One of the beauties of photography is that the camera does not recognize the third dimension: a flat drawing or painting, for example, receives exactly the same treatment as an object that has form and depth. Both appear flat on film.

Sometimes this provides wonderful opportunities for the enterprising and observant photographer – as this witty study of a mural in a town near the Italian Alps illustrates. It is really a cooperative effort – though the painter and photographer never met.

The photographer took pains to maintain the illusionistic style of the artist. She deliberately took the picture on a dull day, because sunlight creates shadows that reveal form, depth, and distance very clearly. In overcast weather, the 'real' scene appears flatter, and the mural more strongly ridged and furrowed by comparison.

The small square would have been interesting even in a snapshot, but the photographer had higher ambitions. Mounting the camera on a tripod, she waited for passing traffic – and an obliging bus added a rush of movement, which contrasts starkly with the static feel of the rest of the picture. Only after processing did the photographer notice with amusement that, in the best traditions of Italian traffic skills, the bus driver was blithely ignoring a red light!

Technique The main priority was clearly to make as good and undistorted image of the wall as possible, so the photographer set up a tripod directly opposite the mural, levelling it carefully before attaching the camera. Looking through the viewfinder, she realized that the camera's lens took in too much of the foreground, but cropped out the top of the building, so she tilted the camera upwards. This approach, though, made the parallel sides of the wall tilt inwards. So she replaced the camera's lens with a shift lens, and levelled the head of the tripod once more. Then, by raising the lens, she shifted the camera's field of view upwards to take in the top of the wall, and less of the foreground.

Transparency film has little exposure latitude, and, in order to get the most accurate possible exposure, the photographer took an incident light-meter reading with a hand-held meter. Since such a method measures light falling on the subject, rather than that reflected from it, an incident light reading is not influenced by subject tones – and therefore provides a very precise way to set exposure.

The meter indicated several combinations of aperture and shutter speed, each of which would have provided equally acceptable results. The photographer chose $1/15$ at f/11, to improve the performance of the lens, and because she wanted to blur the traffic movement at the right of the image.

All that remained was to wait for a suitable vehicle. She picked this bus for its striped sides, knowing that they would leave a coloured trail across the frame.

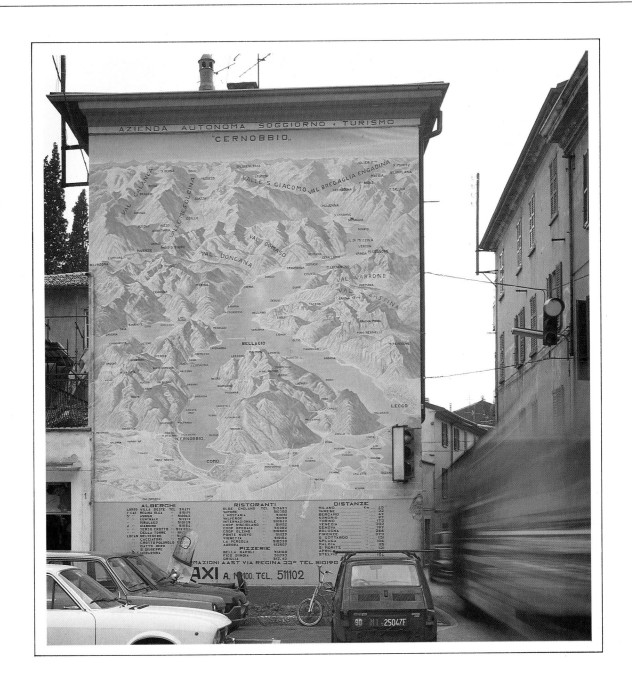

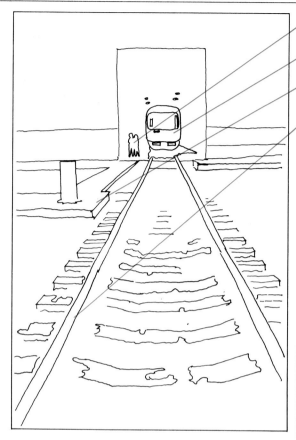

Human figures make the picture softer and less mechanistic.

The train's warm yellow paintwork ensures that, despite its small size, it still dominates the picture.

A concrete pier provides a relief from the otherwise unremitting symmetry of the scene.

The steeply receding rails make a subtle joke about perspective: railway tracks are always used as a text-book example of parallel lines converging at infinity.

Camera:	Metering:
35mm SLR	TTL
Lens:	**Filter:**
24mm	FL-D
Film:	**Lighting:**
ISO 64 colour transparency	Natural

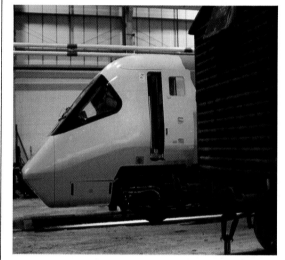

Inside the engine shed, the filter that created an unreal colour cast outside has a different effect. Here it corrects the colours, so that the rolling stock is seen in its true hues.

Composition This picture exemplifies the challenge that daily faces professional photographers: how to make a good picture in the most unpromising or prosaic circumstances.

Paradoxically, the train itself is potentially a very interesting subject – its advanced design enables it to operate at very high speeds on conventional track. However, the train was immobilized in its depot for maintenance and didn't look particularly exciting when stationary.

To put back some of the high-tech glamour, the photographer made use of colour and geometry. He walked away from the train, and picked a low viewpoint precisely in the middle of the sleepers. Tilting the camera slightly downwards brought into view the tracks close to the camera, so that the rails converge like an arrowhead towards the sleek cab at the entrance to the engine shed. The low viewpoint had two other fortunate consequences: first, it hid the rectangle of light formed by the far door of the shed behind the train itself; and, second,

it also aligned the locomotive with the roof lighting, so that spikes of light seem to be radiating like starbursts from the train.

Technique The unreal purple colour cast that washes the picture was the product of a filter. The photographer had been taking pictures inside the shed, and was using a magenta-coloured FL-D filter to match the overly green spectrum of the fluorescent tubes to the daylight-balanced sensitivity of his film. When he stepped outside into daylight, he realized that by keeping the filter on the camera, he could change the rather dull light of the exterior to an exotic mauve – yet record the fluorescent-lit train in natural colours.

The lens used was a 24mm. A shorter focal length would have made the vertical lines of the railway shed diverge violently at the top of the frame when the camera was tilted downwards; and a longer lens would not have included so much of the track at the photographer's feet.

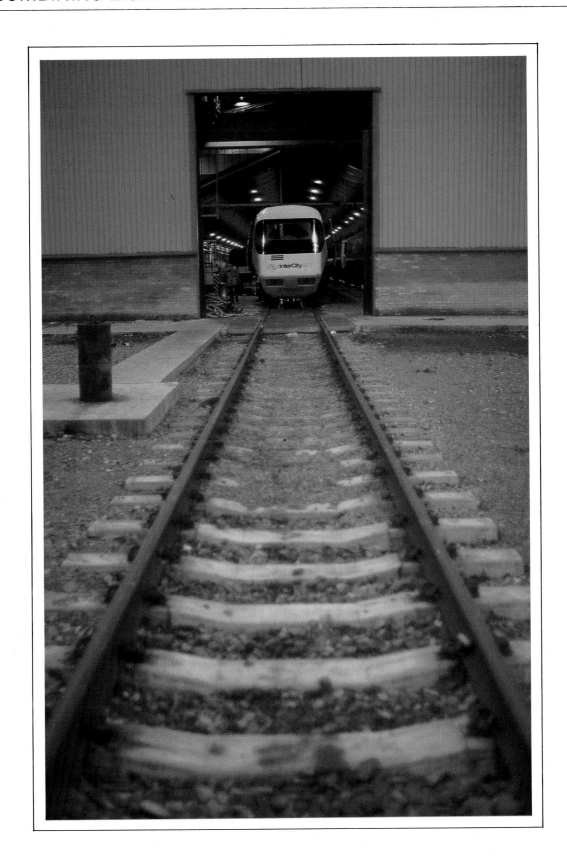

LANDSCAPES

Landscape photography has a peculiar magnetism, quite unlike that of other subjects. Like a well-head, jaded professional photographers go back to the land for rejuvenation and refreshment when the hurly-burly world of fashion and advertising gets too much.

The attraction of landscape photography is threefold. First, it is a wilful subject that cannot be controlled in the way that a still-life in the studio can: the light falling on a landscape can't be switched on and off, or made softer or harder by choice – and you can't use fill-in flash to soften the shadows. So landscape offers the photographer a challenge that other subjects do not.

The constantly changing face of the landscape is the second reason for its charm. Though apparently a static subject, a landscape never looks the same twice: it is in a constant state of flux as the wind blows, and the earth spins. The picture opposite altered by the minute, as the brilliant patch of yellow in the foreground was swallowed up by advancing shadows. If you don't like the landscape you see now, then just wait; it will soon look different.

Finally, the landscape is like a blank canvas, awaiting the photographer's interpretation. More than any other subject, landscape gives a free rein to your creative and compositional energies – a single scene photographed by ten different people will yield ten uniquely different views.

In the chapter that follows, you'll see a range of different approaches to landscape, and the techniques that produced the images. To unlock the potential of landscape, though, copy only the photographic methods: it is the individual vision that *you* bring to the scenery in front of the camera that will stamp the pictures you take with your own unique hallmark.

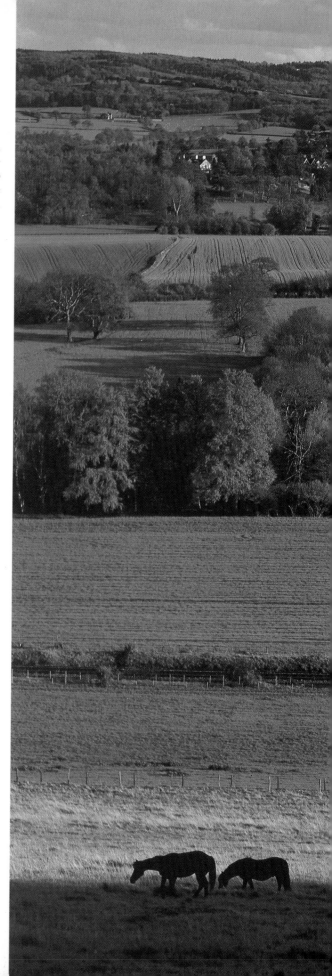

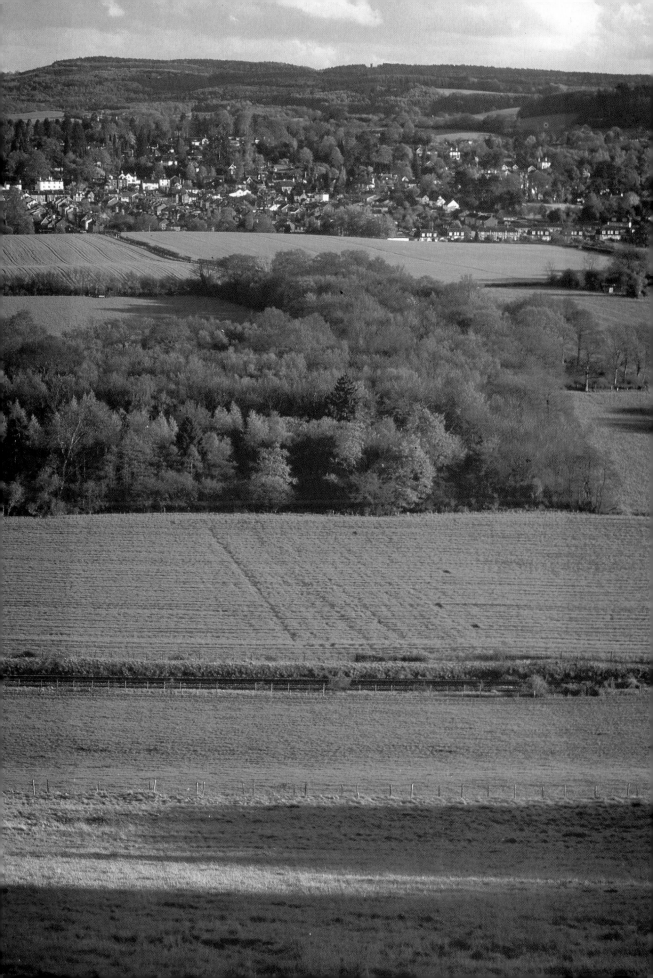

The lines of the framing arch echo the converging lines of the buildings beyond.

Mist exaggerates aerial perspective. Here the succeeding planes of the picture appear progressively and rapidly lighter.

The mist swirling round the scene drains it of colour, suggesting the greyness of much modern city architecture.

Camera: 35mm SLR	**Metering:** TTL selective
Lens: 20mm	**Filter:** —
Film: ISO 64 colour transparency	**Lighting:** Natural

The asymmetry of the main picture opposite contributes to its appeal. The image on the right lacks the imbalance and tension, and is weaker as a result.

Composition 'Skyscrapers – literally!' is what this picture shouts. Geometry meets meteorology in an image that is quintessentially New York.

In taking it, the photographer turned adversity to advantage. With the city locked into a sea-fog, he was unable to get the long distance views he was seeking, and instead stalked the streets looking for pictures that would be unaffected by weather and yet be original and striking.

The specific buildings he chose to photograph are popular subjects for photographers: the juxta-position of mission-church foreground and high-tech background is difficult for anybody with a camera to resist.

The mist and the framing arch, however, add original elements that make this picture different. The mist emphasizes height, suggesting that the building really does stretch up indefinitely. Yet the foreground arch tell us otherwise: it reassures us that, despite the fact that we cannot see the top, the building does end somewhere.

Technique Idea is the essence of this picture, like so many others. Once the idea had formed, execution was almost routine. The photographer tried a number of combinations of viewpoint and focal length; what you see here, shot with a 20mm lens, is the most successful. Longer lenses presented depth of field problems and did not adequately frame the scene with the arch. Shorter focal lengths made the chapel and distant scene subservient to the arch.

To set exposure, the photographer changed lenses and took a meter reading from the middle of the distant block. To the eye this appeared middle grey, and he figured that basing exposure on it would record it as middle grey – and would, therefore, record other tones in the scene in their true relationship.

Shutter speed and aperture presented few problems; the wide-angle lens used has enormous depth of field and can be hand-held at speeds as slow as $1/15$ without risk of blurring the image.

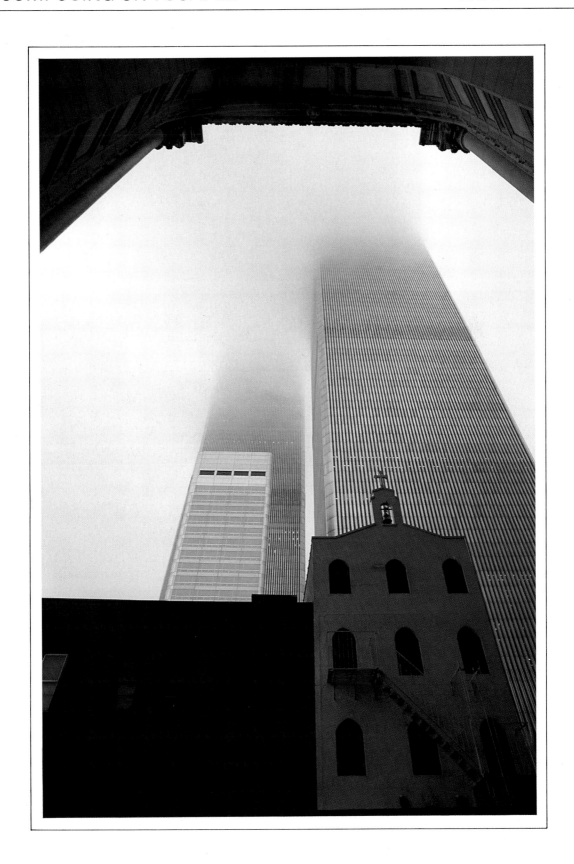

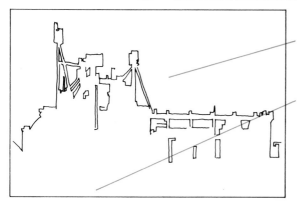

A polarizing filter appeared to make these clouds look more fluffy and white, but in reality the filter had no effect on the clouds – only on the sky behind. The filter darkened the blue colour, increasing the contrast with the clouds.

A meter reading from this foreground area indicated that it was about three stops darker than the sky – just enough to make an effective silhouette, though some detail is still visible in the shadows.

Camera:	Metering:
35mm SLR	TTL reading from sky
Lens:	**Filter:**
200mm	Polarizing
Film:	**Lighting:**
ISO 64 colour	Natural
transparency	

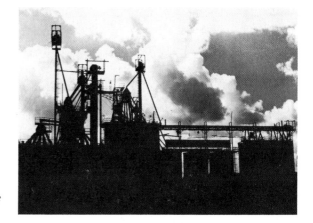

Using black and white film, a red filter darkens the sky more effectively than a polarizer.

Composition For those who must live and work in an industrial landscape, mills and factories will only ever be a visual blight on the countryside; but for those of us fortunate enough to pass only briefly and occasionally through their shadows, these industrial monsters sometimes seem to have a majesty and grandeur all of their own.

It is exactly this savage beauty that the photographer aimed to capture in the image opposite. The soaring towers of the plant near to his cheap holiday hotel reminded him of the masts of medieval galleons – and of Don Quixote's windmills. Seen in overcast weather, though, and against a dull grey sky, the plant was not worthy of a picture. So the photographer kept his camera in its case, and returned to the scene a little later when the sky was blue.

He picked a viewpoint that showed the factory in profile, and resisted the temptation to frame just the elegant towers in the picture. The silos below and to the right of them form an interesting contrast of weight and bulk with the spindly metalwork and gantries above.

All that remained was to wait for the clouds behind to contort themselves into an interesting pattern. Blue rather than grey sky certainly made a more colourful picture, but the clouds add yet another element. Their vast, haphazard shapes make man's work below look puny by comparison, and the juxtaposition of the two very different sorts of pattern – one of them angular and hard-edged, the other soft and fluffy – gives an interesting final twist to the image.

Technique The exposure was made with the camera set on aperture-priority automatic: to record the factory as a silhouette, the photographer took a straightforward TTL meter reading from the sky. He used the camera's memory lock button to hold the setting of 1/500 at f/8 while he recomposed the picture so that it included the factory. The meter automatically took into account the light that was absorbed by the polarizing filter which was used to darken the blue parts of the sky in order to lighten contrast with the clouds.

To fill the frame with the masts and silos from the distant perimeter fence, the photographer used a 200mm lens. The relatively fast shutter speed in use meant that it was safe to hand-hold the lens without risk of camera-shake.

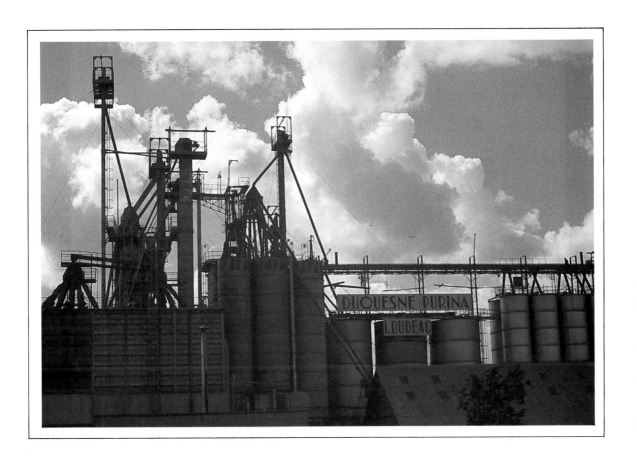

Atmospheric pollution tinted the sky above the city a delicate shade of pink.

The photographer composed the picture with the statue placed at the intersection of the thirds – the horizon, too, cut the frame a third of the way into the picture.

The vertical format makes the most of the distant view, and the foreground/background relationship.

Camera:	**Metering:**
35mm SLR	TTL
Lens:	**Filter:**
180mm × 1.4	—
Film:	**Lighting:**
ISO 64 colour transparency	Natural

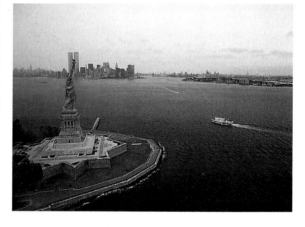

A helicopter ride around the Statue of Liberty provided the inspiration for the main picture opposite; the photographer noticed and photographed the alignment of the two landmarks, and reasoned that he could get a good picture looking in the opposite direction, too.

Composition At twilight the city is in a magic limbo. This is the time that the French call 'entre chien et loup': between dog and wolf, neither day nor night. Daylight and electric light jostle for the upper hand, and neither wins.

The photographer who took the picture opposite scheduled his photo-session at dusk for precisely this reason. He had guessed that a camera position on top of the World Trade Towers would give a different and original view of the famous statue – but that in all but the clearest of weather, atmospheric haze and pollution would soften and diffuse the image. At dusk, though, pin-pricks of brilliant light picked out the buildings and punctuated the picture.

He deliberately composed a very understated picture. The statue is instantly recognizable, and catches the eye even when quite small in the frame. By taking a broader view of the scene, the photographer was able to use the twinkling lights of New Jersey as a backdrop for the image.

Technique The considerable distance between the camera and subject forced the photographer to use a long lens – in this example, a 180mm with a 1.4x teleconverter. Even with this combination, the statue appears quite small in the frame, but, as explained above, its small size enhances the picture, if anything. The lens/converter combination magnified the image – and any camera movement would be magnified some twelve-fold compared to a standard lens, so the photographer locked the camera firmly on to a sturdy tripod, shielding it from the wind with his body.

The TTL exposure meter readings that were taken from various parts of the scene confirmed that the contrast was fairly low, and the photographer was therefore able to rely on the camera's auto-exposure mode. The light levels were by now falling quite rapidly, but auto-exposure saved some time by eliminating the need for repeated meter readings and constant adjustments of the camera's controls.

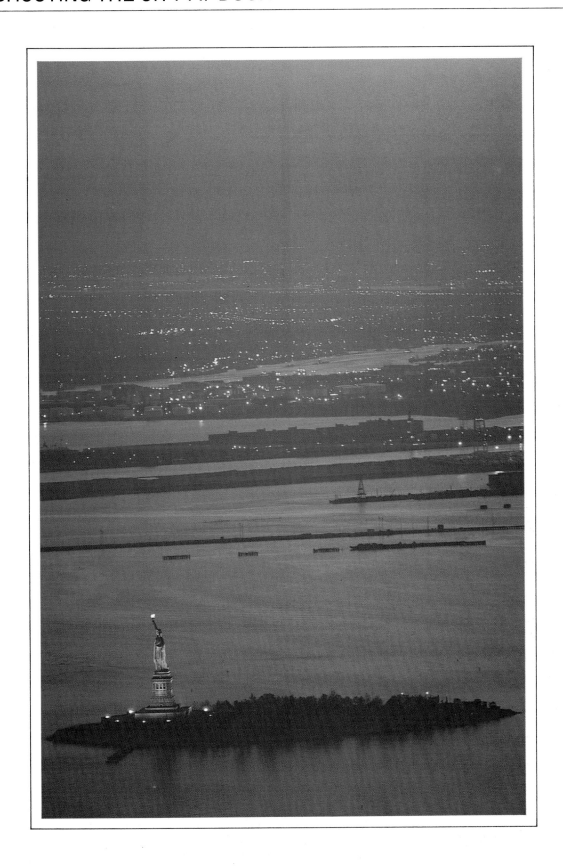

To make double exposures on a camera that lacks special provision for multiple exposure, follow this simple procedure:
1 Turn the film rewind knob clockwise to tighten up the film in the cassette.
2 While holding the rewind crank in position, press in the rewind button.
3 Crank the film advance lever.
This will re-tension the shutter so that you can make two exposures on the same frame.

When adding a moon in the manner described here, avoid taking the main picture with a wide-angle lens, or the contrast of scale between moon and the scene beneath will look unnatural. Here, for example, the cityscape was photographed using a 28mm lens, and the difference in size between the two elements is highly implausible.

An 81D (pale brown) filter added some warmth to the twilight sky.

Separate exposures were needed for the silhouettes and the moon, because the moon was too high in the sky to include in the first picture.

The photographer took a close-up reading from the streetlight to check that it was bright enough to form a white highlight that was clearly brighter than the sky behind. He started taking pictures when the sky was three stops darker than the reading from the lamp.

Camera:	Metering:
35mm SLR	TTL and guesswork
Lenses:	**Filter:**
200mm and 500mm	81D
Film:	**Lighting:**
ISO 64 colour slide	Natural

Composition Figures on the skyline make bold, graphic shapes, particularly when the sky behind is colourful or patterned with interesting cloud formations. The weather is wilful, though, and on the day when this picture was taken, the sky was clear, but uniformly pale blue. To make the subject more interesting, the photographer realized he would have to add some extra element.

Waiting helped. When the street light on the left came on, it provided a twinkling brightness that sets the scene. Now we see that this is dusk, and not just an underexposed picture taken at noon.

Waiting for the right figures to appear was also important. The group of frolicking children on the right make a contrast with the strolling adult, and the distance between them in the frame emphasizes the differences in age and demeanour.

Balancing the composition in a conventional way has given the picture a very stable, reassuring equilibrium. The three figures on the right balance the single figure and the lamp-post on the left, and the scene looks calm and restful as a result. The low horizon moves the centre of gravity down to the bottom of the frame, and this, too, helps to evoke the atmosphere of a peaceful summer's evening.

The giant moon at the top of the frame completes the picture. As explained below, this was added by camera trickery, but its position in the frame was chosen to increase further the sense of stability. Positioned centrally above the figures, it forms the apex of a triangle – a reassuringly stable shape.

Technique Basic exposure for the hillside scene was ⅟₆₀ at f/4, using ISO 64 film. A reading from the sky using the camera's TTL meter provided these settings. A second reading, from the ground, confirmed that the hillside and backlit figures would appear as silhouettes. This main picture was taken with a 200mm lens.

But, after making the first exposure, the photographer re-tensioned the shutter without advancing the film (as explained above left). Then he fitted a 500mm mirror lens, and turned the camera atop its tripod, bringing the moon into view. Exposure for the moon is fairly constant and predictable, and a quick meter reading was within one stop of the educated guess – a shutter speed of ⅟₃₀ with the lens's fixed aperture of f/5.

The second exposure dropped the moon into the picture in the correct position.

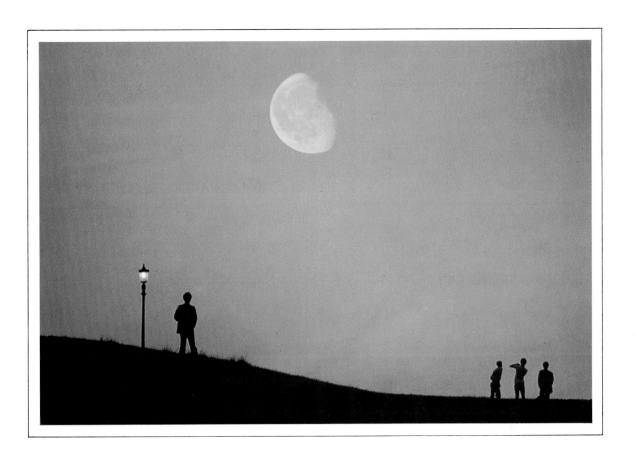

The dark black shadows are a characteristic effect of the red filter. The shadow areas are illuminated only by blue skylight, which is absorbed by the red glass of the filter.

The $1/15$ second shutter speed recorded just enough detail in the water to suggest movement. A longer exposure would have made the stream look more like mist or cotton wool.

By giving the foreground area extra exposure during printing, the photographer ensured that the foaming water did not appear a featureless white.

Slow film produced a negative that had fine detail and good tonal separation – both qualities that are essential ingredients in the fine monochrome landscape.

Camera: 6 × 6cm non-reflex	**Metering:** Hand-held incident light meter
Lens: 38mm, non-interchangeable	**Filter:** Red
Film: ISO 125 panchromatic	**Lighting:** Natural

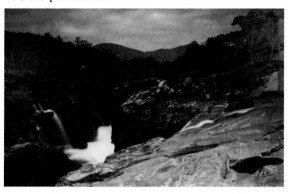

For this image taken nearby, the photographer used a much longer exposure – four seconds – and thereby turns the water to a smooth, misty flow.

Composition The tradition of photographing landscape in black and white runs like an unbroken thread through the history of photography. The advent of practical colour processes at the turn of the century served, if anything, to strengthen the tradition. Indeed, many of the acknowledged twentieth-century masters of landscape, including Ansel Adams and Edward Weston, worked almost exclusively in monochrome.

Looking at this picture, it is not hard to see why. The photographer has exploited the monochrome process to the full, in order to abstract from the real landscape – which is cold, wet and windy – an idealized view of the land. He composed the picture in such a way that the viewer's eye is drawn back from the immediate foreground through to the distant peak. To do this, he first found a subject to fill the area close to the camera, fixing on a tumbling mountain brook. He positioned the camera down low, close to the water. This rushing foreground puts movement into an essentially static scene, and catches the attention immediately. The water catches the light, too, making a brilliant white highlight that provides a welcome relief after the sombre tones of the background and rocks.

The composition was incomplete until the picture was printed: in the darkroom, the photographer carefully controlled the tonal relationship between the foreground, the middle distance, the peak and the sky, so that the viewer's eye weaves a natural path across the rocks to the cloud-covered summit in the distance.

Technique The viewer is projected into the picture by the striking feeling of depth and distance. This was enhanced by the use of a wide-angle rollfilm camera which has a fixed 38mm lens taking in a field of view approximately equivalent to a 20mm lens on 35mm film. The photographer stopped the lens down to f/22 in order to keep every detail in the scene sharp, and to allow him to use a slow enough shutter speed ($1/15$) to turn the water to a blur.

The sky was a pale blue, so to give it tone and bring out the white clouds, the photographer fitted a red filter over the lens.

The camera has no meter, so the photographer took an incident light reading with a hand-held meter, adjusting its dial to compensate for the density of the red filter before finally setting the camera's controls.

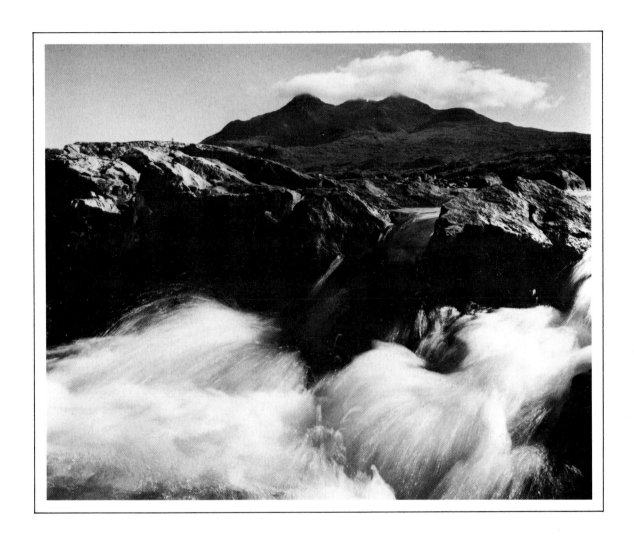

The steeply receding perspective that is evident in the picture opposite is often referred to as 'wide-angle perspective', but this is a misnomer. In reality, it is the short distance between the camera and foreground subject that creates the sharp perspective recession. The lens in use simply alters the field of view, as these three pictures show: the perspective of the centre of the image does not change even when the 20mm lens is changed for a standard lens, or a 200mm.

Direct sunlight brought out texture in the harbour stonework, and put brilliant highlights on the polished metal of the bollard.

A polarizer would have deepened the hues of the ship's hull and the sky, but it would also have killed reflections from the bollard, and given it a velvety, dull texture – so no filter was used.

Camera:	**Metering:**
35mm SLR	Hand-held incident light-meter reading
Lens:	
28mm	**Filter:**
Film:	—
ISO 64 colour	**Lighting:**
transparency	Natural

20mm

50mm

200mm

Composition This massive cast-iron bollard caught the photographer's eye while he was exploring a dockside. The pure functionality of the structure – its obvious strength, its shape, and the chain wrapped round it – made it a promising picture subject. The metal had been polished by countless hawsers and chains, giving it a burnished texture that added to its visual potential.

To give a sense of the mass of the bollard, the photographer chose a viewpoint very close to it, and low down. A close approach always exaggerates perspective, so that the foreground dominates the scene, and background details seem to shrink in relative size.

Moving round the bollard, the photographer looked for a suitable background with which to juxtapose it. The ship was an ideal choice – not just because of its apparently literal connection with the

bollard, but because the two objects were roughly the same size in the viewfinder.

Juxtaposed as equals in this way, the two picture elements appear to pull against each other in the frame, generating a visual tension that matches the supposed physical tension in the chain links.

Technique To include both bollard and ship in the picture, the photographer had to use a wide-angle lens – a standard lens would have shown just a small portion of the chain or the bollard.

The bollard was about half a metre (a couple of feet) from the camera, whereas the ship was effectively at infinity. This wide separation stretched even the extensive depth of field of the 28mm lens chosen and only by stopping down to the minimum aperture was it possible to hold detail from foreground to background.

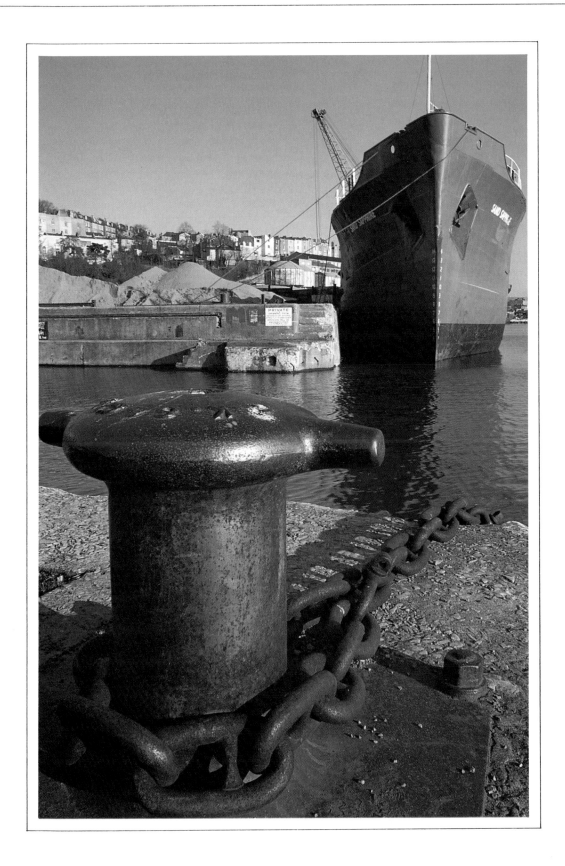

The flat grey sky added little to the picture, so it seemed sensible to compose the picture with a high horizon.

A meter reading from the brightest highlight – the snow – provided the starting point for exposure estimation. Adjusting the camera to the settings indicated would have recorded the snow as grey, so the photographer allowed two stops more than suggested by the meter to make the snow appear white.

An 81B filter eliminated the blue colour cast that often mars snowscapes.

Camera: 35mm SLR	**Metering:** TTL, highlight reading
Lens: 105mm telephoto	**Filter:** 81B
Film: ISO 50 colour transparency	**Lighting:** Natural

In dull weather, sky and snow-covered land can seem to blend together at the horizon. So it's best to exclude the sky, as in the main picture, or look for a way of separating them.

Composition Nothing highlights the patterns and textures of landscape better than a fall of snow. Driven by the wind, it collects under walls and in hollows, and blows off high points. Thus the contours and details of the countryside stand out as clearly as a steel engraving.

Here the photographer has used snow's revealing effect to full advantage. He chose a viewpoint looking north across a shallow river valley, so the background is formed by a distant south-facing hillside. Struck by the sun, the snow on the hill has partly thawed, revealing the darker ground beneath. Since atmospheric perspective tends to make the distance look paler, this choice of dark background gives the illusion of greater clarity and distance. A snow-covered hill would have looked less effective, as seen in the small picture.

In the mid-distance the snow is carved up into a jigsaw puzzle of irregular shapes. The composition, though, is dominated by the horseshoe loop of the river. The broadness and generously meandering habit of the river contrasts with the geometrically straight, narrow lines of the stone walls, just as a flowing brushmark in an ink drawing makes a welcome change from the spindly lines of a steel nib pen.

The photographer tilted the camera down for the picture, so that the horizon barely appears. By

doing so, he was able to fill the foreground with a stone wall, and, more important, to include a figure. Like us, she looks out across the valley, and provides a valuable sense of scale. She also supplies the only patch of colour. Her red hat (lent by the photographer for the picture) springs out towards the camera, repeatedly drawing the eye back to the human element of the scene.

Technique To frame all the elements listed above as he wanted them, the photographer experimented with focal length and viewpoint. His first idea was to use a wide-angle lens, and move close to the stile. This made the figure too prominent, though, and after exploring a couple of other alternatives, he walked some distance back up the wall, and fitted a 105mm telephoto lens to the camera. From a more distant viewpoint, the lens compressed the scene, bringing foreground, middle-ground and background closer together. Stopped down to f/11, the lens had just enough depth of field to keep the whole scene sharp.

In the dull winter light, this aperture meant using a shutter speed of just 1/15, so the photographer squatted down in the snow, bracing his back against a wall, and resting the lens on his knee. This makeshift arrangement provided just enough support to eliminate camera-shake.

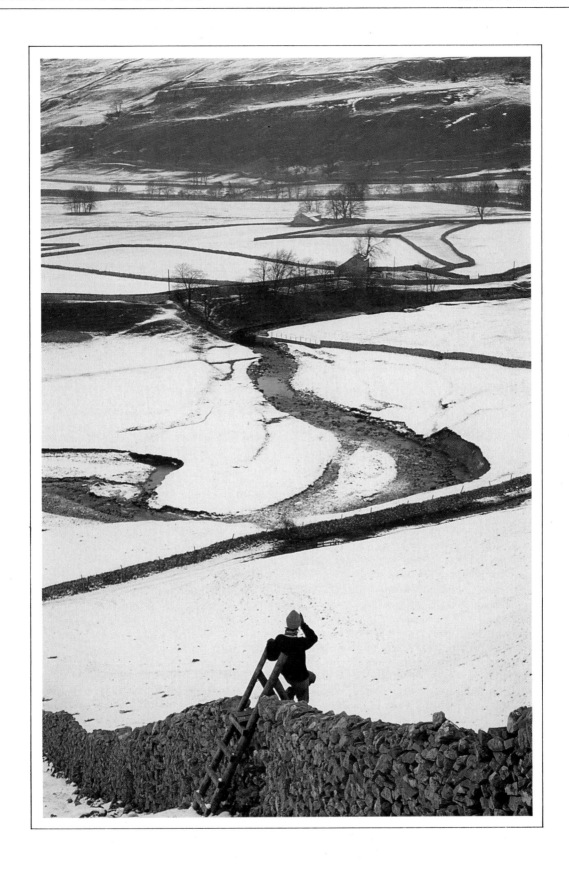

A polarizing filter darkened the blue sky, so that the clouds appear brighter and fluffier.

Trees, too, appear greener with a polarizing filter.

Waiting until shadows fell on the foreground, and the sun lit the background, reinforced the ecological message.

Camera:
Rollfilm rangefinder

Lens:
100mm (standard)

Film:
ISO 64 colour transparency

Metering:
Incident reading from hand-held meter

Filter:
Polarizer

Lighting:
Natural

A clip test can help you to fine-tune exposure. From the end of the roll, the lab clips a shot length of film, and processes it in advance of the rest of the roll. Based on density of this test, you (or the lab) can judge whether the film was correctly exposed. If it was not, pushing or pulling – cutting or prolonging the first processing step – will trim the density of the film to the optimum level. If you plan a clip test, remember to expose the whole roll at one setting, and shoot unimportant frames at one end of the roll. Let the lab know which end to clip.

Composition This field excited in the photographer contradictory emotions: on a visual level, the gently undulating field, the wooded hill beyond and the sky above made a pattern of fascinating graphic shapes; but on the other hand he was struck by the resemblance of the rolled chalk soil to windswept dunes.

The graphic qualities of the scene were enhanced by choosing a frontal view of the row of wooded hills. Swinging the camera round would have given the scene more depth – with the line of trees converging towards the horizon, and the more distant ones very much smaller than those close by. The head-on viewpoint chosen makes the most of the stripes of colour and pattern.

To emphasize the desert-like quality of the field stripped of hedgerows and trees, the photographer decided to highlight the one remaining wilderness in the scene. This was a pit in the centre of the field, which was too deep to be ploughed. The decaying fence around the weed-filled hole serves to reiterate the archaic characteristics of traditional farming methods.

The rapidly moving clouds were a lucky bonus; the photographer waited until their shadows dappled the chalk below. Their fluffy pattern put the final touches to an image that, by juxtaposition, summarizes modern, intensively farmed fields – sometimes severely beautiful, but nevertheless essentially sterile.

Technique Equipment was simple – a tripod-mounted camera and a standard lens, with a polarizing filter fitted to enrich the colours. An incident light meter indicated an exposure of 1/60 at f/16, and with a static subject this would have formed the starting point for a series of bracketed exposures. However, with moving subjects, bracketing is risky because there is a strong chance that the subject will look its best in a picture that is wrongly exposed.

So, instead of bracketing, the photographer exposed all of the film at a single setting, and ran a clip test, as explained above. He judged from this that exposure had been 1/2 a stop too generous, and the laboratory compensated for this in processing.

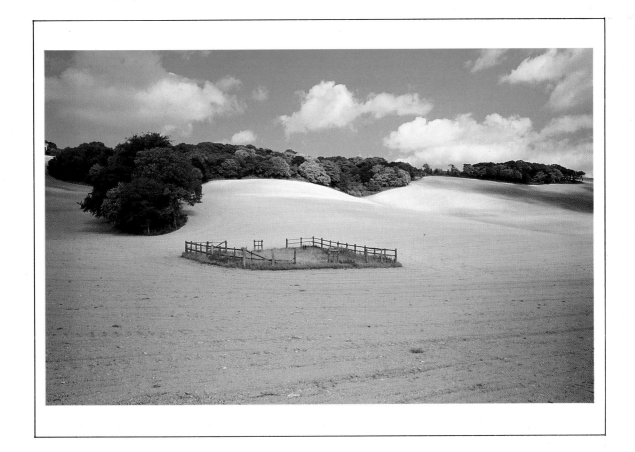

ACTION AND PERFORMANCE

In the pages that follow you'll see pictures of a diversity of subjects from the world of sports, action and performance. And, as you'll learn when you read on, the techniques used in taking them are as varied as the subjects themselves. One essential skill, though, unites all of these pictures, and if you fail to master it, then your efforts to emulate other action techniques will be wasted. The one vital skill, of course, is timing.

The photographers who took the pictures in this chapter spend most of their working days practising this skill, and honing their sense of timing to a fine edge. Through constant repetition, they know just how far the subject will move between the time when they press the shutter release, and the instant when the narrow slit in the camera's shutter begins its speedy travel across the film.

To succeed in action photography then, first practise this sense of timing and anticipation. You don't need to attend an Olympic sports meeting to develop and improve this skill. A local road race provides ample opportunities for you to pit your wits and reactions against the inexorable march of time. The pictures you take needn't be just dry exercises, either. If you can learn to create images that hum with speed and movement, they'll be impressive, exciting pictures, whether they were taken on a slalom course in Aspen, or like the one opposite, on the local snow-covered hill.

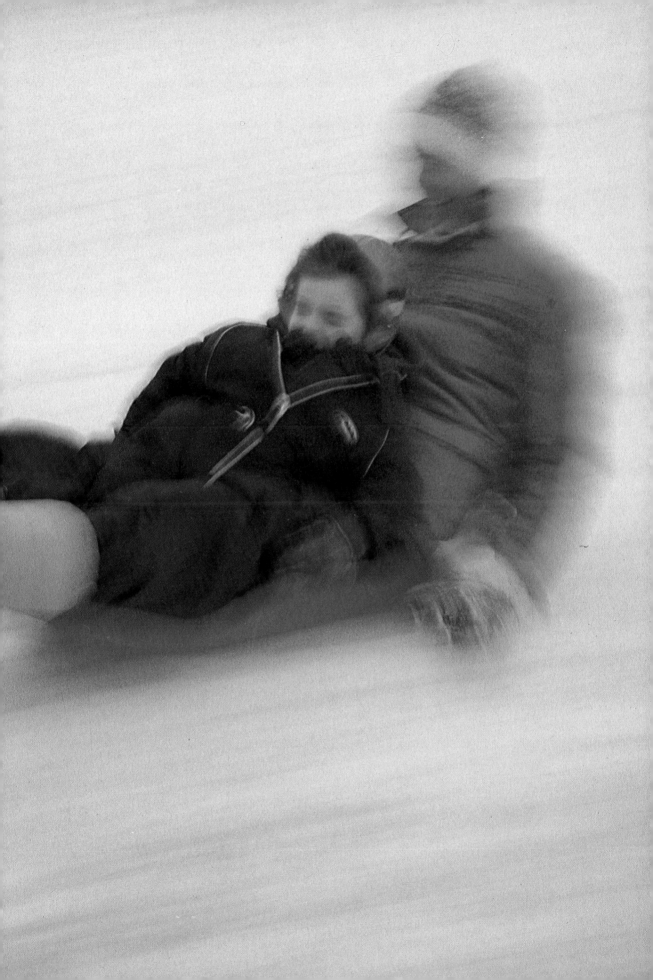

Black and white film added drama and graphic impact to the scene.

Red filtration darkened the sky – an effect that was increased by burning in this area during printing.

The photographer took a meter reading from this sunlit area of paving, so that it appears middle grey in the print.

Camera:	**Metering:**
35mm SLR	TTL
Lens:	**Filter:**
16mm fisheye	Red
Film:	**Lighting:**
ISO 125 black and white	Natural

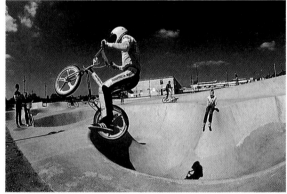

With the sun behind him, the photographer got more detailed, descriptive pictures, but they lack the drama of the backlit image shown opposite.

Composition Frozen in space and time, a young cyclist forms a stark silhouette. The sun hides identity and detail, generalizing the subject, and by forming a silhouette, the photographer makes it clear that we are looking not at a specific competitor – in this photograph one cyclist stands for all BMX riders. The sun, too, plays a symbolic role, acting as a metaphor for energy, vigour and youth.

By shooting towards the sun, the photographer also ensured that shadows of the boy and bike were clearly visible in the foreground of the picture. So, when the bike left the ground, the shadow and wheel separated, and the gap between them is clearly visible on film. Frontal lighting would have thrown shadows away from the camera, making the gravity-defying surge of energy less obvious.

Geometrically, the composition is carefully executed, with the sun placed at the intersection of the thirds at the top of the frame, and the horizon dividing the frame a third of the way up.

Technique Besides being aesthetically satisfying, the composition solved a purely practical problem: the ill-drained cycle park was punctuated with pools of water in which rubbish floated. By picking a low viewpoint, and pointing the camera into the sun, the photographer hid the prosaic and unappealing surroundings.

His choice of exposure settings was made for similarly practical reasons. Not only did the silhouette make the figure anonymous, it also allowed the photographer to choose a fast shutter speed – $1/2000$ – which froze all motion. Depth of field was not a problem, because even at full aperture, the extreme wide-angle lens kept most of the scene in focus.

The cooperation of the cyclists was vital, so the photographer chatted to them before setting up the camera, explaining what sort of picture he wanted. They then made repeated runs over the same course while he took pictures.

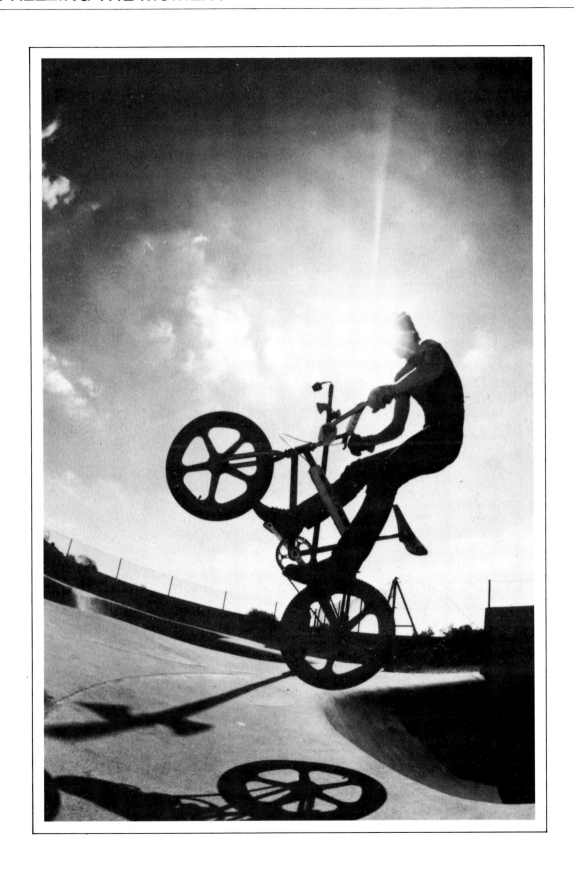

Slight underexposure enhanced the colours in the scene – the photographer habitually rates his ISO 64 film at 80.

Stopping the lens down to f/8 would have provided more depth of field, making focusing easier. However, to maintain exposure, the photographer would then have to use a slower shutter speed, and this in turn would have introduced the risk of movement blurring the figure. The settings chosen were a compromise of these two factors.

Flying snow, caught in mid-air, enhances the impression of speed and excitement.

Camera: 35mm SLR	**Metering:** TTL, substitute reading
Lens: 300mm	**Filter:** —
Film: ISO 64 colour transparency	**Lighting:** Natural

Composition A still camera can never really make a true record of fast-paced action in the way that a ciné or video camera can; at best the still photographer can *suggest* movement. One way of doing this is by blurring the subject through the use of slow shutter speed, but this approach yields a picture which, though evocative, lacks detail. For the image shown here, the photographer chose the alternative, and used a fast shutter speed to arrest all movement.

There is an element of risk in this approach, because the result all too often looks like a cardboard cut-out, static and lifeless. Here, though, the photographer has avoided this pitfall through impeccable timing, and well-thought-out composition. To give the image a sense of downward movement, he boldly chose a vertical format for the picture, despite the fact that this prevented him from including the ends of the woman's skis.

Choice of a low viewpoint further enhances the sense of speed and action. The figure appears to tower above us, as if she is about to come crashing towards the camera. Most crucial of all, though, is the posture of the figure. Timing was obviously the major factor in catching the woman at the precise moment when her every muscle seems to be urging the skis forward. However, the photographer's choice of camera position was equally important.

He picked a point where the slalom course both turned and ran over a bump, so that the skiers had to use their skills to the full to avoid losing time on the turn.

Technique Since this picture was taken at a slalom competition, predicting the positions of the skiers was relatively simple – competitors took each turn at more or less the same point. The photographer picked the most suitable turn as explained above, and set up his camera on a monopod nearly 46 metres (some 50 yards) away. He fitted a 300mm lens so that the figures would fill the frame, and carefully adjusted the height of the monopod so that the outstretched arms of the skiers divided snow from sky in the middle of the frame.

The contrasts in the scene were high, and the figures moved too quickly to get a reliable light-meter reading from them, so the photographer took a substitute reading from a face in the crowd. Setting the camera to manual, he shot at ⅟₅₀₀ at f/8.

Instead of trying to shift focus to follow the skiers as they approached, he focused on the lip of snow near the flag round which they turned, pressing the shutter release just after the ski-tips appeared sharp on the focusing screen. As the shutter opened, the skier's body had moved into the precise position of sharp focus.

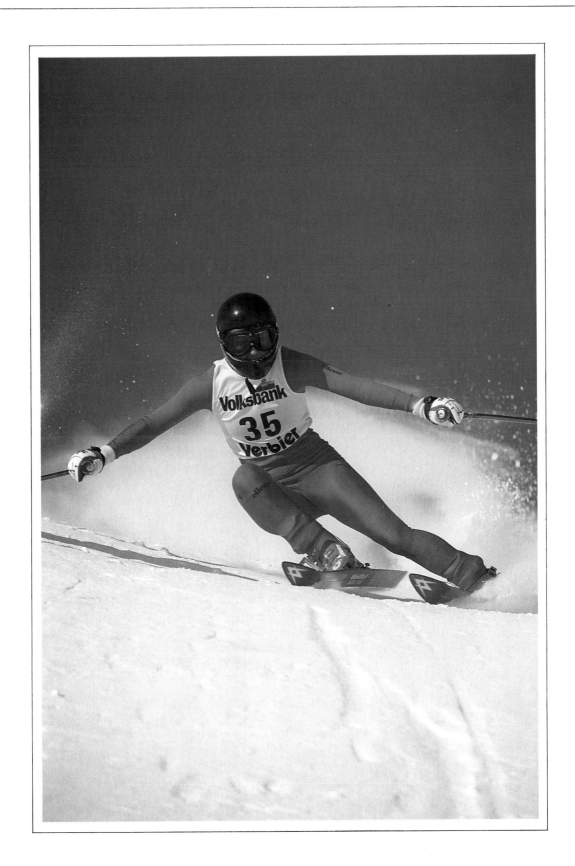

Pushing the film led to a characteristically lowered maximum density in the transparency, making the shadows appear weak or 'smoky'.

Highlights are also affected by pushing the film, losing a certain amount of detail. The alternative to this contrast increase, though, would have been no picture at all.

Shallow depth of field threw other performers well out of focus, concentrating attention on the lead singer.

Camera: 35mm SLR	**Metering:** TTL
Lens: 105mm f/3.5	**Filter:** —
Film: ISO 160 colour transparency, rated at EI 320	**Lighting:** Tungsten stage lighting

Composition In photographing a musician, the photographer's objective is generally to produce an image that is a synthesis of the performer, the musical work, and the instrument on which they are performing. Put more prosaically, an 'artiste and instrument' picture.

Some musicians present few problems; with a saxophonist, for example, the thrust of both the figure and the musical instrument are essentially vertical. Guitarists – and pianists, for that matter – are more difficult, because the performer and the instrument pull in opposite directions.

The photographer resolved the problem by catching the performer in a pose that brought his guitar up almost vertical, creating a dynamic, active image that vividly conjures up the atmosphere of a live stage performance. He had noticed the singer stand close to the microphone and rest his hand on the upward-pointing neck of the guitar a couple of moments earlier in the performance, and it occurred to him that if the action was repeated, it would provide a good opportunity to frame both the guitar and its player in a fairly tight composition. Generally, this type of picture is a compromise: either a horizontal format, which crops the figure at the waist; or a vertical, which loses the machine head of the guitar. Holding the

camera vertically, the photographer had only to wait his moment. The composition also benefits from the low viewpoint: this isolates the performer from the clutter on the stage behind him, making a strong pattern and emphasizing the picture's linear structure.

Technique The picture was shot from the stalls at a public performance – the photographer had no special permission. He used film balanced for tungsten light, pushing it one stop to cope with the dim conditions. In order to get such a tight crop from his position in the audience, he used a 105mm lens, setting it to its maximum aperture in order to make the most of the little light that there was in the theatre.

To set exposure, the photographer used the camera's TTL meter. This had a strongly centre-weighted sensitivity pattern, and, earlier in the performance, he positioned the central area over the performer's face and took a reading, setting the camera manually to the shutter speed and aperture indicated. He knew that the stage lights had only a limited number of configurations, and reasoned that when the lead singer was once more spotlit, the same aperture and shutter speed would yield the correct exposure. He guessed right.

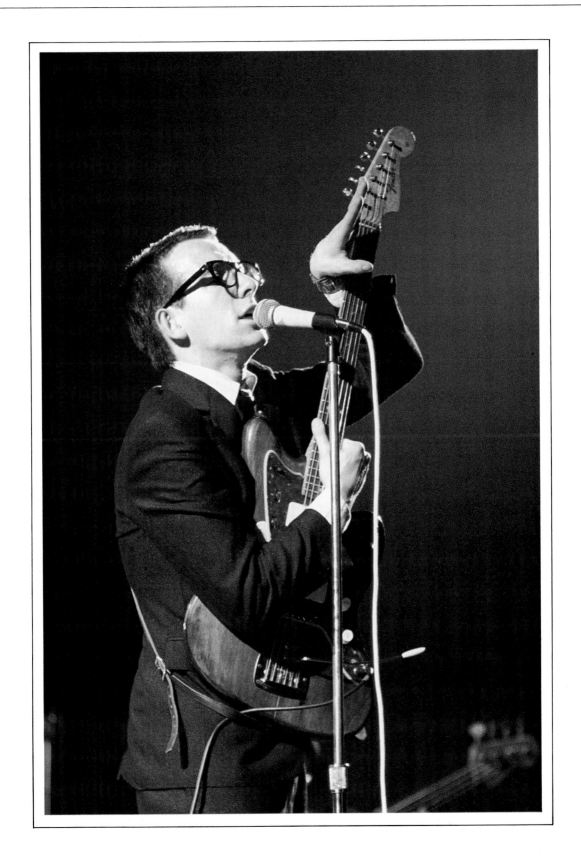

A popular alternative camera anchorage point on hang-gliders is directly in front of the pilot. However, the pilot cannot look at the camera when it is mounted in this position, so in-flight portraits are impossible. Wing-tip mounted cameras, on the other hand, are in the pilot's field of view.

A 16mm fisheye lens produced the curving horizon line which echoes the swirling circular lines on the ground below. There was another reason for choosing the lens, too – its 137° field of view included a broad sweep of the glider's colourful wing.

Fisheye lenses distort only tangential lines, not radial ones, so cross-bars that pass through the centre of the picture appear straight.

To provide a sense of distance, and a focus for the swirling circles, the photographer asked the pilot to bank above buildings and vehicles, rather than unbroken stretches of grass.

Camera:
35mm SLR with motor-drive

Lens:
16mm full-frame fisheye

Film:
ISO 64 colour transparency, rated at 80

Metering:
TTL automatic

Filter:
—

Lighting:
Natural

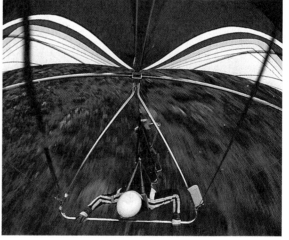

Composition The dizzying, vertiginous swirl of the ground beneath this hang-glider vividly evokes the sensation of soaring like a bird, high above the landscape. The photographer's role in taking the picture, though, was almost vicarious – he watched from below, and the pilot himself pressed the shutter release.

The composition was, nevertheless, conceived and stage-managed by the photographer. He asked the pilot to circle around a pre-arranged point on the ground, banking the craft steeply to make a tight loop. It was this circular motion that created the swirling lines in the picture on the right.

Turning the picture 90° clockwise highlights the giddy feeling that the picture generates. Anyone who has flown is familiar with the compelling sensation of the ground tilting whenever the craft banks. However, a photograph supplies information only to the eyes, not to the stomach and the other sensors of balance, so here the tilted horizon generates a sickening sensation of plummeting like Icarus to the ground.

Technique The camera, a motor-driven 35mm SLR, was fixed at the extreme end of one of the aircraft's wings using an off-the-shelf camera clamp, and carefully positioned with a ball and socket head. The photographer then ran a long cable from the contacts on the motor-drive to a push button on the control-bar gripped by the pilot. A rock, of about the same weight as all the photographic apparatus, fixed to the opposite wing with heavy-duty adhesive tape ensured that the equilibrium of the glider was maintained.

To achieve the required degree of movement in the picture, the photographer set quite a small aperture – f/16. A quick meter reading from the ground then confirmed that the automatic camera would set the shutter speed to ⅛ for correct exposure with the ISO 64 film in use.

Focusing was simple – the photographer just focused the camera on the pilot. Set to such a small aperture, depth of field of the extreme wide-angle lens extended from infinity to several centimetres from the lens.

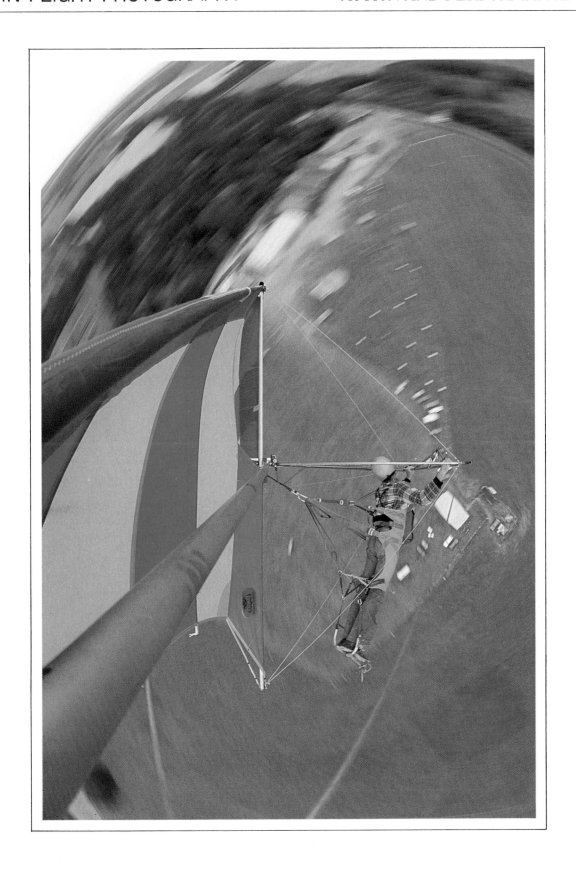

From a more oblique viewpoint, the balloons are immediately identifiable – and so the picture is less surprising.

Parked cars provide the first clues as to what the picture represents.

Areas that are totally in shadow lack the jagged shapes that make the sunlit part of the scene so interesting, and give a hint of how unsuccessful the picture would have been before dawn.

The dark sand forms a neutral background that does not distract from the shapes of the shadows and the colours of the balloons.

Depth of field was not a consideration, because the whole subject area was effectively at infinity. So the photographer set the lens to its full aperture, enabling him to choose the fastest possible shutter speed and thus reduce the risk of camera-shake.

Camera:	**Metering:**
35mm SLR	Substitute reading (TTL)
Lens:	**Filter:**
180mm	—
Film:	**Lighting:**
ISO 64 colour	Natural
transparency	

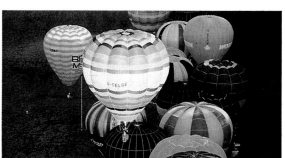

Composition Pictures from the air are conventionally taken obliquely, rather than vertically downwards. There is a good reason for this: straight-down views tend to disguise most subjects on the ground, so that the earth becomes a pattern, with few recognizable features.

Information in a picture isn't always a priority, though. Often impact is more important. This balloon meet, for example, has been described as '... the second most photographed event in America', so here the challenge was not so much to inform the viewer, but to find a way of making an original and interesting picture from a relatively hackneyed subject.

The photographer knew that the sun would cast long, matchstick-like shadows as it rose – but he also knew that the shadows would shrink to more familiar proportions within minutes of dawn. So he hitched a lift from one of the first balloons to ascend, and had his camera ready as the first rays of daylight slanted across the scene.

The vertical view down shears baskets from balloons, so that we see only coloured globes, with no sense of distance or size. The long shadows complete the process of disorientation, so that – far from being a cliché – the scene becomes momentarily unrecognizable, and merits a second and third glance from the viewer.

Technique The photographer took the picture with a 180mm lens. He wanted to show just the tops of the balloons, and a shorter focal length would have revealed too much of their sides and baskets. The angle of view of this short telephoto is 14°, so even at the extreme corners of the frame the camera 'sees' the balloons from an angle only about 7° off the vertical. A longer lens would have been even better – but would have been difficult to hold steady in the swaying gondola.

A meter reading from the dark-toned ground would have produced underexposure. So, instead, the photographer based the exposure setting on the area in which he wanted to retain most detail and colour – the balloons themselves. To this end he took a TTL meter reading from the sunlit fabric of a passing balloon, and adjusted the camera's controls manually to the indicated settings for the image shown here.

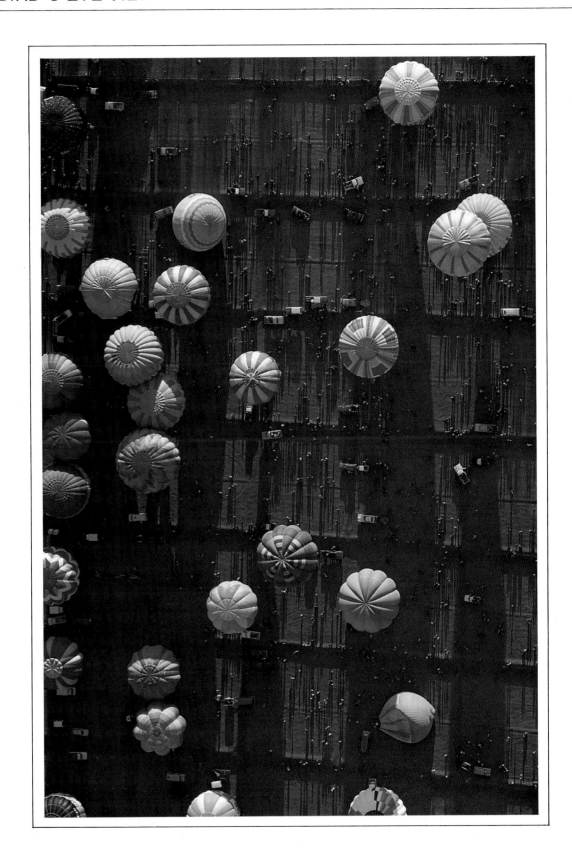

Dull lighting meant that contrast was low, so exposure setting was not critical. The photographer first set the shutter speed he estimated would give best results, then used the TTL meter to determine the correct aperture.

Taking pictures at a range of shutter speeds ensured that there was a choice of several different degrees of blurring.

As with any panned image, a background darker than the subject was essential. Against the light sky, the outline of the car would have seemed 'eaten away' at the edges.

Camera: 35mm SLR	**Metering:** TTL
Lens: 24mm	**Filter:** 81B
Film: ISO 64 colour transparency	**Lighting:** Natural

To pan the camera, first prefocus on the spot where the subject will be when you press the shutter release. Then frame the approaching subject when it appears, but resist the temptation to refocus. Follow the motion as smoothly as possible, pivoting at the waist, and press the shutter release when the subject has reached the point you chose. Keep the camera moving and follow through when the shutter closes again.

Composition Modern Formula I racing cars hurtle along at hundreds of kilometres an hour, but the pace of a vintage car is somewhat more sedate. In making this picture of such a car, the photographer was seeking to put back some of the excitement that motorists must have felt when the horse and trap was a more common means of transport, and the most likely reaction of spectators on the kerb was terror and shock at the sleek green machine.

He picked a stretch of the course where he could climb up high above the road to look down on to the car, and where the background featured some detail and texture, but was not crowded with spectators. He especially sought to exclude evidence of the modern world, such as telephone boxes, opposite the camera.

Blurring concealed much of the detail in the passing cars, but this vehicle was an especially appropriate choice of subject because all its occupants were wearing clothes in keeping with the date of the car. Additionally, the two splashes of red – the hat and the box on the running board – provided a welcome contrast with the otherwise drab tones of the car and background.

The position of the car in the frame was difficult to control, so the photographer framed the image as a generously spaced horizontal, cropping out irrelevant details later.

Technique The streaks of speed across the frame were produced by panning the camera – turning it to follow the vehicle as it passed. Panning is a technique most commonly used when an object is crossing the frame too rapidly to be stopped by even the faster shutter speed of a stationary camera. In that context, the panning slows or arrests the relative motion of film and image, so that the subject appears absolutely sharp.

When the camera is set to a slower shutter speed ($\frac{1}{15}$ in this instance), the effect is rather different. Both subject and background appear blurred, but the background much more so. The photographer added an extra twist by using a wide-angle lens, and standing about 11 metres (12 yards) from the subject. As a result, the swirling lines of motion rush past not in straight and parallel lines, but in wide, curving arcs that evoke a sense of speed even more effectively.

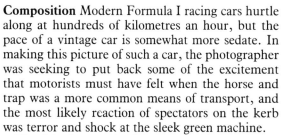

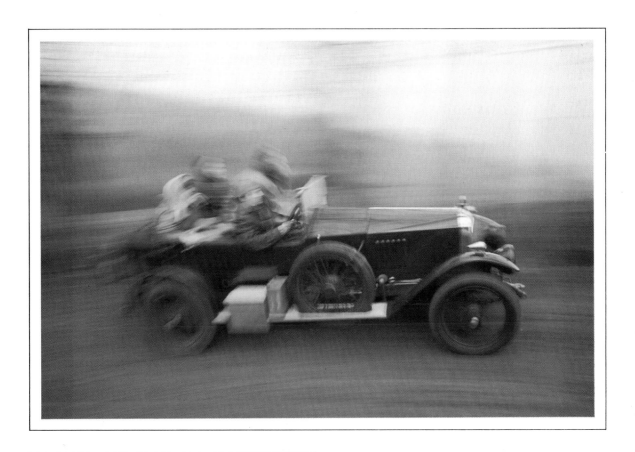

Telling close-ups showing details of the cars provide hard-edged information lacking in the more subjective picture above.

The sunny weather created harsh contrasts, so the photographer took a meter reading from the sea 'and bracketed wildly' to be sure of getting a correctly exposed picture.

The spider's web of lines could easily have made a confused picture, but the photographer prevented this by using the three dominant horizontal lines – the two booms and the horizon – to divide the frame almost exactly into thirds.

Using a mountaineer's carabiner and harness, the photographer clipped himself on to the rigging.

Despite the use of a lens hood, sunlight catching the front element of the lens created this flare spot.

Camera:	**Metering:**
35mm SLR	TTL substitute reading, bracketed
Lens:	
15mm wide-angle	**Filter:**
Film:	—
ISO 64 colour	**Lighting:**
transparency	Natural

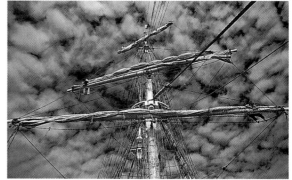

A view upwards from the deck shows a broader general view of the mast, spars and rigging, but gives little indication of the dizzying challenge of the task of reefing the sails.

Composition How do you simulate in a photograph the heady experience of reefing the sails on a tall ship? As the picture on this page shows, not by standing on the deck and pointing the camera upwards! To make the much more exciting image reproduced opposite, the photographer scrambled up the ratlines behind the able seaman to whom the task had been delegated, and perched in the rigging with his camera.

He had a restricted choice of viewpoint: he could move up and down the mast, or out along the boom, but not fore and aft. He eventually opted for the relative security of the mast, climbing a little higher than the boom. This enabled him to point the camera downwards, and thereby show the sheer drop to the deck below. The downward-looking camera angle also included the surging bow-wave which gives some indication of the speed at which the ship is cutting through the waves. Without seeing this foaming wake, one might imagine the ship was anchored; with it, the wind and salt-spray become almost tangible.

Technique The restrictions on viewpoint meant that a wide-angle lens was a prerequisite. The photographer took a choice of several up the mast with him, but used the shortest focal length available for this image. The 15mm lens he picked is a rectilinear lens, not a fisheye, so the spars and the horizon line appear straight on film (a fisheye would have made them curved). The principal motive for using such an extreme wide-angle was that its broad field of view (100°) included both the horizon, and a dizzying glance downwards. The extreme wide-angle lens created a distortion of the figure that would have been totally unacceptable in a portrait – but here the foreshortening helps to impart the drama.

The crew-member was very close to the camera, and though depth of field of the lens even at full aperture is very broad, the photographer still had to stop down to f/11 to keep the whole picture sharp. This meant using a shutter speed of 1/125: only just fast enough to prevent camera-shake and subject movement.

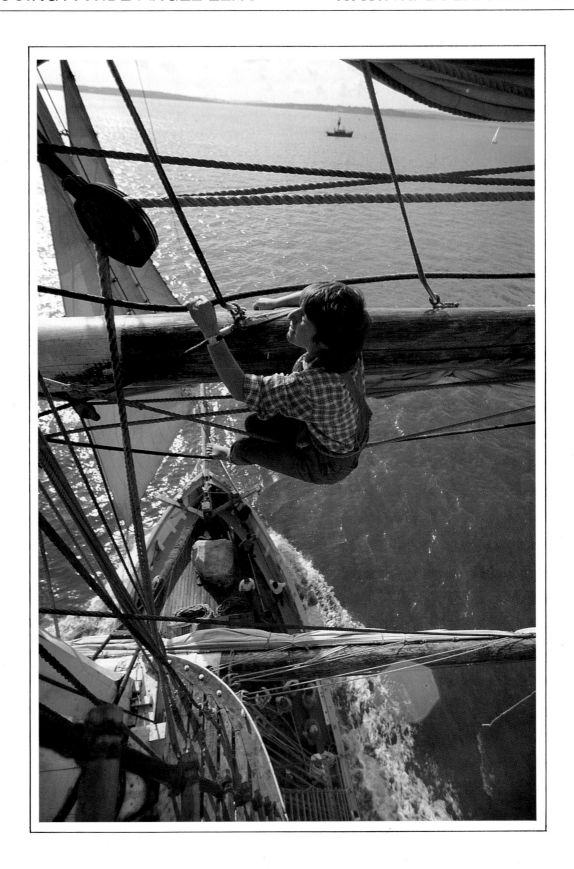

Gels over most of the lights tinted most of the scene a warm pink.

The high lighting contrast and the uprating of the film concealed stageside distractions in deep shadow.

Pushing the film – prolonging development – increased grain size, but in an image as subjective as this, such technical considerations are of lesser importance than the general atmosphere.

Only the principal figure appears in natural colour, because a white follow-spot was trained on him.

Camera:	Metering:
35mm SLR	TTL
Lens:	**Filter:**
200mm f/4	—
Film:	**Lighting:**
Tungsten-light-balanced ISO 160 colour transparency, rated at 640	Tungsten spots

A view of the whole stage perhaps gives a more accurate record of the production and setting, but does not suggest the atmosphere of the opera nearly so effectively as the tightly cropped image on the opposite page.

Composition Shooting good expressive pictures of the performing arts is a tremendous challenge. Photography is often prohibited at the performance, and permitted only at rehearsal, where lighting and staging bear little resemblance to final production and prosaic pieces of equipment litter the stage. Additionally, there is the perennial problem of making a single picture that expresses the spirit of the whole narrative.

The production pictured here is a full dress rehearsal of an opera entitled *The Elixir of Love*. The theme of this is a popular one – of a young man who buys a potion to make his romantic affairs run as he wishes them to. Though the entire plot cannot be judged from the picture, the photographer has succeeded in conveying eloquently the spirit and atmosphere of the opera, and of the pivotal scenes. He waited until the principal character was clutching at the bottle of elixir, literally drunk with love, and composed the picture so that the frame was bursting with figures. He had seen the production in earlier rehearsals, and knew that at this point the women in the village square turn their back on the man, laughing at his foolishness. His face is thus the only one clearly

visible, which sorts out and simplifies what would otherwise be a very confused image.

The movement that is visible in the picture fulfils two important functions. It conceals the small details that are not quite right in rehearsal; but more important, it turns the image into a tremendously powerful evocation of reeling drunkenness and excitement.

Technique Dim lighting dictates the use of fast or pushed tungsten-balanced film for stage pictures. Here the camera was loaded with ISO 160 film, pushed two stops to EI 640. Nevertheless, the camera's TTL meter responded feebly to the ambient light, indicating only ⅛ at the full aperture of the lens. The photographer knew that there would be a risk of subject movement and camera-shake, but, lacking faster lenses or film, had little alternative but to hope for the best. He also knew from experience that an image blurred by subject movement is not always inferior to one that is pin-sharp. That this picture works so well confirms his decision to carry on shooting.

Tripods were not permitted – the camera was hand-held from a position in the stalls.

Sunlit portions of background detail provide just enough information for us to recognize a fellow canoeist waiting by the bank.

Framing the canoe against a shady area ensured that the flying spray appeared brilliantly white by contrast.

The canoeist's open-mouthed expression suggests the shock of cold water on skin.

Camera:	Metering:
35mm SLR	TTL
Lens:	**Filter:**
300mm	—
Film:	**Lighting:**
ISO 64 colour transparency	Natural

This humorous image was a grab shot – a good opportunity seen and seized.

Composition It is easy to forget that not all sports are contests to decide winners and losers; non-competitive sports can be as photogenic as those in which rivals vie for the lead. The subject of this picture is one such event – a canoe expedition.

The picture was taken as the canoeists circled in a relatively calm part of the river, before descending the next section of rapids. The photographer, therefore, had numerous opportunities to catch them making turns and leaning on their paddles, as opposed to the 'one-chance' situation epitomized by his skiing picture on page 113.

He chose a camera angle that looked into the light. Although this put the canoeist's face in shadow, it created backlighting, so that the water splashing over the prow of the hull caught and refracted the light. The same surge of spray reflected some light, too, so that the man's face is not totally without detail.

This image in some respects falls between two stools: it is not tightly cropped enough to be a portrait, and not wide enough to show the craft and paddles as a whole. Nevertheless, it is redolent with the adrenalin of controlling a tiny, fragile canoe in a massive river.

Technique 'Freezing' the splashing water was a priority, so the photographer set a shutter speed of 1/1000. He exposed for the sunlit areas of the figures, turning the camera to take a meter reading at a point in their circuits where the sun hit them full-on. The meter indicated an aperture of about f/5.6, and he set this and the shutter speed manually.

Because the canoeists' actions were cyclical, following focus was a practical proposition – though for a few of his pictures, the photographer prefocused on one of the standing waves in the pool, and took pictures as the craft, one by one, reached the crest.

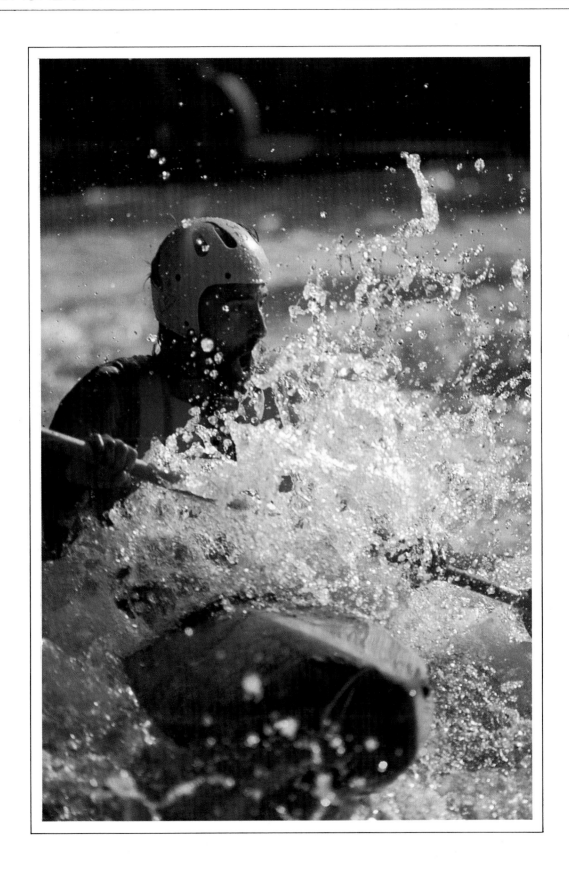

Dim light forced the photographer to use his high-speed lens at full aperture, so depth of field is only a metre (yard) or so. Fortuitously, this turned the clothing of spectators into attractive blotches of colour, rather than identifiable and distracting background elements.

By picking a head-on view, the photographer was able to freeze movement at quite a slow shutter speed. If the runner had been crossing the frame, a far faster speed would have been needed.

The photographer prefocused on these cobbles, and pressed the shutter release just as the runner reached them.

Camera:	**Metering:**
35mm SLR	Substitute reading from
Lens:	palm, compensated
300mm f/2.8	**Filter:**
Film:	—
ISO 64 colour	**Lighting:**
transparency	Natural

Composition Marathon races provide photographers, whether amateur or professional, with numerous opportunities for great pictures. The course covers public roads, and a map is always published before the race, so there's a chance to scout good viewpoints.

This picture was taken near the photographer's home, but he did not pick the location simply because it was convenient. He knew that, since this spot was close to the end of the course, the runners would be showing the strain. The road was shaded by high warehouses at this point (in marked contrast to the brilliant sunlight on the rest of the course) so the lighting was sombre and low-key, which suited the mood that the photographer had in mind for the picture.

He chose to photograph the runners where they crossed a section of cobbled road, since this provides a more interesting foreground than the featureless black of tarmac. To add some texture and interest to the background, he framed the picture so as to include a section of the crowd and a pattern of shadows on a distant building – knowing that these would be too blurred to distract attention from the main subject.

Since these were to be 'human interest' pictures, rather than portraits of specific competitors, choice of which runner to photograph was unrestricted. This man was chosen because he had the characteristic frame of a distance runner – wiry but powerful

– and because his red shorts formed a splash of bright colour against the grey background.

Final adjustments to the framing of the picture ensured that other runners appeared behind the main subject, suggesting the spirit of competition, and reminding the viewer that if this man flags, he will soon be overtaken and forgotten.

Technique The photographer set up his camera on a tripod at a bend in the course, prefocusing a 300mm lens at a point on the line that most of the runners seemed to be following. To allow for last-minute changes in composition, the photographer left the locks on the tripod's pan-and-tilt head slightly slack.

Setting the camera to manual, he took a meter reading from the palm of his hand. This indicated an exposure of $^1/_{250}$ at f/2.8 – the full aperture of the lens. However, when this black competitor came into view, the photographer rapidly changed the shutter speed to $^1/_{125}$ to compensate for the difference in tone between his palm and the man's dark face.

Faster film would have made the picture easier to take: at a smaller aperture focusing would have been less critical; and a faster shutter speed would have reduced the risk of subject movement spoiling the picture. However, faster film would have produced a picture with poorer definition and more pronounced grain.

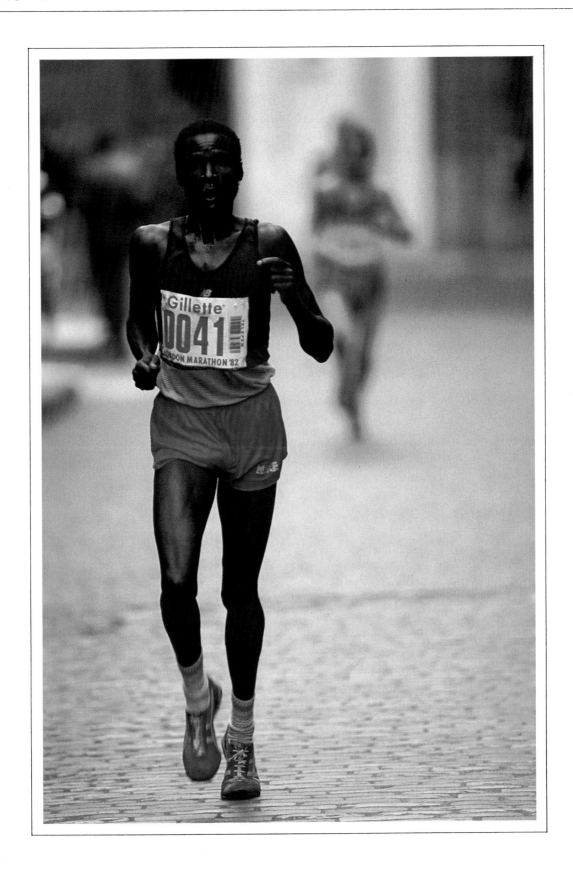

NATURE AND WILDLIFE

Before the advent of photography, the natural history illustrator was charged with the responsibility of documenting nature's bounty so that it could be catalogued, classified and understood. The invention of the camera provided a new and better way of doing this, and, even today, much nature and wildlife photography still follows in the traditions of botanical and zoological illustration.

The fact that pictures in this section delight the eye is therefore of secondary importance; the crucial matter is to record the specimen as accurately and as clearly as possible, and in a setting or posture that is typical for the species. The image opposite exemplifies this approach. It is a black-winged stilt, which the photographer took pains to photograph in its natural habitat, against the plainest possible background, and in a pose that displays both its characteristic coloration and outline. From the other examples that follow, you'll pick up hints that will enable you to get frame-filling studies like these – even if you are photographing subjects a little nearer home than those illustrated.

Nature studies need not be so objective, of course. At the end of the chapter there are several examples that show how, by abandoning objectivity, you can make pictures that have no scientific or documentary axes to grind. These are images that revel simply in the intricate and colourful beauty of the natural world.

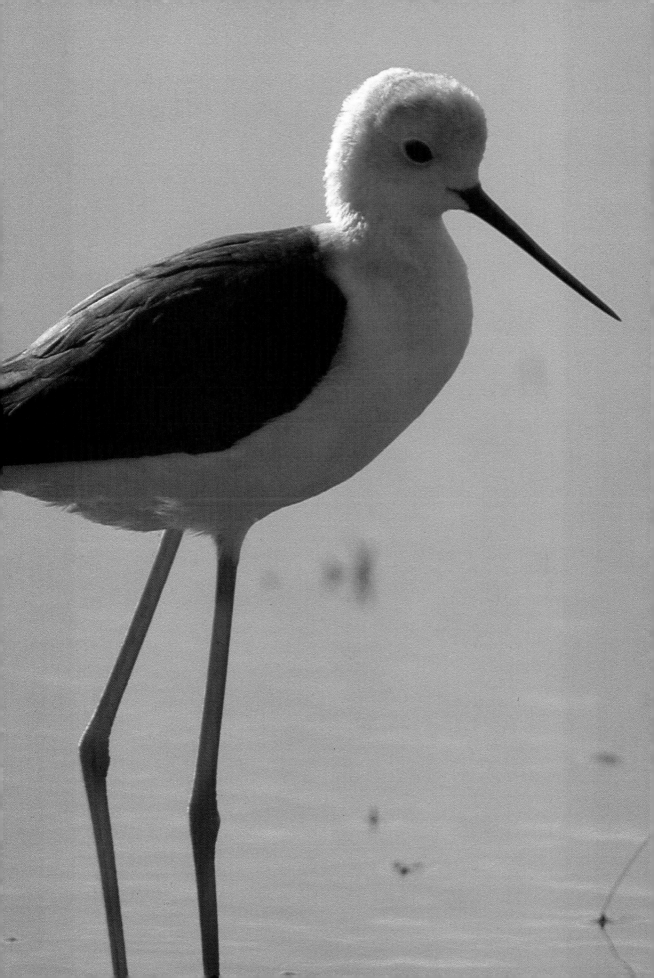

Film faster than the Kodachrome 64 used for this image would have enabled the photographer to set a faster shutter speed. However, Kodachrome's almost invisible grain and renowned archival dye permanence made it a more sensible choice for this shot, which was destined for a picture library, and would be used for many years to come.

The slow shutter speed – $^1/_{125}$ – would not have arrested even quite slow movements of the animal, so the photographer took pictures when it paused momentarily while grazing.

Careful framing and positioning of the camper ensured that the kudu neatly filled the frame when it looked up.

A straw-coloured 81A filter prevented the bluish cast that often mars pictures taken in cloudy weather. Since the front element of the lens is the size of a soup-plate, the photographer did not use a conventional glass filter – which would have been very costly. Instead, he fitted a thin gelatin filter over the rear element.

Camera:
35mm SLR

Lens:
600mm f/4

Film:
ISO 64 colour
transparency

Metering:
TTL

Filter:
81A

Lighting:
Natural

Composition One of a large group, this kudu was photographed from a stationary vehicle. The photographer was on a safari, and had driven out knowing that wildlife rarely find vehicles threatening, and that he would therefore be likely to get quite close to the game on the reserve that he was visiting.

When he approached the herd, he first looked around to see which of the animals would make the best subject for a picture, dismissing those that were slightly injured, or muddy. Having chosen several possible individuals, he took a few quick snapshots, so that if the whole herd should take flight, he would have at least one frame on film.

Composing this picture, though, took more care. From his shortlist of potential subjects, he located one that was not obscured by vegetation, and framed it in the viewfinder. However, the background behind the animal looked untidy, and confused the shape of the animal's horns. So the photographer started the engine of the camper, and rolled it back until the kudu was neatly framed in front of the shadowed trunk of a tree. This gave him the plain background that he had been seeking for a complex image.

He took a few pictures as the animal grazed, then waited to see whether he would get an opportunity to photograph it in any other poses. Hoping for an image like this, he had composed the picture with ample space at the top of the frame so that he would not lose the animal's horns should it raise its head. As he had hoped, the kudu eventually looked up, attracted by a slight movement that the photographer made, and he achieved this neatly framed portrait.

Technique The photographer used techniques as well as compositional ploys to separate animal and background. He set the 600mm lens he was using to its full aperture – f/4 – so that depth of field would be reduced to an absolute minimum.

Despite the large aperture, the dull weather forced him to use a relatively slow shutter speed – $^1/_{125}$, and he steadied the heavy lens on the rolled-down window of the vehicle. A towel placed over the window's edge provided a firm but cushioned support.

He was familiar with the pattern of sensitivity of the camera's TTL exposure meter, and therefore knew that any meter reading would be heavily centre-weighted. So, centring the animal in the frame, he took a reading, then switched the camera to manual in order to fix the exposure at the chosen settings when he recomposed the picture.

Since the weather was dull, lighting contrast was low, making bracketing an unnecessary precaution.

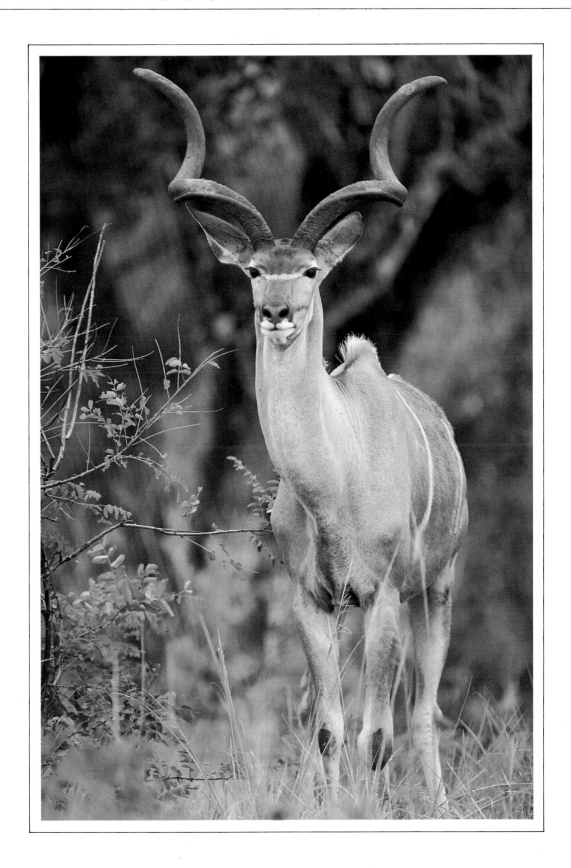

Setting a fast shutter speed was a priority because the birds made unpredictable movements and because the long lens introduced the risk of camera-shake – even with a tripod.

Aperture was of secondary importance: the lens performed well even at full aperture, and stopping down would have increased depth of field only marginally.

Framing the bird against a dark area makes her stand out very clearly from the background.

Camera:
35mm SLR

Metering:
TTL, compensated

Lens:
600mm

Filter:
—

Film:
ISO 64 colour transparency

Lighting:
Natural

The photographer who took this picture was an experienced and knowledgeable ornithologist, and therefore was quite confident that he would not intimidate the mother and chicks. Unless you have similar knowledge, you should always seek expert advice before attempting similar nesting pictures, and always err on the cautious side. It is invariably better to come away without pictures than to upset what you may later discover to be a species threatened with extinction.

Composition This family of storks was just one of several in a colony overlooked by the photographer's hide. At any one time, therefore, he had a choice of nests to photograph, and was able to follow the comings and goings at each.

His specific aim was to photograph the mother bird and chicks, and this in itself proved a limiting factor: a week earlier, and the chicks would have been too small to peep over the edge of the nest; a couple of weeks later, they would be out of the nest and learning to fly.

Apart from timing, and positioning the hide – an improvised shelter – composition was really up to the birds, and how they arranged themselves in the nest: the photographer watched and waited for characteristic poses that made good use of the space in the frame. This particular picture was outstanding because the mother bird is standing in profile, with the early morning sunlight separating her wings from her body, and because she is not obscuring either of the chicks. The two young birds are quite active, too – both have their beaks wide open.

Technique Nesting birds are very vulnerable and easily disturbed, so the photographer's first priority was to ensure that he did not cause the mother to abandon her chicks. He knew from previous experience, though, that gregarious birds living in colonies generally feel more secure than solitary species. He was therefore confident that the birds would not be intimidated by his building a makeshift brushwood hide in the course of a day. He returned to it before dawn the following morning with a 600mm lens and heavy tripod.

He set up the tripod and mounted the camera, but left the ball-and-socket head on the tripod slightly slack. This enabled him to turn and tilt the camera without fiddling with locks and levers.

Centring the mother bird in the viewfinder, he took a reading from her white plumage. The camera's TTL meter indicated 1/500 at f/5.6, but since the reading was from a highlight the photographer gave an extra stop of exposure, setting the shutter to 1/250. Without this adjustment, the feathers would have been grey, and the rest of the picture much too dark.

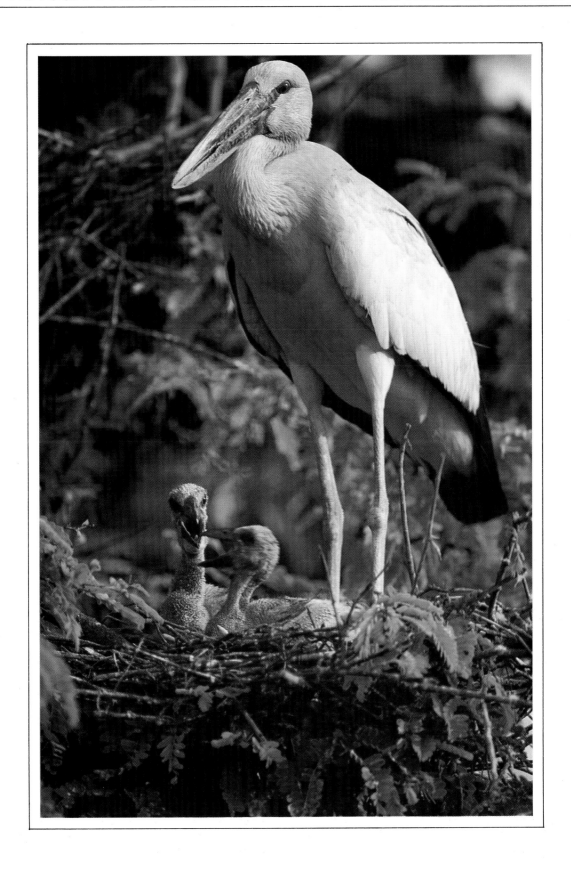

The black background is a characteristic of macro flash lighting. The background was about four times as far away as the insect, so the light fell off rapidly, and the leaves were about four stops underexposed.

The dull green wing case of the mantis was not shiny enough to form specular reflections of the ring-flash; but this lighting technique is unsuitable for some beetles: their shiny carapaces reflect the shape of the flash-tube.

The photographer used slow film – ISO 64 – for its good colour fidelity. The relative lack of sensitivity of such film is not a great problem, because flash freezes all movement, and at such short subject distances, even a weak flash unit allows apertures of f/11 or smaller.

Camera:
6 × 6cm SLR rollfilm with extension tube

Lens:
80mm (standard)

Film:
ISO 64 colour transparency

Metering:
None (exposure based on prior testing)

Filter:
—

Lighting:
Ring-flash

The reflector and flash tube of a ring-flash unit clamp around the front of the camera lens, producing shadowless lighting that is ideal for most wildlife macro work. A separate box carries the batteries and associated circuitry.

Composition Insects move. Sometimes they move very rapidly, and usually out of the frame rather than into it. So compositions like this often have to be framed 'on the run' before the insect springs to the next twig. The photographer grabbed one shot of the praying mantis so that even if it flew off, he would at least have something to take home, albeit an imperfect picture. But then he strove for something better.

His main preoccupation was to get an image of the mantis in a characteristic praying position, so he waited until it caught something to eat. When the insect raised lunch to its mouth, the photographer took the picture.

The black background isolates the insect from its surroundings very effectively, but this was a consequence of the lighting technique used; to illuminate the leaves behind, supplementary lighting would have been needed. In the foreground, though, there was some foliage that the photographer carefully removed just before he took the picture. Not only would the leaves have obstructed the insect, but they would have been closer to the camera's flash, and therefore would have appeared as an obtrusive white blur in the resulting pictures.

Technique The picture was taken on a 6 × 6cm rollfilm camera, fitted with a standard lens – in order to frame the picture tightly, the photographer fitted a 21mm extension tube between the lens and the camera body.

The crucial factor, though, was lighting – a ring-flash unit provided this. The circular flash tube of the unit wrapped right round the lens of the camera, so that illumination was perfectly even and without shadow.

Exposure was set on the basis of prior trials. The photographer had carried out tests at three or four subject-to-lens distances, and had determined the correct aperture that corresponded to each distance. Unlike most flash units, which automatically adjust output according to subject distance, the ring-flash unit has a fixed power. So having set up the lens and extension tube to one of the fixed subject distances, and adjusted the lens to the aperture that he had found to be best in the tests, the photographer had only to move backwards and forwards until the insect appeared sharp. He could then quickly take the picture before the insect leapt off, and be confident that it would be both sharp and correctly exposed.

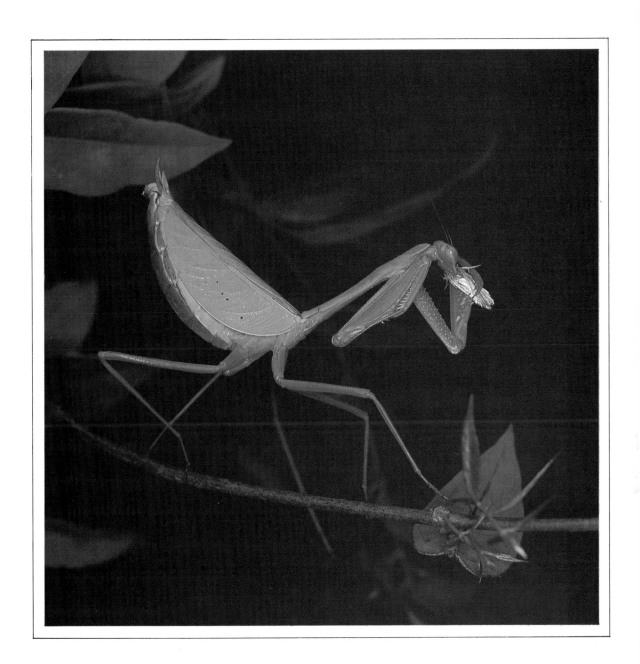

The leaves in the background are important as scene-setters, but they do not tell the viewer any more about the plant than the pad in the foreground. So the photographer deliberately limited depth of field through the use of a moderate aperture, making the background slightly unsharp.

Bracketing is a luxury for the nature photographer, who may only get one crack before the subject flees. Here, though, it was practical to bracket at + and − ½ a stop, to ensure that the delicate hues of the petals did not burn out to white.

A little deliberate splashing put these water droplets on the leaf, breaking up the plain surface with sparkling highlights.

Camera:
6 × 6cm SLR

Lens:
250mm telephoto

Film:
ISO 64 transparency

Metering:
Multiple readings with hand-held reflected-light meter

Filter:
—

Lighting:
Natural

Composition As with most nature pictures, composition of this one began with selection: instead of taking pictures of the first lily he found, the photographer spent some time seeking the best specimen in the area, and the one that was least obstructed by surrounding vegetation. In particular, he took care that the bloom was not partly hidden by the raised lip of the leaf. Finally, the photographer located this flower with an open stretch of water in front, so that the bloom would be reflected in the water.

The principal consideration was to show the flower in its natural surroundings. This lily is a water plant, so it made sense to take a fairly broad view and include some of the aquatic habitat. This is a still pool – not a rushing torrent – and to convey the brackish, unmoving nature of the pond meant that the photographer had to move back even further, until the plant filled just a quarter of the frame.

Moving left and right, he looked for the best viewpoint. He particularly wanted to include the giant lily pads, showing the detail of the raised, ribbed edges. To do this, he moved round the flower until the adjacent pad came into the frame. Lowering the camera a little brought more lily pads into view in the background, without revealing the far side of the pool.

The picture was taken in the mid-afternoon,

when the light was less harsh than at noon, and, because the sun was lower in the sky, the photographer had a choice of lighting directions: by moving round the flower, he was able to choose between sidelighting, front-lighting or backlighting. Earlier in the day the sun was higher in the sky, so there was no choice – only toplighting.

Technique Photographing a large bloom presents the photographer with far fewer technical problems than does a tiny flowerhead. With the plant some distance away, depth of field is greater, so it is not necessary to stop the lens down to a very small aperture. This in turn means that no additional lighting is needed.

For this picture, the photographer used a 6 × 6 cm SLR camera, and fitted a moderate telephoto lens – a 250mm. This takes in a horizontal field of view approximately equal to a 135mm lens on a 35mm camera, and enabled him to get a good picture without getting his feet wet.

Using a separate hand-held light meter, the photographer took readings from the water, the lily pad, and the flower itself (representing shadow, mid-tone and highlight areas). With these measurements in mind, he decided to set the shutter speed to 1/125 – just fast enough to hand-hold – and the aperture to between f/8 and f/11.

Printing the picture on hard paper ensured that the tree's shape appeared clear and wiry.

The photographer took care when printing the picture that the snow was not a pure white, so that the image area appears marginally darker than the border, lifting the image off the page.

Drawing a black 'keyline' on the finished print made the separation between image and border more pronounced.

Camera:	**Metering:**
35mm SLR	TTL automatic, compensated
Lens:	
28mm wide-angle	**Filter:**
Film:	—
ISO 400 black and white	**Lighting:**
	Natural

Composition Trees often prove surprisingly difficult to photograph. They rarely grow in splendid (and photographically convenient) isolation, and when they do, there's usually something distracting behind them to spoil the background.

This hardy hawthorn tree was no exception. Growing on an outcrop of limestone, it was a tantalizing subject. Its very shape suggested a massive struggle to grow in such an exposed spot, battered by the prevailing wind, and meagerly nourished by the thin soil. However, the tree tended to blend into the hillside behind it: in summer the tree was green – but so was the hill. When the leaves fell in winter, the dull grass behind still provided insufficient contrast.

A fall of snow provided the answer. The photographer returned to the tree during a cold spell, and found as expected that the hill behind was blanketed in white so that the wizened tree stood out starkly. Falling snow eventually obscured the background completely.

Since the tree's shape is the focus of the composition, the photographer pared away all other elements that might form distractions. The broad area in front of the tree gives its outline ample space. A tighter crop would have made the image seem cramped and enclosed, and would additionally have eliminated the band of rock on which the tree grows. The lack of colour further simplifies the picture.

Technique A distant viewpoint and a telephoto lens would have been ideal for this photograph, flattening out the perspective, and emphasizing shape. However, the blowing snow made this impractical – stepping back just a few metres (yards) reduced contrast to an unacceptable level. The photographer therefore fitted a wide-angle lens, and moved close to the tree, keeping the camera horizontal in order to avoid distorting the tree's shape.

With gloved hands, it was difficult to operate the camera's controls, so these were set to automatic. However, the photographer had taken the precaution earlier of setting two stops extra exposure on the compensation dial, to take account of the snow's high reflectance.

The photographer held his breath for a couple of seconds before pressing the shutter, so that the exhaled air would not drift past the lens in a cloud – a frequent problem in very cold conditions that is often overlooked until it is too late.

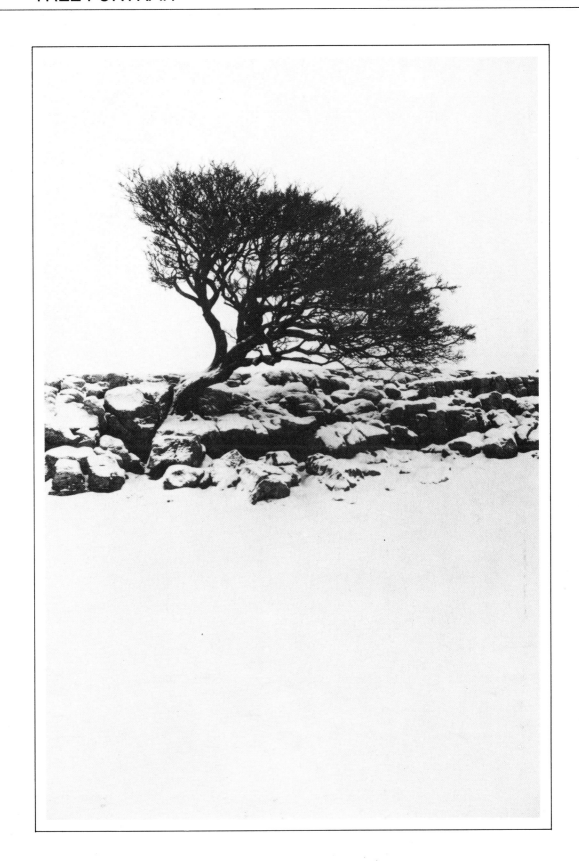

Against the dark background, the shrimp's translucent body appears to glow with light from the lamps overhead.

The photographer took the picture when the shrimp was momentarily stationary. At the slow shutter speed in use, any movement would have produced blurring on film.

With the lens set to full aperture, depth of field was virtually non-existent, so the photographer waited until the shrimp turned flat-on to the camera. The creature's legs, pincers and body were then in more or less the same plane, and the unsharpness of other areas is less conspicuous.

Camera: 35mm SLR	**Metering:** TTL
Lens: 55mm macro	**Filter:** 80A
Film: ISO 64 colour transparency	**Lighting:** Domestic tungsten lamps

Composition To those of us accustomed to finding shrimps on a plate with a slice of lemon, seeing one alive can come as a revelation. This one was scuttling around inside a large tank at a public aquarium.

Aquarium lighting can be quite attractive: diffused by weed and water, it illuminates the wildlife in the tank with a soft glow. So the photographer opted to use the available light, rather than adding supplementary illumination from a flash unit.

The shrimp had unlimited movement inside the tank, so the photographer did not have much control over viewpoint and framing. It was clear that an objective natural history portrait was going to be impractical, so instead the photographer aimed for a subjective image. He closed in as tightly as possible, filling the frame with this tiny animal encased in its translucent armour, abristle with sensitive antennae. His picture expresses the fascination that so many people feel when they first see the curious beauty of a shrimp in its own element, rather than in ours – cooked.

Technique Lighting in aquaria is usually either from tungsten bulbs or fluorescent tubes, so the photographer arrived armed with two colour correction filters: an 80A and an FL-D. Here the lighting was tungsten, so he fitted the deep blue 80A. The correction this provided was not complete, and the photographer realized that the pictures would have an orange colour cast. However, since he was not aiming for textbook style illustrations, perfect in every detail, exact colour fidelity was not essential, and he took pictures in spite of the mismatch between film and light.

Tripods were forbidden, so, in the dim light, the photographer steadied the camera by pressing the macro lens he was using against the glass of the tank, cushioning it with his hand. Even at the full aperture of f/3.5, the camera's TTL meter indicated a shutter speed of 1/8.

The glass side of the aquarium picked up the reflections of the room lights, so the photographer fitted a rubber lens hood to the front of the macro lens. This shielded the glass from stray light, and solved the problem. The only other alternative – using a polarizing filter – was ruled out by the low light (polarizing filters stop as much as 70 per cent of the light reflected from the subject, forcing the use of an even slower shutter speed).

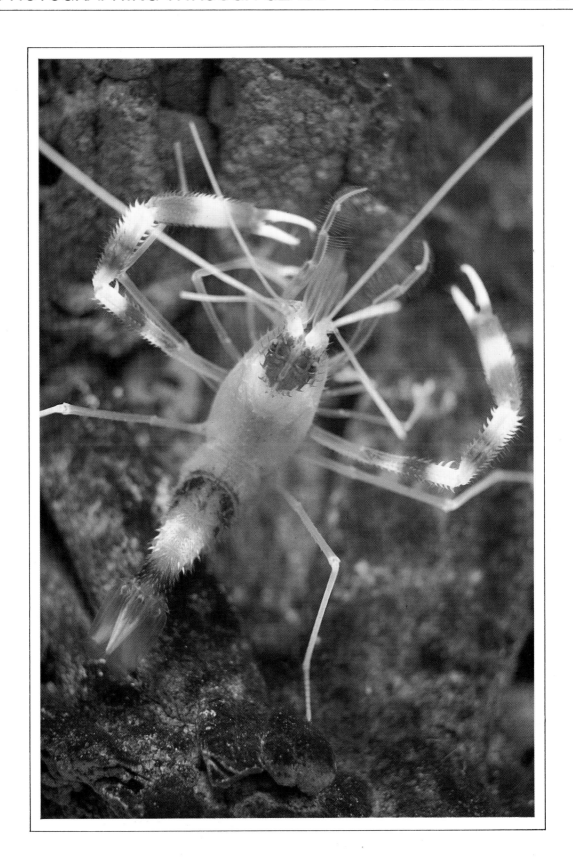

Filters can enhance colours, as well as just correcting them. Here the photographer 'cheated', and used an 81C filter to add extra yellow to the leaves.

Setting the exposure was difficult – and as it turned out, the estimate was not perfect. A more satisfactory method would have been to use a spotmeter to measure the brightness of the light from a single leaf.

Flare would have lightened these dark areas, making the bright walls behind clearly visible, so the photographer took special care to stop all non-image-forming light. He used a French Flag (see Glossary), carefully adjusting it to cast a shadow across the camera.

Camera:	**Metering:**
35mm SLR	TTL, compensated
Lens:	**Filter:**
105mm	81C
Film:	**Lighting:**
ISO 64 colour	Natural
transparency	

A second picture taken at the same time as the one at far right shows the importance of exposure. Giving two stops extra exposure clearly reveals the background, and the texture of the trees' branches, thus destroying the picture's atmosphere.

Composition The falling of the last leaves from a tree marks the end of one season and the beginning of another: a barely noticed reminder that winter is about to set in.

This picture of the cherry tree outside the photographer's window captures not just the few remaining leaves, but the last weak rays of autumn sun. The resulting backlighting makes the leaves shine on the dull black branches like gold coins.

The composition chosen is a tightly framed detail of the tree, rather than an overall view. This tight cropping was forced on the photographer, because the tree was hemmed in by buildings, and the sun's position dictated the viewpoint.

Scrutinized so closely, the tree's twigs criss-cross the frame in a disorderly way, but the lines they make on film are always overshadowed by the brilliant glow of the yellow leaves – the essential subject of the picture.

Technique Surrounded by unsightly brick houses, the tree was not an easy subject. Choosing a 105mm lens helped to throw them out of focus – the photographer set the lens to its maximum aperture of f/3.5 to ensure that depth of field was as narrow as possible.

It was the minimal exposure, though, that really obscured the background, rendering it as the film's Dmax – the maximum density that can be achieved, or a solid black tone.

Exposure was set by taking a reading from the walls behind the tree, and then setting the shutter three speeds faster than the one indicated. Since this was a rather rough-and-ready fashion of determining the correct exposure, the photographer took three pictures, bracketing two of them a stop either side of his estimate. The picture shown opposite was the frame that received one stop less than the estimate.

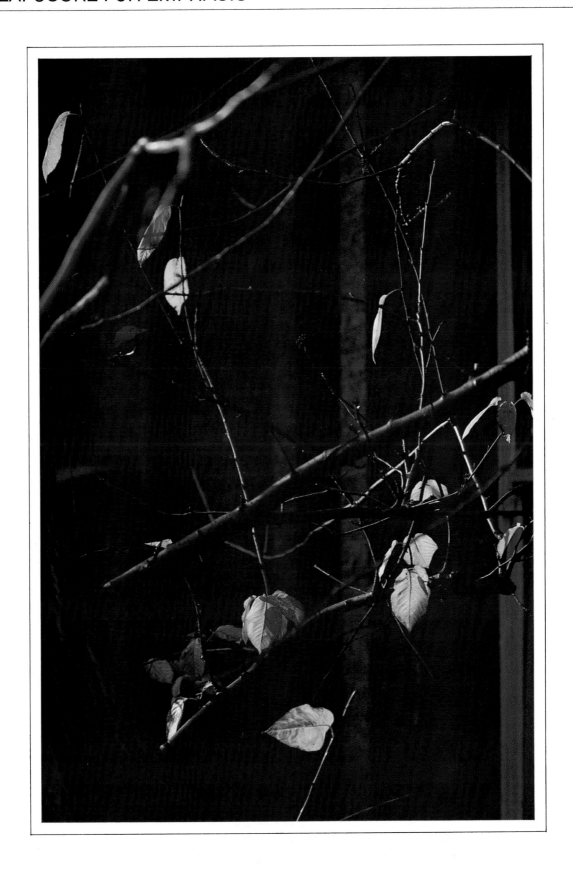

The photographer arranged the leaf with its bars crossing the frame diagonally: diagonals give a picture a greater feeling of activity and movement than horizontal or vertical lines.

A flash meter provided an indication of the level of incident light, and the photographer bracketed the pictures half a stop above and below the indicated reading.

The Phelsuma lizard was bought from a local pet shop.

Camera: 35mm SLR	**Metering:** Flash meter
Lens: 55mm macro	**Filter:** —
Film: ISO 64 colour transparency	**Lighting:** Studio electronic flash unit

Composition Photographers of wildlife rarely have the opportunity to control the composition of their pictures in the methodical manner of, say, still-life photographers. There are, however, exceptions to this rule. A few species of animal can be removed from their natural environment to the controlled convenience of the studio, without any great risk to the animal's health and safety. Many members of the insect world fall into this category. So do small reptiles, as illustrated here.

A few words of warning, though: if you decide to make a studio portrait of an animal, read about its habits and requirements to make sure that the creature comes to no harm; second, make sure that you are not breaking any laws covering the preservation of wildlife; and, finally, always return the animal to the place where you found it – don't just release it through the kitchen window.

As you can see from this image, though, studio portraits provide an opportunity to manipulate every aspect of the photograph – particularly the background. Here the photographer bought a palm leaf from a city florist, picking it out for its interesting linear ribs, its colour, and its lustrous surface texture. Before buying the leaf, though, he checked in a botanical book to make sure that it grew in the lizard's habitat, and would therefore look authentic on film.

The soft sidelighting puts brilliant bars of light down the ribbed leaf, and brings out the texture in the lizard's skin. By choosing a diffuse light source, the photographer kept the shadows soft and open, and effectively reproduced overcast daylight, or open shade conditions.

Technique To prevent the lizard from jumping off the leaf and scuttling across the studio floor, the photographer arranged a small 'set' in an open-topped aquarium. He lit it using a studio electronic flash unit – this was powerful enough to allow him to set an aperture of between f/22 and f/32 even with slow film.

Light from the flash unit was diffused by a sheet of opal acrylic material to give a directional daylight effect, and the whole lighting unit, including diffuser, was moved to within about half a metre (two feet) of the set. Flash lighting had a further advantage, besides its ability to mimic daylight: its brief duration froze all movements that the lizard made and thereby ensured that the final image would be absolutely sharp.

The photographer used a 35mm camera, with a macro lens. Lizards can move quite rapidly when they have a mind to, and a larger format of camera would have been more difficult to hand-hold and track the animal around the set.

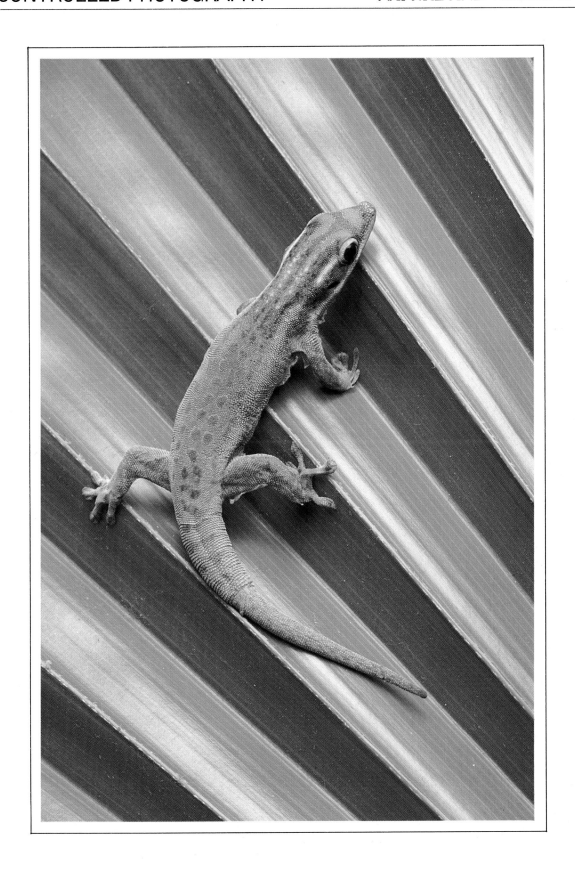

Filtration and liberal exposure ensured that the background appeared pure white.

Focusing was critical, and the optimum point of focus was found to be this front edge of the central petal. The camera's stop-down control made previewing of depth of field simple.

The stem drifted out of focus, but was included in order to enclose the bloom on the fourth side, thus holding the picture together.

Camera: 35mm SLR	**Metering:** TTL meter + 1 stop
Lens: 55mm macro with 27.5mm extension tube	**Filters:** 10 red colour correction
Film: ISO 64 colour transparency	**Lighting:** 'Colour matching' fluorescent tubes

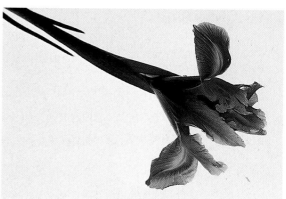

A less tightly cropped image does not have the same impact as the bigger, frame-filling portrait opposite.

Composition The botanist's priorities when photographing flowers are to show the organism in its natural habitat, and to present as precise and complete a picture of the flower as possible. If the aim, however, is to make beautiful, rather than accurate, pictures, these constraints are irrelevant.

This impression of an iris, for example, owes nothing to the exact science of botanical illustration and Latin classifications. The picture shows the flower head in a way that the naked eye never sees it; to get this close to a real iris would require a magnifying glass.

Since the petals burst out of the edges of the frame, the viewer is left with no lingering suspicions that this might be an objective record of a plant. A more timid approach to framing – such as that shown above right – falls awkwardly between art and science, and is less successful for this reason. Cropped on all sides, this bloom directs our eyes inwards to its delicately fluted, fecund centre, then outwards along exploding spikes of gold.

The lighting for the picture was chosen to emphasize the plant's transparency, and lighten the hues of the petals. By reflected light, the flower head appeared a ponderous and heavy purple.

Technique The light source for the picture was a light-box, of the type used for sorting slides. The opal-glass top was lit by fluorescent tubes – a type of light source that normally creates colour casts in pictures. However, the tubes used in light-boxes are more satisfactory than most, and give out a colour of light that closely resembles daylight. Prior experiment had taught that, used with ten units of corrective red filtration, this box produced natural colour rendering on film.

To get close enough to the flower demanded a macro lens. This was fitted on to an extension tube so that a subject the size of a matchbox filled the frame. Use of a tripod eliminated camera-shake, so that quite a long exposure – ¼ second – was possible. This, in turn, allowed the photographer to use an aperture of f/22, and hold almost all of the flower in focus.

The camera's TTL meter provided an ideal way of measuring the exposure. A reading taken by a separate meter would have required compensation at such a close subject distance; a TTL reading eliminated the tedious calculations. Based on the meter reading, the photographer gave one stop extra exposure to lighten the hues of the petals.

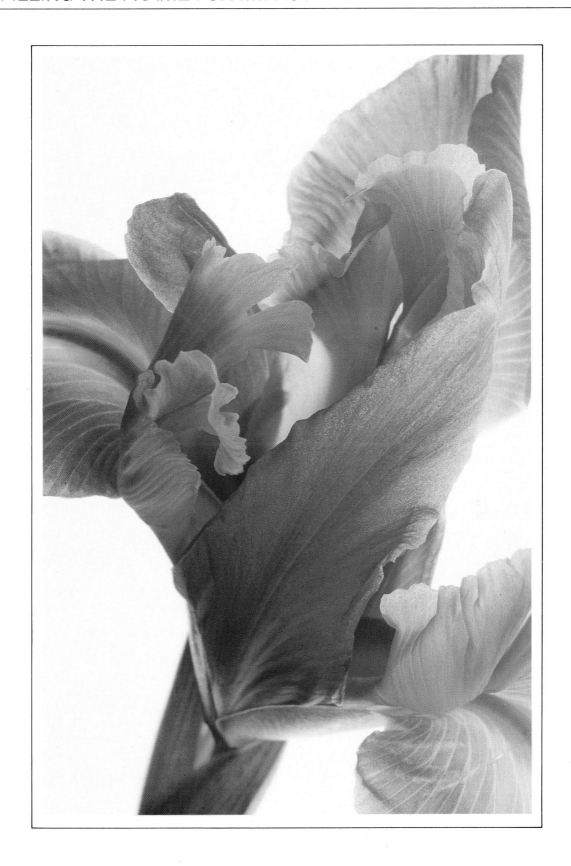

A black corduroy cushion absorbed most of the light falling on it, so that the background appears almost pure black.

Light from a window on the left brought out the texture and form of the dog's body.

Camera:	**Metering:**
35mm SLR	TTL +1 stop
Lens:	**Filter:**
50mm (standard)	—
Film:	**Lighting:**
ISO 64 colour transparency	Daylight from window

This was an earlier attempt to catch the dog's elegantly curled shape. However, the domestic surroundings weaken the image.

Composition The structure of this picture moves the viewer's eye round and round in a circle, as if the sleeping dog is chasing his tail. Nothing breaks the line: his tail points us up his haunches to his serrated back. There the dog's ribs, lit obliquely from a window, slant up like chevrons, directing us onwards to his bony shoulders, arrow-shaped head and nose – and back to the tail.

The dog's sleek lines suggested the picture, but in a basket or on a patterned carpet, the background always intruded. A plain background was the obvious answer – black providing the maximum possible contrast with the animal's virtually white coat.

A long walk and a heavy meal calmed the (normally highly strung) dog's nerves, and he was coaxed on to the unfamiliar cushion with a little harmless subterfuge – a hot water bottle under the cover. All that was required then was to tuck in his tail and frame the picture tightly so as to exclude all other details in the room.

Technique The principal problems were lighting, exposure and viewpoint. Soft but oblique lighting proved to be the best illumination to bring out the dog's musculature and bony frame. Frontal lighting such as that produced by a flash in the camera's hot shoe would have recorded the hound as just a round white blob, with no shape or depth.

Most TTL meters read the light reflected from the centre of the picture, and, uncompensated, such a reading would have produced underexposure. To prevent the dog appearing grey, the photographer gave an extra stop of exposure, setting the shutter to 1/60, and the aperture to f/5.6.

The viewpoint had to be downward-looking, so the photographer stood on a chair, and took the picture with a standard 50mm lens.

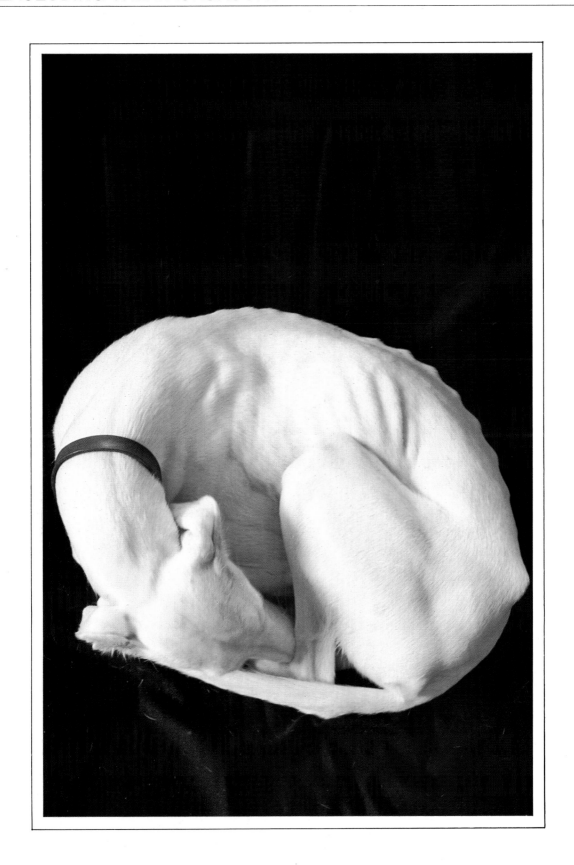

HOLIDAYS AND LEISURE

Everyone takes a camera on holiday, or on days out with the family; simple cameras are designed with these leisure activities in mind, and excel at pictures of the children building sandcastles on the beach.

Leisure photography doesn't just mean snapshots, though. The next few pages show how you can make better use of the photo-opportunities that a change of scene provides. The picture opposite, for example, was taken alongside a busy freeway, with an untidy car park in the foreground. Yet by composing the image around the colours of dusk and the green glow of fluorescent light, the photographer has turned the weary end of a day's driving into a sublime moment of peace and beauty. Like this picture, almost all the others that follow were taken in similar situations where you might use your camera to take conventional snaps; yet, in each case, the photographers have put in a little extra time and effort, and made images that have an appeal to a circle wider than the immediate family. Follow their example, and you'll produce holiday photos that you will want to blow up and hang on the wall, rather than relegate to an album in the bottom of a dusty drawer.

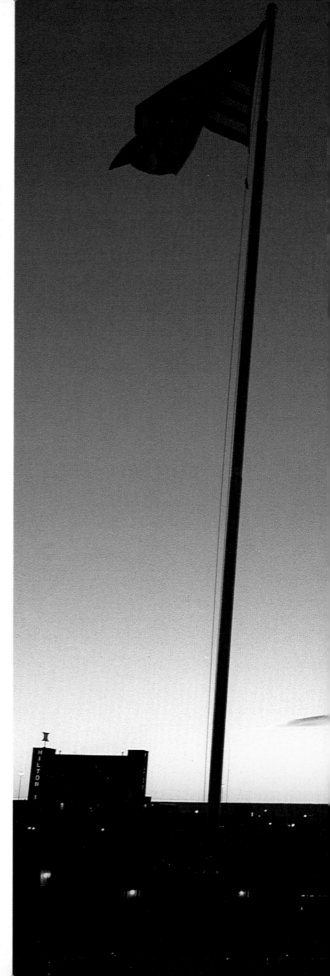

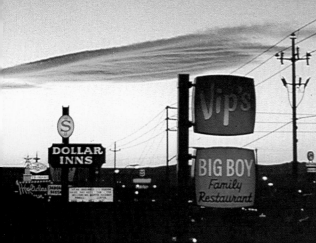

The low contrast that is a characteristic of most mirror lenses here adds to the picture's early morning atmosphere.

Bathers and hotels in the background set the scene, but the lens blurs them sufficiently to prevent them from distracting.

Hand-holding the lens was not difficult, because its wide (but fixed) aperture meant that the photographer could set a fast shutter speed – here it is ¹⁄₂₅₀.

Camera:	**Metering:**
35mm SLR	TTL substitute
Lens:	**Filter:**
500mm catadioptric	—
Film:	**Lighting:**
ISO 200 colour negative	Natural

Composition The beach is a rich source of pictures: of the scenery itself (see overleaf); of natural close-ups; and, of course, of people.

This picture, taken at Laguna Beach in California, shows the value of adopting a decisive approach to pictures on the beach. Instead of aimlessly wandering in a vague search for 'beach photos', the photographer set out with the deliberate objective of making pictures of the people who visited the beach.

The photographer chose the early morning as the best time for picture-taking, reasoning that at this time of day the beach would be occupied by local people who used it regularly – for jogging, swimming, walking the dog, or just ambling before work. He figured that these year-round beach users would make more interesting photo-subjects than the swimmers and sunbathers who visited the beach later in the day. The photographer's hunches were correct: he returned to his hotel with a roll of excellent candid studies, rather than a haphazard collection of snapshots.

The one picture on the roll that stood out from the other 35, though, was not strictly a portrait – and therein lies its strength. To suggest the sense of space and openness that we experience on a wide beach, the photographer had framed the picture in asymmetrical fashion. Composing the picture with the figure at the extreme edge of the frame, he makes the woman stare into the broad width of the image, and, by implication, out to sea.

Facing away from the sun, the photographer could have made good use of the low lighting, and recorded hard-edge images with rich, saturated colours, and very much in the mould of the West Coast school of photography. Instead, he turned round and pointed his camera up the beach, making a picture that is less colourful, but, undeniably, very much more evocative.

Technique Beaches are confused, often untidy places that challenge the ingenuity of a photographer in search of interesting, atmospheric images. To eliminate the clutter that can creep into the background of beach pictures, the photographer went armed with a long lens – a 500mm. This was doubly valuable: it enabled him to close in on a single face or figure at a time; and the shallow depth of field changed background detail to a blur.

The lens had a fixed f/5 aperture, so the photographer adjusted the camera's shutter speed to set exposure. He took a meter reading from a shaded area of sand near his feet, in order to weight the exposure in favour of the shaded side of the figure (the strong backlighting would have biased a regular meter towards the sunlit highlights).

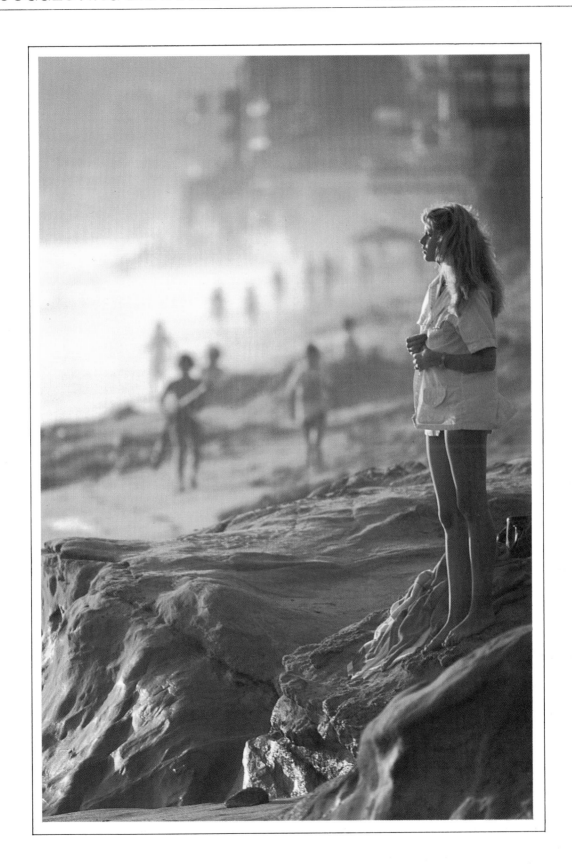

The severe underexposure darkened the blue sky almost to black, rendering a polarizer unnecessary. On the 20mm lens in use, a filter would in any case have caused vignetting.

The sun formed a flare spot at the top of the frame, but stopping the lens well down – to f/16 – kept this under control.

With the shutter set to ¹⁄₅₀₀, the moving waves appear glassy-sharp on film.

Camera:
35mm SLR

Metering:
TTL (see text)

Lens:
20mm

Filter:
—

Film:
ISO 25 colour transparency

Lighting:
Natural

Exposure metering is subjective. The exposure of this image was, strictly speaking, 'correct', but it has none of the atmosphere of the main photograph opposite.

Composition A walk along an idyllic, empty beach at midnight, with the warm waves gently lapping at your bare feet padding on the wet sand: this is the stuff of dreams (and holiday brochures).

The camera, of course, can distort reality, and bring it closer into line with our dreamworlds. The picture opposite fits the description above, yet the only thing that the words and the shot share is the emptiness. The beach was indeed empty, because the picture was taken in mid-winter: a freshwater lagoon nearby was frozen over. The sun (not the moon) was low in the sky because it never crept much further from the horizon at that time of year.

In composing the picture, the photographer used the sun as his starting point, placing this centrally at the top of the picture. This largely dictated the position of the horizon, since he also wanted to include a broad expanse of sea-washed sand in the foreground. Moving left and right changed the position of the headland in the frame. In this image, the land juts out two-thirds of the way across the frame, so that it is clear that we are looking along the beach, not inland.

The driftwood in the foreground of the picture

was 'imported' from another part of the beach to break up the stretch of water.

Technique Day was turned to night by the simple expedient of underexposure. Exactly what is the 'correct' exposure for any particular scene is a matter open to debate, but here an appropriate method of metering would have been to take a reading from an area of sand that was not reflecting the sun. The picture above was based on just such a reading. For the main image opposite, though, the photographer pointed the camera directly at the sunlit water at his feet, so that the TTL meter read the brilliant highlights sparkling from the waves. Then he used the 'memory hold' button to retain the reading while he recomposed the picture. As a result, the automatic camera gave about three stops less exposure than that required for an objective, lifelike shot, and the picture resembles a night scene.

To include the broad expanse of foreground, the photographer used a 20mm lens, taking care to clean the front element carefully before taking the picture; dust on the lens would have caused veiling flare, reducing contrast and weakening shadows.

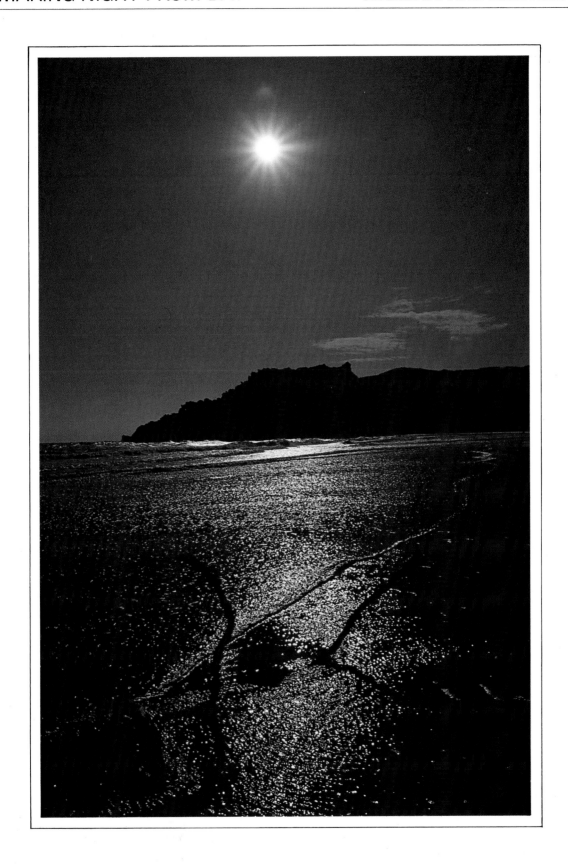

The intrusion of an ornate balcony rail made other pictures on the roll look busy by comparison with the simplicity of the main photograph on the facing page.

In this example – as with many photo-subjects – less is more. Having decided to make colour the theme of the picture, the photographer made the composition as simple as possible, using just a few palm leaves to divide the frame into broad zones.

Red often seems garish and glaring in photographs – particularly when the colour covers much of the image. Kept small, the red shutters add spice, and act as a counterpoint to the cooler hues that dominate the frame.

Besides having weaker colour, an overexposed picture would have recorded the white wall as a completely featureless object. Here the wall retains a little texture and solidity.

Camera:
35mm SLR

Lens:
28mm wide-angle

Film:
ISO 25 colour transparency

Metering:
Highlight reading using TTL meter

Filter:
Polarizing

Lighting:
Natural

Composition This image is a sparkling celebration of colour, but takes its theme from a mundane subject – the holiday hotel.

The picture is dominated by the three primary colours – red, green and blue – to the exclusion of all other hues. Composition of the picture was largely dictated by the desire to maximize the intensity of these three colours, and to bring each separate area of solid colour as close as possible to all the others.

However, the appeal of the scene did not stem only from the bright colours. A further consideration for the photographer in composing the picture was to juxtapose the regimented, angular lines of the hotel with the organic, flowing edges of the palm leaves in the foreground.

Technique Practical limitations on the picture were traffic and pedestrians in the street below the building, and advertising signs on the whitewashed wall. These problems were overcome by choosing a low angle, and pointing the camera so steeply

upwards as to exclude totally the foreground. A 28mm wide-angle lens provided ample depth of field, so that every detail in the scene is sharp.

To achieve maximum colour saturation, the photographer had to control exposure very precisely. Too much exposure would weaken colour; too little, and the hues would appear muddy. A highlight reading from the white wall provided a basis for exposure setting. Giving two stops more exposure than indicated by the camera's TTL meter ensured that the wall would appear white – not grey – and that the colours would be as brilliant as possible.

Fitting a polarizing filter over the lens darkened the blue sky, and cut spectral reflections from the palm leaves and shutters, so that these, too, appear to glow with colour.

The final step was carried out weeks after the picture was taken. The photographer copied the image using a slide duplicator – a process that increases contrast and makes the colours richer and brighter.

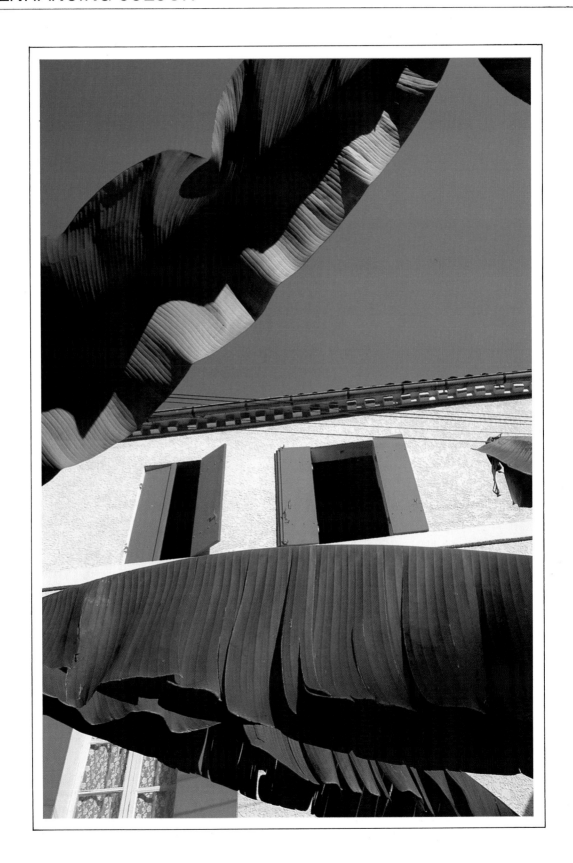

Fitting a polarizing filter can partially remove reflections, just as Polaroid sunglasses cut glare from sunlit roads. To orientate the filter correctly rotate it while looking through. Then fit the filter to the lens with the filter's index mark in the same position. With an SLR, the effect can be seen through the viewfinder with the filter fitted to the lens.

The red stripes on the lifebelt provide a vivid contrast with the blues of the water.

This turn in the line of the shadow is an important element in the composition, nudging the eye gently towards the shadow of the ring.

Camera:
35mm SLR

Metering:
Automatic TTL

Lens:
35mm wide-angle

Filter:
Polarizing

Film:
ISO 25 colour
transparency

Lighting:
Natural

A With polarizing filter

B No filter

Composition Taking an attractive picture is often less to do with photographic technique than with attention to detail, and with careful composition: this composition is deceptively simple, but despite appearances, the picture took some time to get right. The first consideration was to exclude all the pool-side clutter. This meant photographing from one end, rather than the side. The left of the pool, though, was sunlit, so at this side the tiles were a single shade of blue. The shadowed side opposite was a better choice, adding a second tint to the photographer's palette.

Floating the lifebelt into the best spot proved the most difficult task of all. Too far to the right, and it drifted into shadow; farther up, and it came uncomfortably close to the edges of the frame. The shadow was important, too – it shows that the ring is floating, rather than resting, on the bottom of the pool, and it echoes the ring's shape. The shadow disappeared from the picture whenever the ring drifted either downwards or to the left.

The tracery of light lines on the tiles appeared only when the water was slightly rippled. In totally still conditions, and when the water was splashed vigorously, it vanished. Gentle assistance with a foot provided just the right amount of rippling.

Technique This was straightforward, compared to the mechanics of organizing the subject of the picture. The light was fairly even, so the photographer relied on the automatic exposure meter of his 35mm SLR. However, to enrich the colours slightly, he dialled in ½ stop underexposure using the camera's compensation dial.

A wide-angle lens allowed the photographer to get a generous view of the pool without having to negotiate the diving board, and a polarizing filter killed the reflections from the surface of the water, so that the ring appears to hover unsupported in an empty pool.

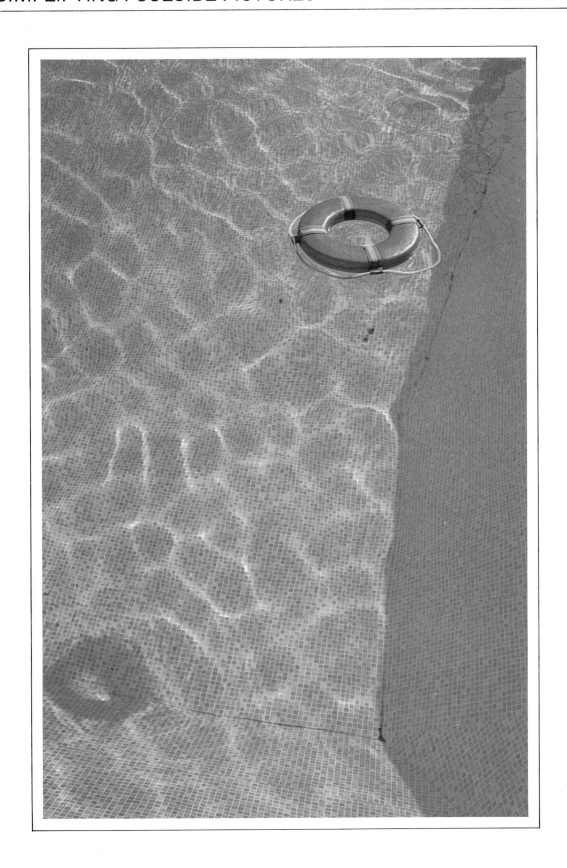

Longer exposures produced more loops of light; wider apertures made each loop 'fatter'. This picture was taken with a ten-second exposure at f/8. For hand-held cameras, shorter exposures and wider apertures will produce more reliable results.

The sparkler's motion is frozen by the flash. If you don't want the sparkler in the picture, ask the model to let go of the handle just before you take the picture. Make sure there's nobody nearby to get burned, though.

Light from the sparkler has made the model's face look very ruddy and warm – this could have been corrected with a filter, but warm tints are usually less objectionable in portraits than cool bluish ones, and the photographer did not bother with corrective filtration.

Camera:
Rollfilm rangefinder
camera
Lens:
100mm (standard)
Film:
ISO 64 colour
transparency

Metering:
—

Filter:
—

Lighting:
Portable electronic flash

Composition Pictures of firework displays rarely live up to expectations, largely because the camera reproduces only an impression of the visual aspects of the experience, and omits all the other subtle pleasures: the 'Oohs!' and 'Aahs!' as the rockets burst; the smell of smoke and cordite; but, most of all, the familiar proximity of friends in the crowd.

For this picture, the photographer's aim was to make an image that evoked the atmosphere of fireworks, but which had more human interest. So he picked a hand-held firework, which provided more opportunity for taking portrait-style photos.

He asked his sister to dress in light-coloured clothes, knowing that dark-hued trousers would disappear against the dark background. Then he tried making a number of different patterns using sparklers. The most successful one is shown here. For the picture at right, she bent the wire handle a couple of centimetres (an inch) from the end, and spun it in front of her.

Looking through the camera's viewfinder, the photographer realized that, at the top of its arc, the sparkler was crossing the model's face, so he asked her to raise her hand higher before shooting.

Technique The woman's face is lit not only by the sparkler, but by electronic flash. The photographer made several attempts, locking open the camera's shutter using the 'B' setting and a locking cable release. He made exposures ranging from three to ten seconds, and at apertures of f/4 and f/8. At the end of each exposure, he operated a hand-held flash unit by pressing the 'open-flash' button. The action-stopping briefness of the flash provided the sharp image of his sister's face.

Before taking pictures on conventional film, he took a Polaroid test-shot; this proved to be unnecessary, simply confirming that the aperture recommended on the calculator dial of the flash unit would give correct exposure. The instant film test did give some indication of how the circular streaks of light from the sparklers would appear.

The camera was tripod-mounted, so that circles and face were correctly superimposed. However, since electronic flash lit the face, camera-shake was not a problem. Similar pictures can be taken with the camera hand-held, provided that exposures are no longer than about three seconds, and the figure is close to the camera.

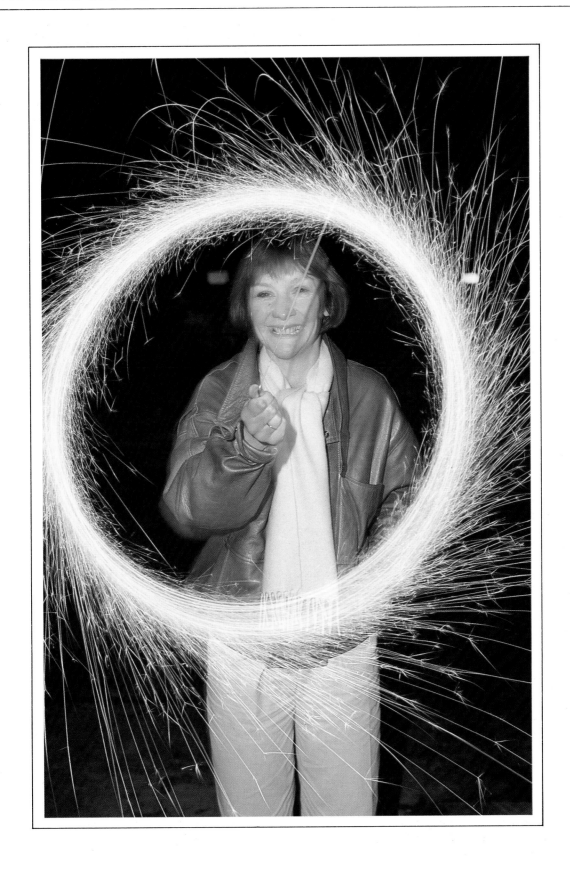

The photographer placed the figures slightly off-centre, making a far more dynamic picture than if the principal subjects had been on the axis of the frame.

By waiting until the little boy raised one of his toys, the photographer injected some movement and tension into the picture.

High midday sun cast only small shadows beneath the two children.

In the bright sunlight, slow colour transparency film provided ample speed, and ensured that colours were saturated and accurately reproduced.

Camera: 35mm SLR	**Metering:** TTL, bracketed
Lens: 28mm	**Filter:** Polarizer
Film: ISO 64 colour slide	**Lighting:** Natural

Composition 'Toddlers on the beach' is possibly the most hackneyed of all holiday subjects, yet this picture has an innocent charm that is lacking in most other examples of the genre. The composition is pared down to the barest of essentials, so that the two children sit alone on a patch of land sandwiched between sky above and water below. The deliberately generous framing makes the isolation of the figures even more emphatic, suggesting that they are in a world of their own – a childhood idyll.

The reality was only slightly more mundane: the photographer was touring Kenya with his family, and stopped at this beach near Mombasa, attracted by the unbroken sand and the safe shallow water. He carried the two children from the beach to a low sandbank just a few metres (yards) out, leaving them to play on their own while he took pictures. He had made a point throughout the holiday of carrying round brightly coloured objects for use as props in his pictures, and this example illustrates how his foresight paid off – the buckets and spades made brilliant splashes of colour that bring the eye repeatedly back to the middle of the frame.

The principal decisions in composing the picture were where to place the horizon, and how tightly to frame the children. Conventional wisdom is to get down to child's-eye level, but in this example such an approach would have made the two children break the horizon line. The slightly higher viewpoint chosen allows the horizon to continue uninterrupted, and places the toddlers against a plain background of sand.

Technique Choice of lens for the picture was not restricted by the camera position – the photographer was free to move closer to the children or further away. So the primary criteria for lens selection were the depth of field, perspective and sense of space in the image. A distant viewpoint and a telephoto lens would have flattened the perspective and reduced the depth of field, effectively isolating the children from the beach surroundings. Since the charm of the place was its isolation, a telephoto was ruled out. A wide-angle lens had precisely the opposite effect, stretching the perspective so that the image vividly suggests long expanses of sand and open skies. A 28mm lens proved an appropriate compromise between angle of view and distortion. To guard further against distortion, the two children were kept close to the centre of the frame.

The photographer relied on the camera's TTL meter when setting exposure – though he bracketed the picture at one stop above and below the indicated settings. Contrasts in the picture were high, but the white sand reflected a lot of light back into the shadows, so that these appear quite open in the final picture.

Here a polarizing filter fulfils a dual function: first, it deepens the blue of the sky so that the white clouds stand out more clearly; and, second, it also cuts down the reflections from the surface of the sea-water close to the camera, so that we are conscious only of the pattern of light dancing on the submerged sand.

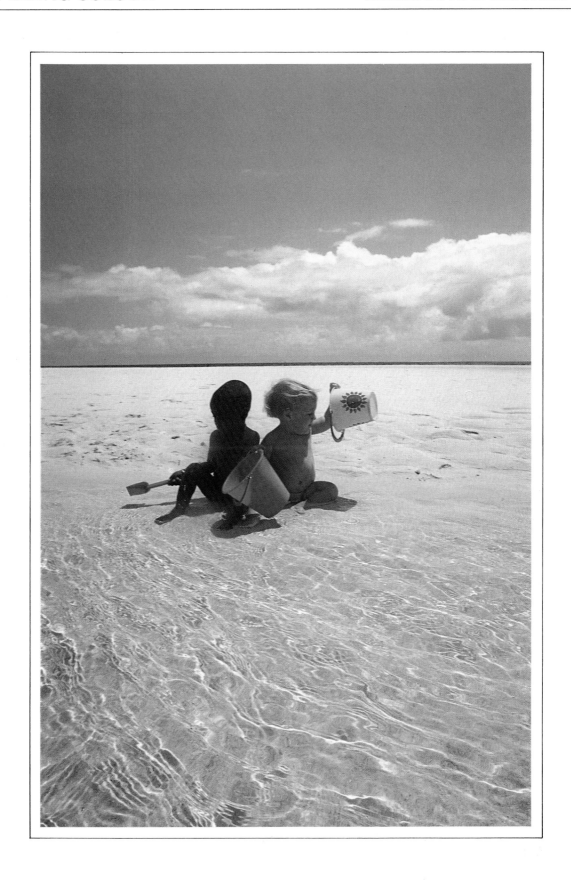

Take care when using a polarizing filter to darken skies. With ultra-wide lenses (focal lengths of 24mm and shorter), the sky may appear uneven in tone, as shown here. This is because the blue light from the sky is not uniformly polarized. A band of maximum polarization stretches across the sky, and this band appears darkest when a polarizer is fitted. Areas on either side look lighter. Deliberately limiting the visible area of sky – as shown opposite – avoids the problem.

Ultra-wide lenses have an undeserved reputation for distortion. This picture is virtually distortion free, because the camera was held absolutely vertically. Only the elongation of the C in the corner gives the game away.

Sidelighting from the afternoon sun cast shadows of the rails on to the deck and cabin, creating yet another converging line.

These lifeboat davits break the straight line of the rail, but, by moving well back from them, the photographer made sure that the disruption to the picture's geometry was minimal.

Camera:
35mm SLR

Lens:
20mm wide-angle

Film:
ISO 25 colour
transparency

Metering:
TTL from key tone

Filter:
Polarizer

Lighting:
Natural

Composition Streaking off into the far distance, the converging lines of this ship lead the eye to the horizon. The vessel thus points the way to the end of the voyage; the start of the holiday; perhaps the beginning of a new life? The division of the frame suggests a sea-change, too. On the left of the picture, all is order, with straight lines and vast expanses of clean white-painted steel plate. On the right, the shapes are jumbled and fussy.

Leaning over the central deck rail, the photographer used it to divide the picture neatly in half vertically, separating the world of order and safety from the life-rafts with their hint of disorder and panic. And, by holding the camera absolutely level, he allowed the horizon to bisect the frame. This rigid adherence to geometry exaggerates the powerful perspective lines within the frame.

Holding the camera level allowed another welcome side-effect, too: the vertical lines in the picture appear parallel on film, instead of converging as they would had the camera been tilted.

Technique The ship's dramatic lines, which form the primary feature of the picture, would have appeared to converge at the same angle, regardless of the lens in use. This is because perspective is controlled by viewpoint, not focal length. However, a standard or telephoto lens would have shown only the central part of this picture. To include as much as possible, and to dispel the cramped feeling of a ship's promenade deck, the photographer used a 20mm wide-angle lens.

The scene had very high contrasts, ranging from the pure white of the cabin sides, through to the deep blue of the sky, and the black of the funnel. So the photographer decided which area of the scene needed to appear as a mid-tone, and took a reflected light-meter reading from there. He metered the deck, using the camera's TTL meter.

Fitting a polarizing filter deepened the blue of the sky, and killed reflections on the funnel, so that this appears as a rich velvety crimson, rather than washed with white highlights.

Use of slow Kodachrome film ensured that the scarlet tunics appear in their full glory. Saturated primary colours are very difficult for any film to record correctly, and many faster emulsions rapidly lose detail in brilliant reds.

The slight variation in the line of the boots adds interest to the image. Nobody – not even the Queen's guards – is perfect!

Sunlight created very high contrast, with spectral reflections from boots, buttons and bayonets at one end of the tonal scale, and black serge trousers at the other. An exposure error of just half a stop would have lost detail in either highlights or shadows.

Camera:	**Metering:**
35mm SLR	TTL
Lens:	**Filter:**
300mm telephoto	—
Film:	**Lighting:**
ISO 25 colour transparency	Natural

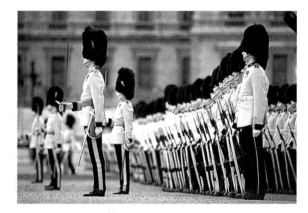

A broader view made less of the regimented ranks of guardsmen. This image was made with a 200mm lens.

Composition Virtually every tourist who visits London photographs the Queen's lifeguards, so perhaps it is futile even to attempt to make new and different imagery from these men in their archaic uniforms. The photographer who took this picture tried anyway – and succeeded.

He started by looking at other people's photographs of guardsmen – on picture postcards – and tried to determine which were the most important and the most memorable features of this time-honoured pageant.

He concluded that it would be best to portray several specific aspects of the ritual trooping of the colour, rather than aiming to show a very general view. He chose a distant viewpoint, therefore, from where the troopers' tunics formed a brilliant stripe along the frame – literally, the 'thin red line', as the British troops were nicknamed in the heyday of the Empire.

By crouching on the ground, he shifted the emphasis of the composition down to boot level. This eliminated the guardsmen's faces, reiterating the idea of military discipline at the expense of the individual will. And by pressing the shutter release just as the guardsmen stamped their feet in chorus, he introduced an element of movement and activity to an otherwise static picture.

Technique From such a distant viewpoint, a standard lens would have taken in several rows of guardsmen, so the photographer replaced it with a 300mm telephoto. This filled the frame with just part of one row and eliminated from the picture all background details.

To catch the stamping feet as the picture's focal point, the photographer set a shutter speed of $\frac{1}{500}$, and from a TTL meter reading taken from the face of a nearby soldier, he determined that an aperture of f/5.6 would yield the correct exposure at this shutter speed.

He made several exposures similar to this one at different points in the parade, using the drill-sergeant's shouted commands as a cue for pressing the shutter release.

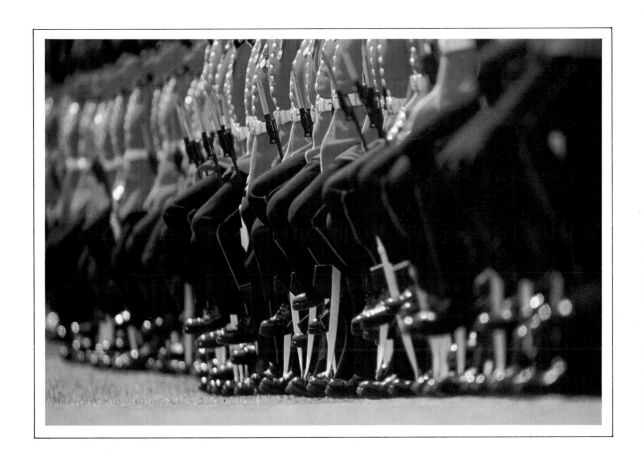

Daylight film recorded the light bulbs and the areas they lit as a warm yellow colour.

To get some tone and colour in the sky, the photographer took his pictures at dusk – when it is really dark, the sky turns black.

Light changes rapidly at dusk – and exposure can drop by a stop every five minutes. Frequent meter readings are therefore the rule.

Areas lit by the flash unit not only appear sharp, but in their natural colours, too.

Camera: 35mm SLR	**Metering:** TTL from sky, −1 stop
Lens: 24mm	**Filter:** —
Film: ISO 64 colour transparency	**Lighting:** Portable flash

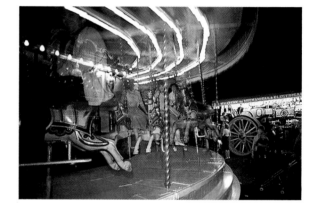

In close-up, the flash overpowers the daylight, so that it is only the light sources themselves that convey a strong indication of movement.

Composition Fairgrounds – and traditional ones in particular – burst at the seams with subjects for the camera. There are opportunities for splendid character portraits, and close-ups of intricately painted panels. Fairgrounds are at their best after dark, when the multitude of moving lights adds atmosphere and warm colour to the scene. The picture opposite focuses on these two important aspects – colour and movement.

The photographer decided to mix sharp imagery with a swirl of movement. He tried to recreate the experience of watching a roundabout: horses flash by in streaks of colour, and it is only when you gaze at just one as it makes a full circle that it suddenly appears sharply defined.

The unusual shapes and vivid colours draw the viewer into the picture: arcs of colour and light flow past at the top and bottom of the frame, sweeping us up with the motion of the merry-go-round, and drawing us towards its hub. There is interest in the background, too, when the eye tires of movement. Behind, we see the cool hues of the

night sky, and the warm, comforting glow of electric lights below.

Technique Electronic flash produced the subtle combination of moving and static images. The photographer knew that used at full power, the flash would totally freeze the motion of the roundabout, so he aimed to balance daylight and flash in equal measure. First, he set the shutter speed to ⅛ to provide an appropriate level of blurring. Then he took a meter reading from the sky to determine the level of daylight. This indicated that an aperture of f/2.8 would record the sky as a middle tone. To make the sky a deeper blue, the photographer used f/4. Next he set his flash unit to manual and looked at the calculator dial to find the subject distance at which an aperture of f/4 would yield the correct exposure. Finally, he moved forward until he was just a little further away than the dial indicated, knowing that this would yield slight underexposure, and therefore richer colours.

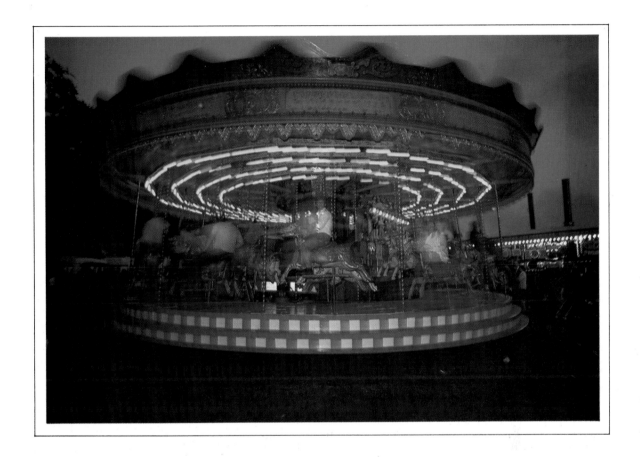

Foliage behind the engine echoes its green livery.

The relatively shallow depth of field of the 300mm lens threw background details sufficiently out of focus to prevent them from drawing attention from the foreground, yet retained a hint of texture.

The distracted, nonchalant attitude of the passengers emphasizes the benign nature of the monster that is carrying them.

Camera:
35mm SLR

Lens:
300mm

Film:
ISO 64 colour
transparency

Metering:
—

Filter:
—

Lighting:
Natural

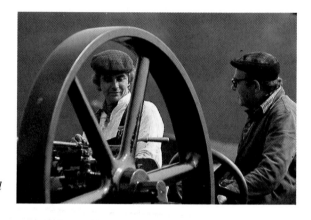

Seen from the other side, the same traction engine provided picture opportunities of a more graphic kind, its vast flywheel framing a portrait of its driver.

Composition Going to a steam rally is like stepping into a bygone age: an age when ponderous metal dinosaurs roamed about at walking pace, belching fire, steam and smoke.

These vast machines dwarf their owners – a fact that the photographer who took this picture was quick to seize upon. He was struck by the sheer scale of the huge flywheels, and used these as the hubs of his composition, positioning their centres symmetrically on either side of the centre-line of the frame. By pushing the figures to the edge of the frame, he left us in no doubt of the power of the machine.

The scale and perspective of the picture have considerable bearing on how we judge the relationship of man and machine. By choosing a distant viewpoint, the photographer showed the human and mechanical elements of the scene in their true relative proportions, and we see the enormous power and might of steam, harnessed for the moment to the will of the driver. Had he stood closer to the engine, and looked up at the figures, the driver would have appeared to tower high above, and the equilibrium of the picture would have been quite different.

Technique The photographer had spent much of the day wandering round the rally taking pictures, when he spotted this beast and its burden lumbering past some distance away. He used a 300mm lens so that he could crop tightly in on the engine without having to move closer to it. The photographer then had several opportunities to take the picture as the engine lumbered back and forth across the field.

He had been taking pictures constantly, and periodic meter readings – usually substitute readings from the palm of his hand, using a second camera and a shorter focal-length lens – had confirmed that the light was not changing. So here the photographer left the controls untouched, and shot pictures without taking a meter reading. (Less self-confident souls would probably still wish to use the meter to confirm this, before pressing the shutter.)

In the late afternoon sun, shutter speed and aperture settings presented little difficulty: the subject was not particularly deep, so depth of field was adequate even at quite wide apertures; and the slow movements of the engine did not warrant an excessively fast shutter speed.

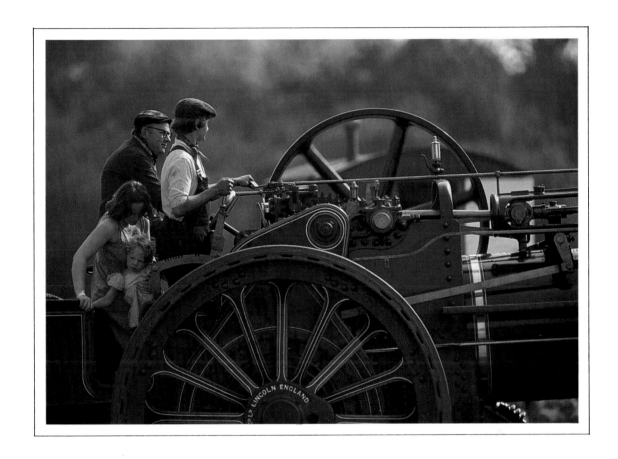

STILL-LIFES

Photography of objects hides behind the label 'still-life'. The phrase is less than inviting. It conjures up images of solitary photographers spending days making the perfect picture of the perfect soap-powder pack. Yet every photographer makes – or finds – still-lifes at one time or another. And many of these are very far from being dry and dull; far removed from the French title 'nature morte' – literally dead nature.

Look at the picture opposite. It is suffused with a human presence. It transports us to a forest clearing, or a beach. We're about to have an alfresco lunch with a friend – a methodical, tidy person who doesn't forget small but important things like salt and napkins; a friend who wouldn't dream of eating off plastic picnic plates. Hardly nature morte. More nature vivante.

In constructing or finding images like this one, the emphasis is on seeing the potential for a picture, and creating a composition that milks the subject of every last bit of visual appeal. Camera skills are of secondary importance: developing a visual eye is the key.

The original picture included a metal chair at the left. This seemed a distraction and was cropped out of the final image.

The photographer moved this apple close to the corner of the picture, knowing that the wide-angle lens would distort its shape, adding to the picture's unreal appearance.

The large size of film that was used gives the picture a seamless, pristine appearance, which makes the viewer even surer of its truthfulness – and therefore even more disturbed by the distortions of space that it creates.

Camera:
5 × 4 in sheet film
Lens:
90mm wide-angle
Film:
ISO 64 colour
transparency

Metering:
Hand-held incident light
meter
Filter:
—
Lighting:
Natural

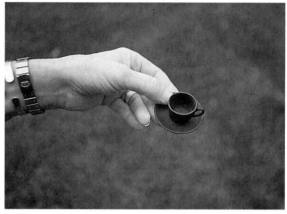

Held in the palm of the photographer's hand, the teacup and saucer appear in their true scale.

Composition The camera has a remarkable facility for untruth. When looking at a photograph, we are able to view the subject from only one angle – the viewpoint chosen by the photographer. When examining real objects, it is usually possible to move around them and verify that all is as it appears to be; but when the camera mediates our vision, this option is closed, and we have to draw our conclusion from limited information. Sometimes we draw the wrong conclusions.

The picture opposite elegantly and amiably takes advantage of our inclination to believe what we see in a photograph. The photographer has created a benign image, but with a slightly nightmarish perspective. The composition started, though, as a simple still-life. The marble table-top reminded the photographer of a rushing stream, and she decided to make a photograph that exploited the onward-rushing pattern of the white veins.

Having arranged the bowl of apples on the table, she looked around for an extra element to place at the far edge of the table so that the still-life would look less spartan. She chose a doll's-house cup and coffee-pot, each perfect in every detail, and the

illusion suddenly was complete. The veins in the table sweep us onwards from the bottom of the frame, past some (mostly) ordinary apples, and up to the far edge, where the crockery makes us question the size and scale of everything else.

Technique The picture was taken using a 5 × 4 in sheet film camera, and a 90mm wide-angle lens – though it could equally well have been shot on a 35mm camera using a 20mm wide-angle. This sheet film camera, though, had one important advantage: it enabled the photographer to tilt the plane of sharp focus. Normally, this lies parallel with the film, and the zones further from the camera and closer to it are progressively less sharp. By tilting the lens panel forward, though, the photographer shifted the plane of sharp focus until it was almost horizontal, running from the apples in the foreground to the edge of the table at the back. Objects above and below this plane were then less sharp, but stopping the lens down to f/22 brought most of these into focus.

Exposure was determined using an incident light meter, followed by a check using Polaroid film.

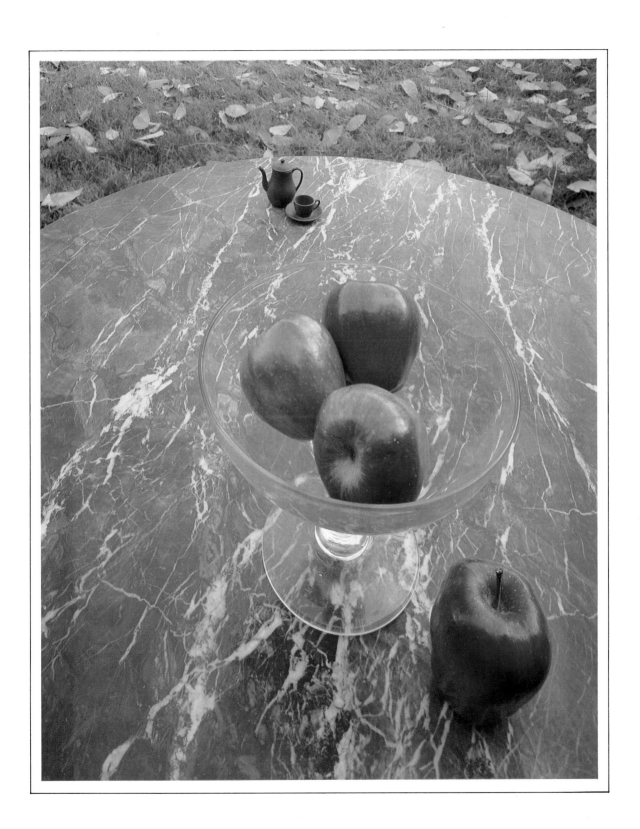

The warm yellow crust of the bread reflects a glowing golden highlight into the shadow at the side of the plate. Too much fill-in lighting (perhaps through the use of a foil, rather than newspaper, reflector) would have swamped this tiny patch of colour.

The mussel shells themselves provide the extreme top and bottom of the tonal scale, so exposure was critical. Too much, and the pearly highlights would burn out; too little exposure would have filled in the shadows. Incident light metering is ideally suited to subjects such as this one that have a very long tonal scale.

Turning the plate so that it makes a vertical shape within the camera's horizontal format makes the picture more interesting. Compare the composition of the main picture with the more 'logical' arrangement in the smaller image.

Camera:	**Metering:**
35mm SLR	Hand-held incident
Lens:	light-meter
55mm macro	**Filter:**
Film:	—
ISO 25 colour	**Lighting:**
transparency	Sunlight softened with
	white reflector

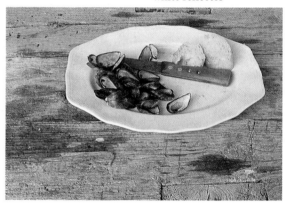

Moving away from the plate made an image that was different again.

Composition Still-life is one of photography's great themes. Like the nude, or portraiture, it is an area that has absorbed photographers since the invention of the medium. Part of the attraction is in the capacity of the camera to make something out of nothing; an elegant photograph from the simplest of components.

The subject for this picture is the remnants of the photographer's lunch. He moved the table and plate out into the late afternoon sunlight, and turned the table so that raking light crossed the camera's field of view. This hard, oblique lighting showed up the form of the plate very clearly, and picked out each of the characteristic and contrasting textures of the china, wood, bread and mussel shells.

The aim was to suggest a casual meal eaten at leisure, so order and regularity were discarded in favour of asymmetry and randomness. The only exception is the knife which cuts diagonally, with a sense of geometry across the plate, as if to segregate the bread and the shells.

Technique Natural daylight is an excellent introduction to still-life lighting. With just one light source, the photographer soon learns to husband his or her resources carefully, using diffusers to soften the sun's rays, and – as here – reflectors to soften shadows. In the studio, there is a temptation to use a battery of lights where just one would do.

The sun's rays cast very deep shadows, which made the still-life slightly too harsh and hard-edged, but a sheet of newspaper held up to the right of the subject put some light back into the deeper shadows. With the camera on a tripod, it was easy to see by looking through the viewfinder how moving the reflector changed the effect of light on the subject.

A hand-held exposure meter was used to measure the incident light, and from the scale the photographer chose a small aperture – f/16 – to ensure good depth of field. Since the camera was fixed securely to a tripod, the shutter speed of 1/30 required at this small aperture did not pose the risk of camera-shake.

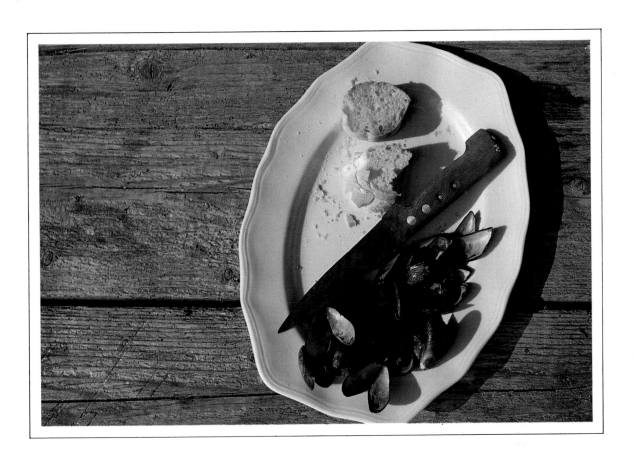

From a different angle and in black and white, the subject appears utterly mundane – just another piece of engineering machinery.

These two shapes at the top of the frame echo the curves and straight lines below them.

Zigzagging diagonals ensure that the composition never appears static.

These white highlight areas, though tiny, have an important role: they pick out the corners and curves in the metalwork, and give the otherwise featureless areas of yellow depth and solidity.

Camera:	**Metering:**
35mm SLR	TTL, bracketed
Lens:	**Filter:**
55mm macro	—
Film:	**Lighting:**
ISO 25 colour	Natural
transparency	

Composition Colourful pictures don't need to be ablaze with all the spectrum's hues. Restricting the palette to just a single colour can sometimes be a more effective approach. This picture, for example, is totally dominated by one colour, and is that much stronger for the elimination of other hues.

The subject matter – a piece of newly painted earthmoving equipment – is unrecognizable from such a close viewpoint. This, of course, was what the photographer had intended. The scraper reminded him of the heavy-handed style of some abstract steel-plate sculpture, and he composed the picture partly as a parody of such ponderous modernism.

He aimed to make a wall-photograph that would emanate warmth and sunshine, and that would be abstracted, but not entirely non-figurative. So, from the massive components of the machine, he picked those with strong, geometric shapes, using one horizontal line to divide the frame in two.

Angling the camera slightly, though, proved to make a more exciting image. With the camera tilted sideways the circular plate above the centre-line appears unstable, and about to roll to the left and

out of the frame. This give the image a sense of imminent movement and tension. The round shape casts a small shadow, too, which prevents the picture from looking entirely two-dimensional.

Technique The principal difficulty here was in making the yellow hues as brilliant as possible. To the human eye, yellow is the brightest of colours, but unfortunately most colour films reproduce yellow less well than any other colour. This is because the cyan and magenta coloured layers of the transparency are not pure primary colours – both contain an unwanted trace of yellow. Therefore, to prevent neutral greys appearing too warm on film, manufacturers make the film's third, yellow-coloured layer less strong than the other two; so, rich yellows appear weaker than other hues.

There is no practical solution to this problem – all the photographer could do was make the most of the film's existing capacity for the reproduction of yellow. He did this by bracketing exposures very carefully, at half-stop (rather than one-stop) intervals, around the setting of $\frac{1}{60}$ at f/11 recommended by the camera's meter.

Split-field close-up lenses can create severe flare if light strikes the cut edge of the lens. The photographer shaded the camera very carefully, but this flare patch was unavoidable. Nevertheless, positioned as it is over the trumpet, and at the edge of the frame, it does not severely mar the image.

These double images of the folding chairs were an inevitable consequence of using a split-field close-up lens.

The foreground area was propped up on a camera case, with the lid raised so as to reduce the depth of the foreground area. Without this precaution depth of field would have presented problems even at very small apertures.

Camera:
120 rollfilm SLR

Lens:
80mm standard

Film:
ISO 64 colour
transparency

Metering:
Incident light meter

Filter:
Split-field supplementary
close-up lens

Lighting:
Natural

Split-field close-up lens
These are regular supplementary close-up lenses, sawn in half, and mounted in a rotating holder. Their power is measured in diopters – the reciprocal of the lens' focal length in metres (the required reciprocal is 1 divided by the number in question). Thus a one-diopter lens has a focal length of $^1/_1 = 1$ metre (about a yard); a two-diopter lens has a focal length of $^1/_2 = 0.5$ metres (20 inches); 3 diopters – $^1/_3$, or about 0.3 metres (just over 1 foot). The focal length of the split-field lens indicates what part of the foreground subject is sharp when the main lens is focused on infinity – regardless of the focal length of the main lens. So with a two-diopter split-field lens, such as the one used for this picture, foreground subjects half a metre from the camera will be sharp when the camera's main lens is set to infinity.

Composition This park bandstand, with its attendant military musicians, formed a moderately interesting subject, but did not quite merit a picture in its own right. However, the interesting shape of the bandstand, the bright scarlet uniforms of the guardsmen, and the lazing audience make a fine backdrop for an outdoor still-life.

The photographer bought some sheet music and hired a trumpet to form the centrepiece of the picture. Opened flat, the score provided an appropriate yet quite plain background, and concealed the heat-parched grass close to the camera. The pattern of notes, additionally, made an interesting contrast with the flowing lines of the instrument resting on the score.

Vertical lines predominate in the background of the picture – the bandstand's columns and the surrounding trees all draw the eye up the frame. To balance this, the photographer arranged the trumpet horizontally, so that its shining tubes ran from left to right of the frame.

Finally, a piece of scarlet paper held just below

the camera lens was reflected along the length of each of the trumpet's tubes – thus echoing the splash of red on the tunics of the distant bandsmen.

Technique To keep both foreground and background sharp, the photographer used a split-field close-up lens (see above). With the camera's prime lens set to infinity, this supplementary lens keeps in focus nearby details at the bottom of the frame, without affecting the sharpness of the distant scene at the top of the picture. However, because the split-field lens covers only half the picture, there is a transitional zone of unsharpness where neither near nor far subjects are recorded clearly. The photographer therefore arranged the composition so that the middle of the frame contained relatively unimportant detail.

Based on an incident light-meter reading, the camera's controls were set to f/16 at $^1/_{60}$. The photographer then took an instant-film test shot to confirm composition and exposure before switching to conventional film for the final picture.

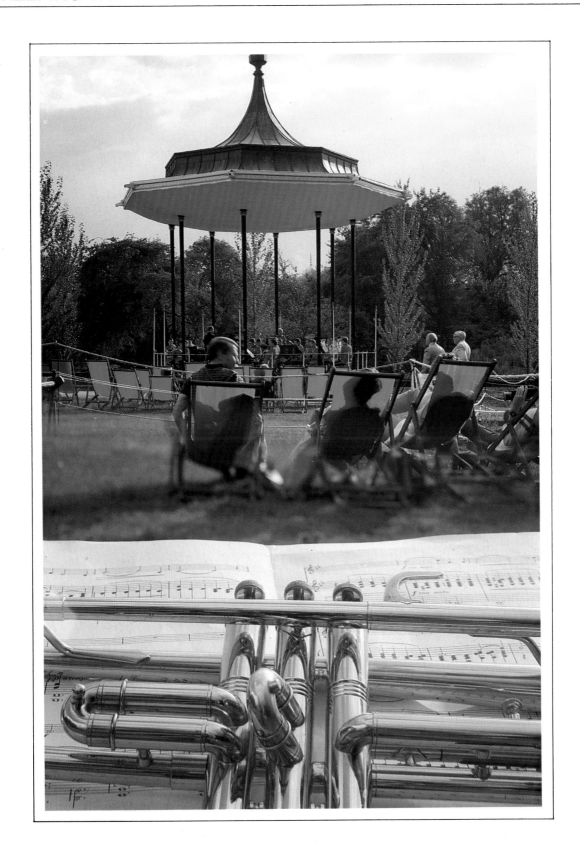

Warm colours such as red and orange appear to advance towards the viewer, so the painted surface of the can stands out, giving an illusion of depth to the picture.

Sidelighting picked out the raised lettering on the grille.

Walking along the road the photographer found a point where the lines ran over a gulley, creating brilliant chevrons of black and yellow and moved the can to this more promising setting.

Camera:	**Metering:**
35mm SLR	Automatic TTL
Lens:	**Filter:**
55mm macro	—
Film:	**Lighting:**
ISO 200 colour transparency	Portable electronic flash unit

Composition Photography provides us with the ability to control and direct the gaze of the viewer. With a camera, we can draw attention to things that people generally pass casually by, or take a view of the familiar from a novel perspective. The ground beneath our feet rarely comes under close scrutiny – only, perhaps, when someone loses a contact lens, or when we drop a tiny bolt while mending the car. So, in this picture, the photographer asks us to look more closely, and see what he sees.

His aim was to lift this small area of tarmac completely out of context, so that we look at the road not in a practical way, as we would when parking the car, but in a purely visual manner – as a pattern of textures, shapes and lines. He did this by pointing the camera vertically downwards, so that the road appears just as a flat surface, with no hint as to its angle of orientation. By limiting the camera's field of view, the photographer has ensured that the viewer sees only this small area, without the benefit of any surrounding detail to reveal which particular road this is, nor in which city or country it is.

The flattened can echoes the anonymity and multi-nationalism. Identical and ubiquitous, Coca-Cola represents the ultimate international consumer product. Its trademark is instantly recognizable – even when creased and half erased. In choosing this can, then, the photographer looks back to the Sixties, when pop artists made icons from banal packaging and advertising brands. In the Eighties, however, the message is different – the picture reminds us that, drained of its contents, even the market leader ends up in the gutter.

Technique To make the picture as colourful as possible, the photographer would have preferred to use sunlight for illumination. However, the weather did not oblige – the sky was overcast, making the scene itself equally dull, and muting the shine in the can's traffic-polished surface. To put back the sparkle the photographer used electronic flash, removing the unit from the camera, and holding it at arm's length to one side. This created sidelighting, emphasizing the texture of the road's surface and the gulley cover.

Other technical details were straightforward: a macro lens simplified framing, allowing the photographer to focus continuously down to a subject distance of a few centimetres. To set exposure, the photographer relied on the auto-exposure capability of the flash unit. From the choice of three apertures, he selected f/16, bracketing at half-stop intervals on either side of this setting.

A quick reading using the camera's meter indicated that to make an exposure by available light, a wider aperture would be required. This meant that the flash light dominated the picture, so there was no risk of the daylight forming a blurred second image during the 1/60 second exposure.

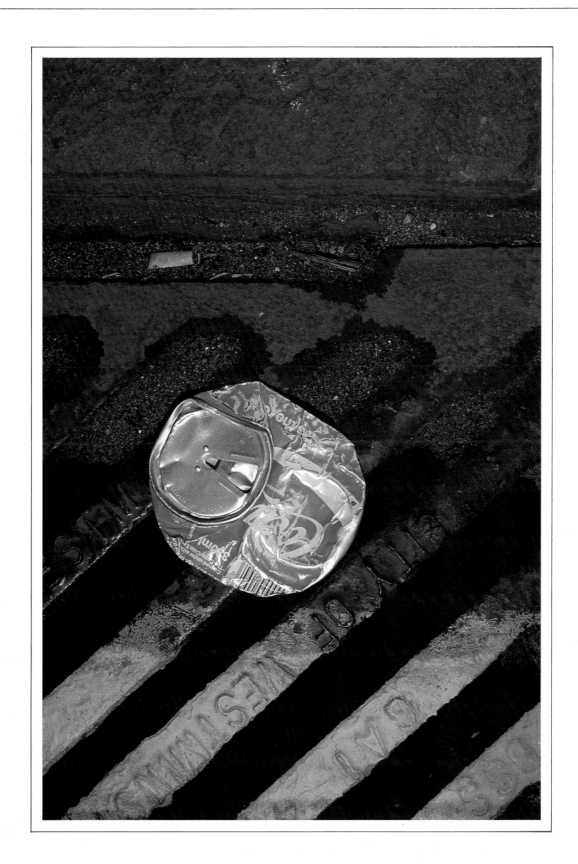

The camera's heavily centre-weighted meter drew less than 10 per cent of its reading from the frame corners, so this dark area had little influence on the exposure set by the camera. Instead, the camera metered the central area and set exposure so that the colours appear brightest there.

Conventional fluorescent strip lighting created this reflected band of lime-green in the foreground.

Camera:
35mm SLR

Lens:
Standard 50mm

Film:
ISO 25 colour transparency

Metering:
TTL −0.5 stops

Filter: –
—

Lighting:
Natural

Composition A rainy night in the city turns the streets into uneven mirrors, which pick up and distort the multitude of coloured lights on buildings and commercial signs. Pointing his camera earthwards, the photographer used the wet tarmac to transform gaudy advertisements for tacky shows into a luminous carpet of colour.

First, though, he took advantage of good weather to seek out those parts of town that were most liberally decorated with suitable signs, picking locations that had the broadest range of colours fairly close to the ground. When the weather was wet, he moved quickly to the best sites.

Composition itself was a matter of finding a viewpoint that concentrated an interesting spectrum of colours within the frame, then moving around the area until the reflection fell on a suitable patch of wet ground. Puddles of standing water reflected too true a picture of the signs; very rough ground shattered the image too much. The compromise chosen falls between these two extremes.

Despite the distorting effect of the rough pavement, the image still has some recognizable lines of emphasis. The photographer tilted the camera so that the bright colours are stretched out across the frame from one corner to the other, creating both movement and depth. Though highly distorted, this is clearly a flat surface that we are looking at,

and we have an impression of its recession into the distance. The picture, therefore, retains an element of reality, without which it could be taken for accidental splashes of colour on canvas.

Technique Photographing a wet road is like taking pictures of a mirror – the shiny surface and the subject reflected come into sharpest focus at two different points. A wide-angle lens or a small aperture will record both road and light patterns sharply, but here the photographer instead opted to blur the road, and focus on the coloured patterns.

Choice of lens was dictated not only by the considerations of depth of field, but also by the viewpoints available from the kerbside, and by the position of the sign and its reflection. A standard lens proved most suitable.

The photographer used slow transparency film – ISO 25 – so that colours were as rich as possible, cutting exposure by a ½ stop to increase colour saturation still further. None of the light sources were incandescent, so there was no real reason to use tungsten-light balanced film – the pictures were taken on ordinary daylight film.

In the dim light the viewfinder display indicated that the shutter would remain open for about ½ a second, so the photographer braced the camera against a lamp-post for extra support.

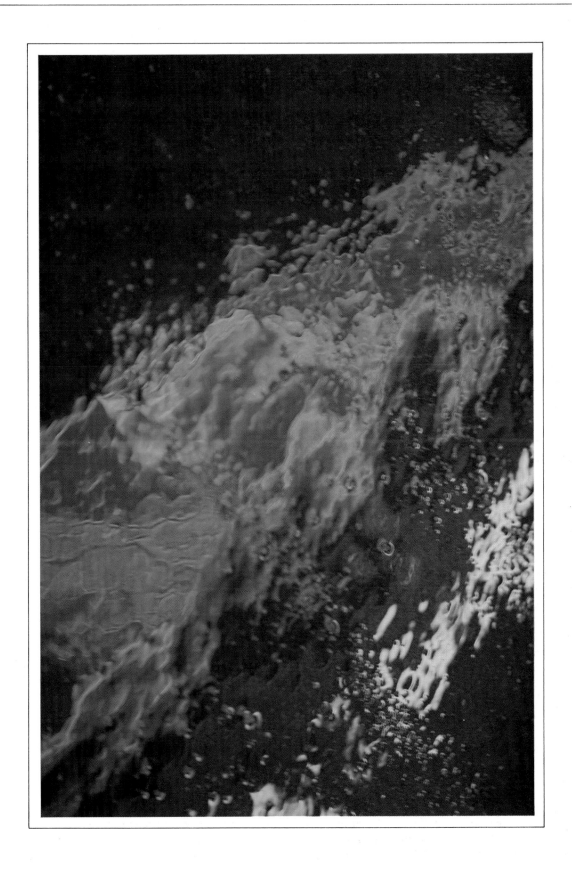

GLOSSARY

ASA
Measure of film speed now superseded by ISO scale, to which it is numerically equal.

AERIAL PERSPECTIVE
The bluer, lighter appearance of objects at increasing distance from the camera. Gives an impression of depth to a picture.

APERTURE
Adjustable hole made by several small metal leaves between the elements of a camera's lens. Used to control the intensity of light reaching the film and thus also the exposure
See also STOP.

BLEACH
Chemical used to remove silver from photographic image, thereby reducing density. On prints, applied locally to lighten small areas.

BLIND *See* HIDE.

BRACKETING
Process of making several pictures of the same subject, but giving each picture a different exposure to ensure that one is perfect. For example, a photographer might make one exposure at the setting indicated by the meter, then give one picture half a stop extra exposure, and a third half a stop less. This acts as an insurance policy, and is a particularly useful technique in high-contrast situations where exposure is critical.

BURNING IN
Giving extra printing exposure to an area of a picture during enlargement, in order to make that area appear darker when printing from negatives, or lighter when printing from transparencies.

CABLE RELEASE
Flexible cable inside a pliant tube. One end screws into the camera's shutter release; pressing a plunger at the other initiates the exposure without vibration being transmitted to the camera.

CAMERA MOVEMENTS
Blanket term that refers to the relative movement of film and lens on a large-format camera. These movements permit precise control over sharpness distribution, and field of view of the camera.

CATADIOPTRIC LENS
Lens that forms images using not only glass elements which focus light by refraction, but mirrored elements which focus by reflection – like a magnifying shaving mirror. Combines very long focal length with compactness and light weight.

CENTRE-WEIGHTING
Term used to describe TTL exposure metering systems that are more sensitive to light reflected from the central area of the subject than to the outer areas of the frame. Most TTL meters are centre-weighted, but some much more heavily than others.

CLOSE-UP LENS
Add-on lens resembling a filter. Reduces camera's minimum focusing distance, thereby permitting close-up pictures.

COLOUR CAST
Usually undesirable wash of colour uniformly covering the whole of a photograph.

COLOUR SATURATION
Term loosely used to connote richness and depth of colour.

COLOUR TEMPERATURE
Scale used by photographers to describe colour of light. Bluish light, such as that from an overcast sky, has a high colour temperature. Yellowish light like candle-light, a low colour temperature. Usually measured in kelvins.

CONTRAST
Difference between lightest and darkest areas. On a print or slide, contrast refers to the difference in the amount of silver or dye in the darkest and lightest areas of the image. In a scene before the camera, contrast is the difference in brightness between different parts of the scene as perceived from the camera position.

DARKSLIDE
Thin, box-like, light-tight container holding two sheets of film. See also SHEET FILM CAMERA.

DAYLIGHT FILM
Film manufactured to give lifelike colours when daylight or electronic flash illuminates the subject.

DEPTH OF FIELD
Amount of a scene or picture in focus, measured outwards from the camera.

DODGING
Process of giving less exposure during enlargement to a local area of a print, in order to make that area appear lighter when printing from negatives or darker when printing from transparencies.

EXPOSURE
(1) Term used loosely to mean amount of light received by film or printing paper. Exposure is affected by three factors: brightness of light reflected by subject; how long the shutter is open; and size of aperture.
(2) Often used to mean picture or frame, as in 'make three exposures'.

EXPOSURE LATITUDE
Ability of film or paper to tolerate over- or underexposure.

EXTENSION TUBE
Metal tube fitted between camera and lens to permit closer focusing.

F-NUMBER
Measure of aperture size, marked on camera lens in a standard scale. Alternate f-numbers double, so the scale runs 2, 2.8, 4, 5.6 etc. Changing from one f-number to the next doubles or halves the amount of

*light passing through the lens. Large f-numbers connote
small apertures, and vice versa.*

F-STOP
Term used interchangeably with aperture.

FIELD OF VIEW
*The amount of the scene in front of the camera that a
particular lens takes in. Wide-angle lenses have a
broad field of view, telephoto lenses a narrow one. See
also FOCAL LENGTH.*

FILL-IN FLASH
*Flash used in sunlight to illuminate shadows and
thereby reduce lighting contrast.*

FILM SPEED
*Measure of the sensitivity of film to light. Measured in
ISO values.*

FLARE
*Non-image-forming light which forms either regular
disc-shaped marks on film, or veils the whole picture,
reducing contrast.*

FOCAL LENGTH
*In practical terms, a dimension in millimetres
indicating the field of view of a lens. Long focal length
lenses (telephoto lenses) take in a narrow field of view;
short focal length lenses (wide-angle lenses), a wide
one. On a theoretical level, focal length is an actual
distance corresponding to a physical measurement
between the film and the notional centre of the lens,
when focused on infinity.*

FOCUSING
*Act of adjusting distance between lens and film in order
to render the subject sharply.*

FRENCH FLAG
*Flat piece of black card or metal attached to a flexible
arm, used to shade lens from light, thereby preventing
flare.*

GRAIN
*Grit-like texture of film's structure that appears when
picture is greatly enlarged. More evident with fast films
than with slow.*

HIDE
*Shelter which conceals photographer from a timid
subject. A hide may be ready-made, from canvas and
alloy poles, or improvised from local materials such as
brushwood.*

HIGHLIGHT
Brightest areas of subject or image.

ISO
*Numerical measure of film speed. Fast films have high
ISO ratings and vice versa.*

INCIDENT LIGHT
*Light falling on a subject, as opposed to that reflected
from it.*

INCIDENT LIGHT METER
*Hand-held meter that measures the above. Has the
advantage that it is not misled by subject tones, and
therefore gives reliable indications even when setting
exposure for dark or light subjects. See also LIGHT
METER.*

IRIS DIAPHRAGM
*Arrangement of metal blades that together forms the
aperture within a lens.*

JOULE
*Measurement of power of flash. Small portable flash
units give out 20 50 joules; large studio units, up to
10,000.*

LARGE-FORMAT CAMERA *See* SHEET FILM
CAMERA.

LIGHT METER
*Instrument that measures the light intensity, and, when
programmed with film speeds, indicates which
combinations of shutter speed and aperture will yield
correctly exposed pictures.*

MACRO LENS
Lens that permits extreme close-up pictures.

MIRROR LENS *See* CATADIOPTRIC LENS.

MODELLING
*The appearance of form and depth created by the light
falling on a subject. Side-lighting creates a lot of
modelling – the appearance of high relief.*

MODELLING LIGHT
*Tungsten lamp fitted into studio flash units to stimulate
the quality of illumination created by the flash tubes
themselves.*

OVEREXPOSURE
*Usually undesirable effect of allowing too much light to
reach the film or print. Yields images that are too light,
or lack highlight detail.*

PANNING
*Act of swinging the camera to follow a moving subject,
in order to render it sharply on film or to evoke a sense
of motion.*

PARALLAX ERROR
*Difference between what the photographer sees through
the viewfinder of a non-reflex camera, and what
appears on film.*

PERSPECTIVE
The appearance of depth in a scene.

PERSPECTIVE CONTROL LENS
*Lens for 35mm or rollfilm camera that duplicates some
of the camera movements found on a camera of larger
format.*

PULLING
*Reduction of film developing time to compensate for
overexposure.*

PUSHING
Extension of film developing time to compensate for underexposure.

RANGEFINDER CAMERA
Type of camera that has one lens for use as a viewfinder and a separate one to form the image on film. Rangefinder cameras are focused indirectly: the photographer turns the focusing ring until twin images of the subject in the viewfinder merge to form a single image.

RECIPROCITY FAILURE
Reduction of film's sensitivity in dim light. Unless there is compensation for reciprocity failure at the moment of exposure, photographs taken with exposure times of a second or more will be underexposed, and may have a colour cast.

REFLECTANCE
Amount of light reflected by a subject, relative to the amount that falls on it. Thus light-toned subjects have a high reflectance.

REFLECTED LIGHT METER
Instrument that measures the light reflected by the subject. See also LIGHT METER.

SLR
Abbreviation for Single Lens Reflex camera: highly versatile and convenient design of camera that uses just one lens: both for viewfinding and focusing the image; and for making the exposure. Principal advantages are that the subject appears in the viewfinder exactly as it will on film, so close-ups are simple to take, and when lenses are changed the photographer can see immediately the changed field of view.

SHADING *See* DODGING.

SHADOW
Darkest areas of a subject or print – not necessarily those in the shade.

SHEET FILM CAMERA
Camera which uses film in large individual sheets (usually 5 × 4 in or 10 × 8 in), rather than rolls or cassettes. Most such cameras offer the user camera movements, that give unparalleled control over how the subject appears in the photograph.

SHIFT LENS *See* PERSPECTIVE CONTROL LENS.

SHUTTER
Device fitted into cameras to regulate the duration of exposure. Closed, the shutter stops all light from reaching the film; open, a shutter allows light to reach the film unhindered.

SHUTTER SPEED
Measure of the time for which the shutter remains open. Usually calibrated in doubling steps, so that each setting admits light for twice or half the time as the adjacent settings.

SPLIT-FIELD CLOSE-UP LENS
Literally, half a close-up lens. When fitted on to the front of a lens, this device permits the photographer to keep very nearby objects in focus on one side of the picture, while recording distant objects sharply on the other side.

SPOTMETER
Reflected light meter that measures light from a very small area of the subject – typically 1 degree of arc.

STOP
Term used very loosely, but generally one unit of exposure, always used in relative terms. For example . . . 'give one stop extra exposure' means doubling the exposure, by opening up the aperture to the next, wider setting or choosing the next slower shutter speed.

STOPPING DOWN
The process of using a smaller aperture, to reduce exposure or to increase depth of field.

STUDIO FLASH
Powerful flash unit operated from mains electricity.

SUBSTITUTE READING
Meter reading taken from an area similar in tone to the main subject, when the latter cannot be metered directly.

SYNCHRONIZATION
The firing of a flash unit at the precise moment when the camera's shutter is open.

TTL METERING
Abbreviation for Through The Lens metering. Method of metering that reads light reflected from the subject, using light-sensitive cells within the camera body itself.

TELECONVERTER
Optical device that multiplies the focal length of the lens to which it is fitted.

TUNGSTEN FILM
Film manufactured to give correct colours when subject is illuminated by photographic tungsten lights.

TUNGSTEN LIGHT
(1) Any lamp that produces its light by the heating of a metal filament inside an evacuated glass envelope. (2) The light given out by (1).

UNDEREXPOSURE
Usually undesirable effect of allowing too little light to reach the film or print. Yields images that are too dark, or lacking shadow detail.

VIEW CAMERA *See* SHEET FILM CAMERA.

VIGNETTING
(1) Shading of the corners of a portrait during enlargement, to create an oval image. (2) Accidental darkening of the corners of an image, commonly caused by the fitting of a lens hood too long for the focal length.

WATT-SECOND *See* JOULE.

INDEX

Acknowledgements

Michael Busselle: 32, 33,
35, 37, 38, 39, 41
Michael Freeman: 94, 95,
131, 133, 135, 137, 139, 143,
147
John Garrett: 7, 165
Cecil Jospé: 21, 61, 63, 70,
71, 81, 175, 177
Laurie Lewis: 115, 124,
125
Jerry Young: 18, 19, 24, 25,
28, 29, 50, 51, 82, 83, 86, 87,
90, 91, 110, 111, 113, 116,
117, 118, 119, 121, 122, 123,
126, 127, 129, 153, 155, 168,
169, 170, 171, 172, 173